# SNOWDON

# STILLS

## 1984-1987

# SNOWDON

# STILLS

## 1984-1987

INTRODUCTION BY HAROLD EVANS

WEIDENFELD AND NICOLSON
LONDON

First published in 1987 by
George Weidenfeld & Nicolson Limited
91 Clapham High Street, London SW4 7TA

Designed by Paul Bowden

ISBN 0 297 79185 0

Colour separations by Newsele Litho Ltd
Filmset by Deltatype Lecru, Ellesmere Port, Cheshire
Printed and bound by L.E.G.O., Vicenza

In memory of my sister Susan

# ACKNOWLEDGEMENTS

I would like to thank everyone who so kindly gave me their valuable
time to take stills of them; Michael Rand and Gunn Brinson at *The
Sunday Times* colour magazine for their stimulating encouragement
and enthusiasm; Beatrix Miller, Anna Wintour, Patrick Kinmonth,
Felicity Clark, Lillie Davies and all the other editors at *Vogue* I have
had the pleasure to work for; Alexander Lieberman, Tina Brown and
Elisabeth Biondi for their transatlantic friendship; Andrew Macpher-
son, Simon Mein, Tim O'Sullivan, Matthew Donaldson and Robin
Matthews for their kind assistance both in the studio and on location;
Terry Lack for his skilled black-and-white printing and processing
and Terry Boxall for his talented retouching; Sophie Miller and
Evelyn Humphries for all their endless efficiency and tireless work in
the organizing and arranging of sittings, filing and finding the
photographs, which have been laid out with such care by Paul
Bowden; Peter Lyster-Todd and Kathy Saker for their much
appreciated work in scheduling so many of the commissions; Victoria
Charlton and Peter Brightman for inviting me twice to Russia;
Richard Goodwin and John Brabourne for asking me to photograph *A
Passage to India* in Bangalore and *Little Dorrit* in Rotherhithe; and
Michael Dover from Weidenfeld for his patronage and patience.

# INTRODUCTION

I think of Snowdon as the sorcerer's apprentice. Let Marlene Dietrich's cigarette fail to produce the trademark of photographic smoke for his Café de Paris portrait and in a flash three people puffing cigars will materialize under the piano. Isolate him in a bare rehearsal room at the Bolshoi Ballet and he will produce a studio, rabbit out of hat, from the 12-foot rolls of white paper he took as hand luggage aboard Aeroflot. Give him three minutes in a darkroom and where there was only one Gerald Scarfe you will see two, one artist and the other Chelsea socialite. Confront him with the problem of supporting fashion models in exquisite poses and he will turn a dozen naked black men into classical sculptures. It is no surprise to have had his confession that one of his earliest photographs of matches tumbling out of a box was a fake made by glueing them together, or to learn that when he began photographic printing at Eton he did it with an enlarger impudently fashioned out of a couple of empty tomato cans. My own experience as a sitter for him was to arrive empty-handed and find my fingers sprouting a large vintage steam typewriter. I had remarked that it was a model I had used as a young reporter in 1946. Snowdon seized it at once and carried it into the bare studio. It was a mark of his happy improvization, no doubt, but for me it was pure legerdemain.

Snowdon could of course easily qualify as a grand master of sorcery. He won't and can't because he doesn't take it seriously enough. He breaks the rules of wizardry by acknowledging the mirrors and pulleys of deception and admitting that sometimes artifice fails. He even puts on his cover of this volume his own magic toad performing an ironic overture for Baryshnikov and company. Master sorcerers, in truth, are dull establishment figures who have forgotten the art of adventure and stopped trying. It is the wit, enthusiasm and playfulness of the apprentice that is entirely appropriate to Snowdon's work, especially his portraiture, and makes it so surprising and enjoyable. He never stops experimenting and this edition contains livelier surprises than any of this earlier volumes. There is the slapstick of Scarfe the ghoul, adorned with ketchup, the wicked surrealism in the presentation of Georges Baselitz and son, the play on Goya in the portrait of the King of Spain with dog and cape, the curious still life of flesh and feet that my sense of mercy prompts me to reveal is a baby upside down. Of the comic juxtaposition of images there is a quantity, jokes, wheezes, digs and japes that I leave the reader to find for himself.

Snowdon's straight portraiture is unpredictable, except in the certainty that the image will be an honest likeness, a useful attribute that some clever photographers find inhibiting. There are portraits clinically sharp and theatrically grainy; portraits composed over hours in the studio and images caught on the wing, singly and in sequence: some are comically active (Anthony Sher), some serenely static (Benazir Bhutto). There are full figure studies (the matador brave in his braces) and there are snaps (Mayor Kollek); there are assiduous explorations of

physiognomy (the unsmiling Nancy Reagan, juxtaposed with Nicol Williamson as the Gnome King); there are profiles, full heads loosely framed and audacious cropping (William Golding). The range is extraordinary in its imagination and technique. Bob Hoskins, the star of *Mona Lisa*, is posed nude and imprisoned in a cage (Snowdon's upended garden seat), and Alan Bennett, dissector of the English classes, sits happily in an abattoir. These represent the photograph as metaphor. Georg Solti is the photograph as verb. One feels the pulses of energy he is conveying to the players. Rowan Atkinson, his head caught absurdly in his own hands as if it were a catch at slip, is the photograph as satire.

Snowdon likes to acknowledge his debt to other photographers, notably Penn and Cartier-Bresson. The studiously beautiful portrait of Rossellini is reminiscent of Penn, and the hilarious shot of Cartier-Bresson in a bonnet is a joke on Cartier-Bresson the indefatigable snapper who does not like to be photographed. And perhaps there is a touch of Arnold Newman in the geometric design that functionally frames Max Bill of the Bauhaus. But what impresses is Snowdon's effervescent originality. There are two portraits of Noel Coward that will endure. One is Snowdon's, in his book *Personal View*, in which the suavest of men lolls not against a night club grand piano but a pile of cheap Covent Garden fruit boxes roughly stencilled. The other, a very different matter, was made for Vanity Fair in 1932 by Edward Steichen. It is composed of black curves on three planes. An elegant Coward sits pensively in half light and a faint plume of cigarette smoke, only one eye visible. This is the photograph as essay. It takes longer to explore. But it is not superior for that. In part it subordinates the subject to the elements of design, very much as does Arnold Newman, the greatest environmental portraitist, whereas Snowdon maintains his concentration on the person. The Coward portrait, moreover, is succinct. It is an epigram, and that is the essence of Coward as artist.

I think this is where lies the particular achievement of Snowdon as portraitist. No one else is so adroit at epitomizing the public persona of a subject. There's Hoskins and there's the Princess of Wales. There is the flamboyant Charles Haughey proud with his possessions and Garret Fitzgerald alone with his thoughts. There's Boy George and clones, and Tina Turner. There's John Betjeman in *Assignments*, caught on a railway platform seat on a damp day, clearly dreaming of Joan Hunter Dunn. There are scores of others evident in his work for *The Sunday Times*, British and American *Vogue* and *Vanity Fair*. This might be thought a small or superficial achievement. Aren't portrait photographers supposed to give us a glimpse of the private person beneath the mask? This is the conventional attribute of greatness and conventionally we are referred to Richard Avedon and Diane Arbus as the exemplary disclosers of private truth. I wonder. Diane Arbus posed her people square to camera with direct front light so that their freakishness was pitifully isolated. The pictures are searing, but that they are shocking does not mean they represent the truth about those people. Many of Richard Avedon's portraits have been contrived in harsh light and with angles that document the degeneration of the flesh, some so wide-angled they sacrifice recognition for drama. One thinks of the sequence of photographs of his dying father that track the thinning of flesh on the skull and the ebbing of life, of the Windsors staring with lockjaw dejection at the lens, and the recent study of characters of the rural American West who were not so much pinned as nailed to the specimen table. Again, the critical response is to confuse shock with reality, or to accept a fragmentary perception as the whole truth. Maybe the mask of the Windsors did slip, maybe that momentary glumness truly conveyed that they were irredeemably depressed with life and each other. The biographical

evidence, for what it is worth, does not give that credence. But whatever the truth of the matter it is surely an error to equate the true with the brutal, or to assume that a public persona must represent a falsehood. A mask can be worn so long that it moulds the character as well as the face, and there is significance in the masks people wear. August Sander made the point well, after a lifetime in a massive exercise of objective realism photographing the people of Thirties Germany in all walks of life. People posing to camera, said Sander, reveal their secret self-image. That is a truth all right and it is one that Snowdon's unobtrusive artistry time and again captures and preserves. He teases out of his subjects the very best performance. Snowdon is in many ways a romantic. But capturing people at a high point in the realization of their self-image is, at the very least, as legitimate a statement as catching them at low ebb.

I single this out as an original feature of Snowdon's work, but it is not all there is, even to his portraiture. Some of his more private portraits have a depth that is profound. There is Graham Greene here, I recall without needing to find the book, and poetic sensitivity is revealed in his study of the indispensable, elegant Denis Hamilton when editor of *The Sunday Times* and the haunted eyes of Francis Bacon in *Personal View*. A comparison is again instructive. Bill Brandt's famously surreal image of Bacon was evoked by photographing him at dusk under gaslight on Hampstead Heath; Snowdon's is remarkable for the economy of its effect.

Snowdon has the craftmanship to adopt the technique that seems to him appropriate for his effects and a restless desire for originality that could tempt him to gimmickry. Two things control that: his taste and his discipline. He carries self-criticism to the point of parody. He has told us how he learns all he can about a subject before the session, and his colleagues on *The Sunday Times* will attest to the intensity of his effort. He also has the talents of a considerable mimic. But knowledge does not necessarily translate to perception, nor impersonation to insight. There is an emotional, intuitive quality to Snowdon's identification with his subject. He has empathy. This is most striking in his portraits of writers, artists and actors with whom he most naturally identifies. One senses that his nervous strain is less in portraits of this kind. Lear by Olivier is a genuine double bill. But the quality has deeper springs. It also shows in his photographs of the vulnerable in society, in children, the mentally ill, the dying and the old.

There is more to Snowdon than a talent for portraiture. It needs a full-time lepidopterist of the rank of Nabokov to keep up with him as photographer, filmmaker and designer. His design is relevant to his photography. He is aware of the graphic environment of our times in a way which most photographers are not, so that his work succeeds by a modernity within its classical framework. He has been for nearly forty years a relentless and brave experimenter. In the early Fifties he did for photography what John Osborne did for drama and Johnny Cranko for dance. He opened the stage drawing room windows – and not to say 'anyone for tennis?' but to let out the stale air of photo calls whose stilted images rendered drama anaemic. It is good to see some new examples of this style: Lear positively lunges off the page. Snowdon was early in exploring what could be done Cartier-Bresson-style with a miniature camera and available light (with a little bit of sorcery in rematching lenses from different makers to his own Leica).

His Fifties pictures at the Café de Paris were propitious. Marlene Dietrich had a friend at American *Vogue* and she told him how impressed she was by the work of the young Armstrong Jones. Her friend, the redoubtable director Alexander Lieberman, at once invited Snowdon to New York and encouraged him to follow his radical impulses. I turned through the pages of the 1959 *Vogue* the other day and it's startling to see what Snowdon achieved. There are sequences

of women, art and fashion from such masters as Penn, Horst, Beaton and Munkacsi. They are delightful images, all very much in the same tradition of illusion, symmetry and adornment, but they are upstaged by the naturalism of Snowdon. An early assignment was to photograph the celebrated society hostesses, but instead of the pose beneath the candelabra in the living room he had Mrs William Paley leaning vertiginously out of the window of her skyscraper apartment at the St Regis, and Mrs Henry Fonda, Henry Fonda and Mrs Winston Guest scurrying through the New York streets like ordinary people. When he turned in the photographs there was consternation among *Vogue*'s fashion editors at the social heresies; and rapture from Alexander Lieberman. It says something for the charm of the photographer that they were taken at all, and something for the magazine that when they were published it was with the great bravado of one of Lieberman's best layouts.

Those images, if revolutionary, were in themselves ephemeral. It is likely that the naturalism and sensitivity Snowdon has brought to another area of photography will endure. I am referring to his work in social reportage. It began on *The Sunday Times* colour magazine when he worked on a story on the problems of the old, and it extended to reporting on children's stress, cruelty to children, disabled people and the mentally handicapped. I recall being so moved by one of Snowdon's photographs of a nurse and a patient in a mental hospital that I transferred it to the black and white main editorial page and began a campaign on mental health. The verb is moved. The pictures were not shocking and, as Snowdon has said, that was not his intent. I would contrast those images again with the portraits from an asylum by Diane Arbus. They are shocking, but their effect I feel is to isolate the subject from the viewer, to remove the people to a nether world we never want to reach and touch. Snowdon's honestly poignant pictures form a bridge to understanding. Even in this field of social documentation, where the hint of a false nose would be fatal, there is a sense of style that transforms commonplace candour into art.

That talent is briefly indicated here by the relaxed photograph of Welsh miners in the showers. It reminds one of Snowdon's range that it should appear in a gallery of models and princesses, transvestites and lawyers, with studies of feet and hands and landscape, with exuberant Rastafarians at a gallop and architectural nudes that echo Weston. Snowdon is the most versatile photographer of our times. He has a lot of fun demonstrating it in this volume and I am glad to share it.

Harold Evans, New York, 1987.

11

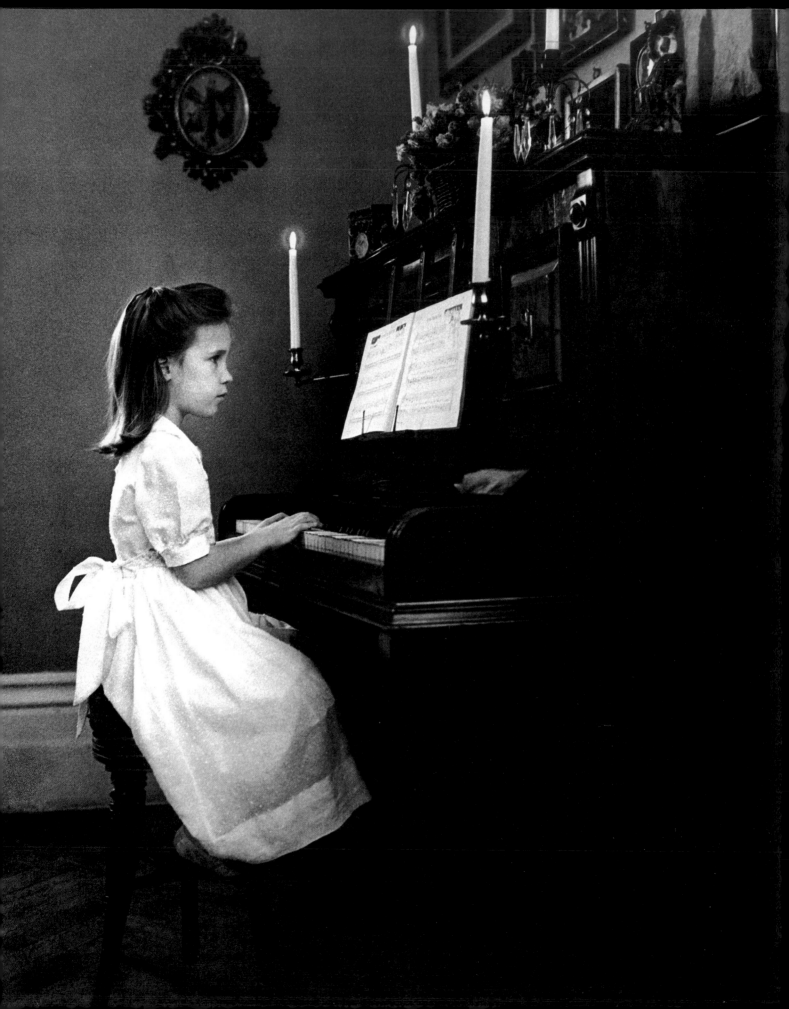

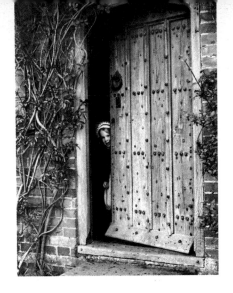

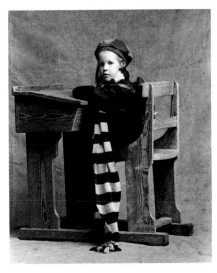

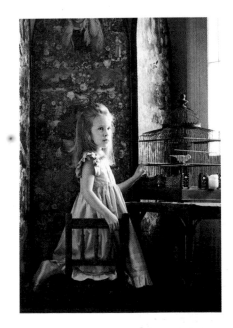

Frances. Christmas Cards:
TOP TO BOTTOM 1983, 1984 and
1985; OPPOSIT 1986.

13

Sarah, 1984.

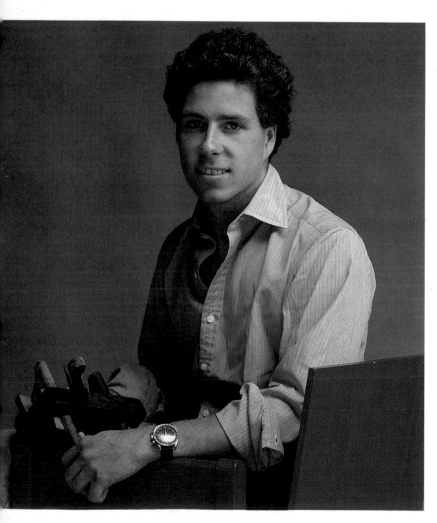

David, 1985.

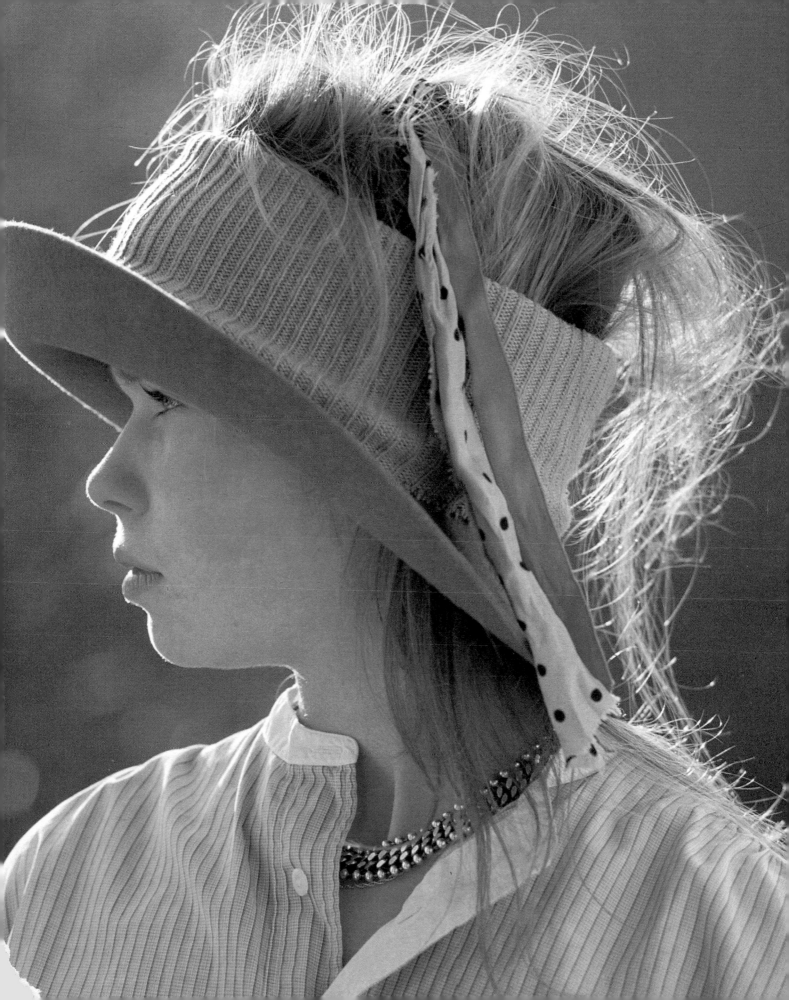

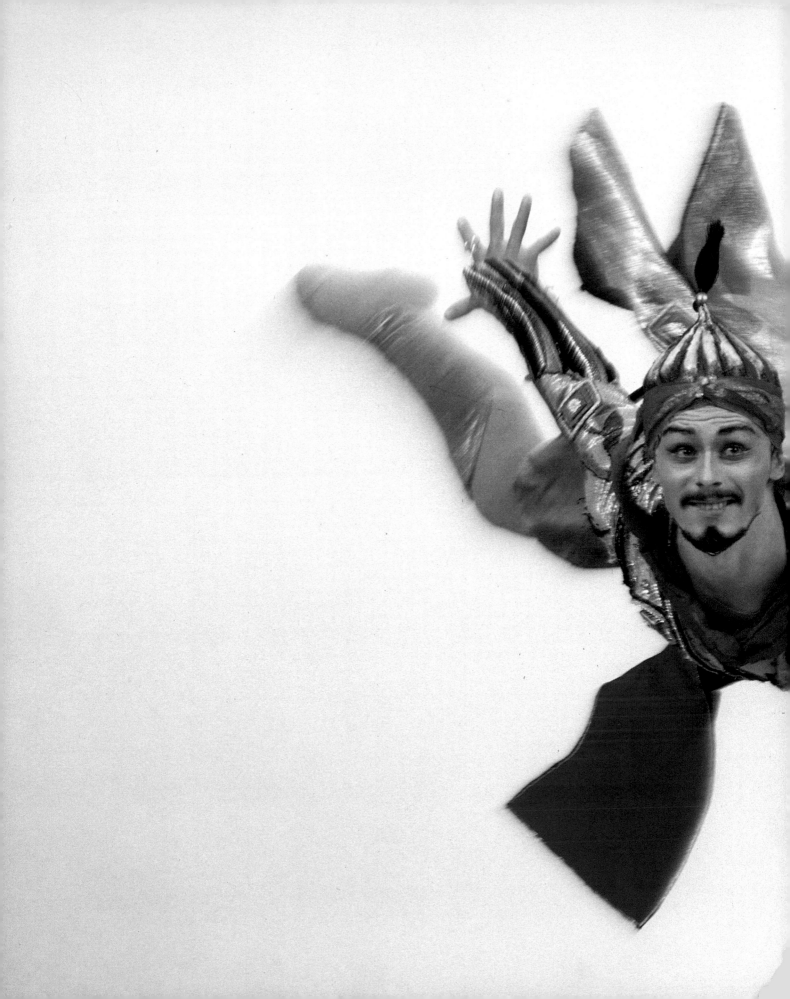

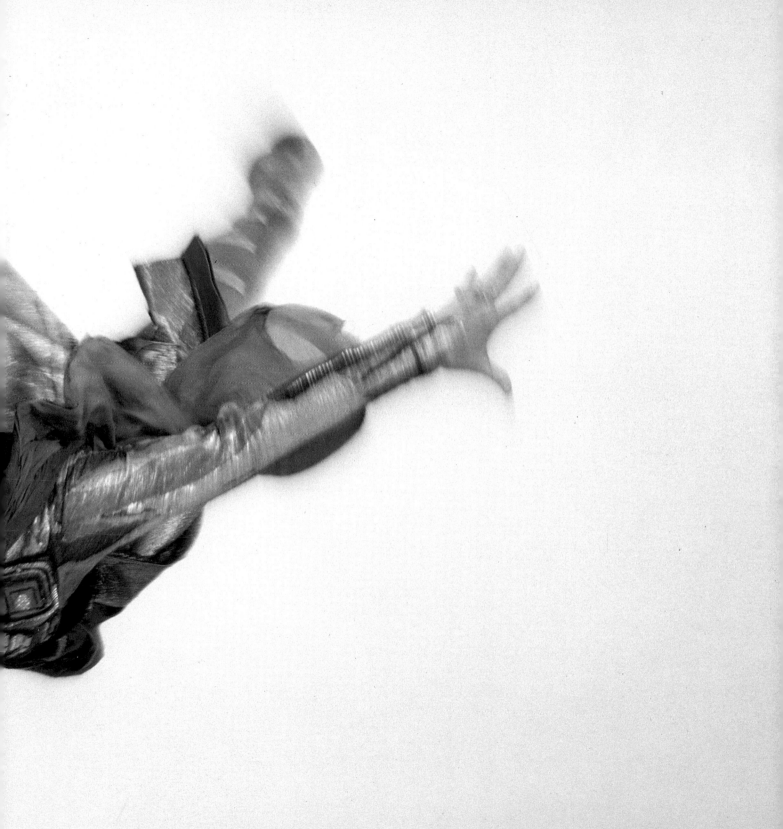

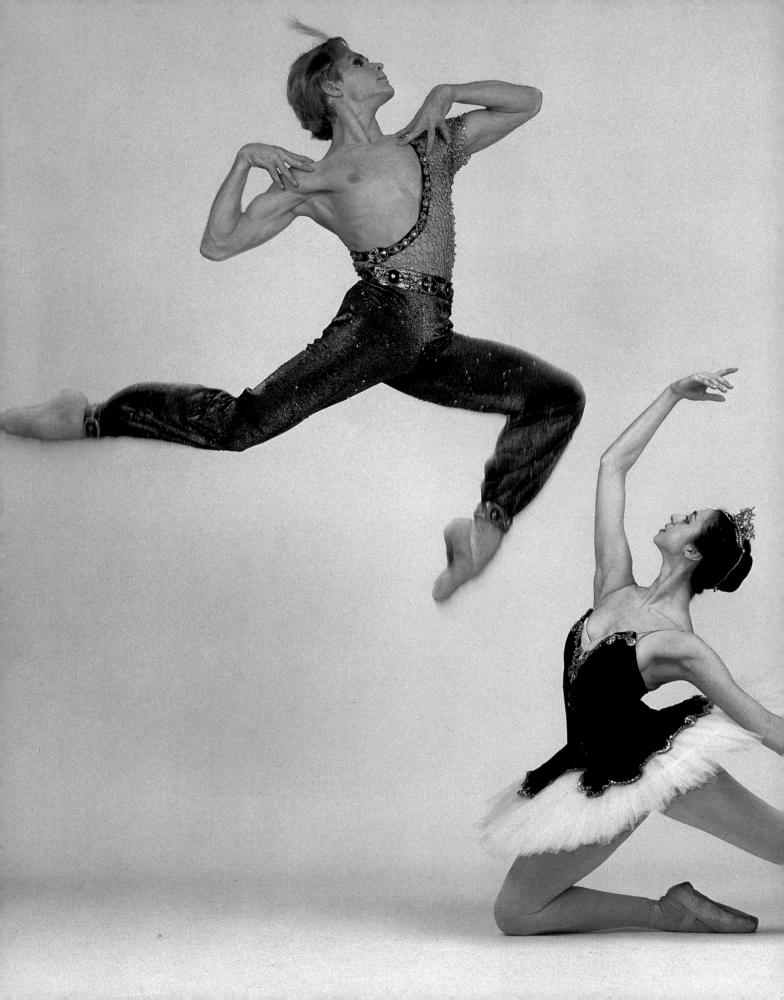

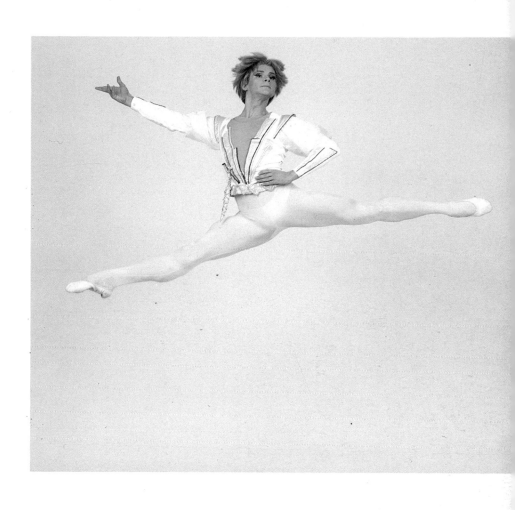

Gediminas Taranda in *Raymonda*,
The Bolshoi Ballet, Moscow, 1985.

Nina Ananiashvili and Andris Liepa in *Corsaire*, The Bolshoi
Ballet, Moscow, 1985.

Andris Liepa in *Raymonda*,
The Bolshoi Ballet, Moscow, 1985.

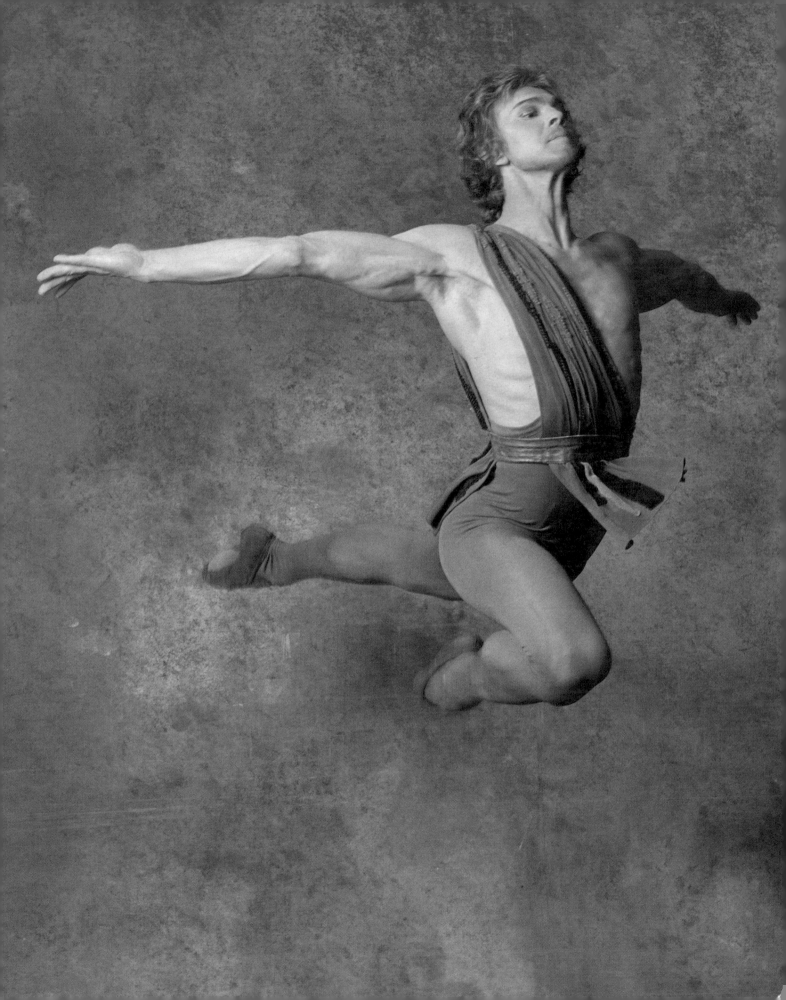

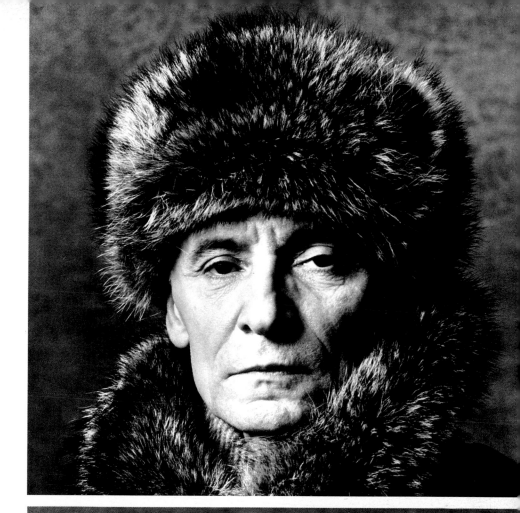

Yuri Vasyuchenko in *Spartacus*,
The Bolshoi Ballet, Moscow, 1985.

Yuri Grigorovich, Artistic Director
and Chief Choreographer of
The Bolshoi Ballet, Moscow, 1985.

Galina Sergeyevna Ulanova,
*répétiteur*, twice awarded the
highest civilian honour –
Hero of the Soviet Union – 1985.

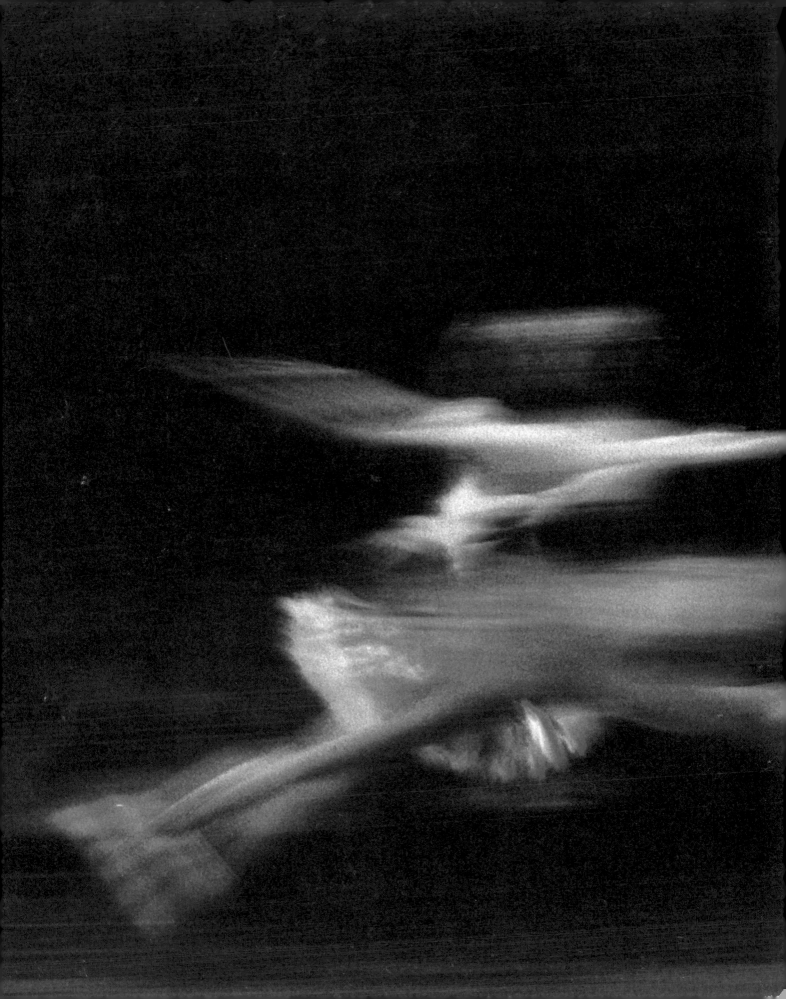

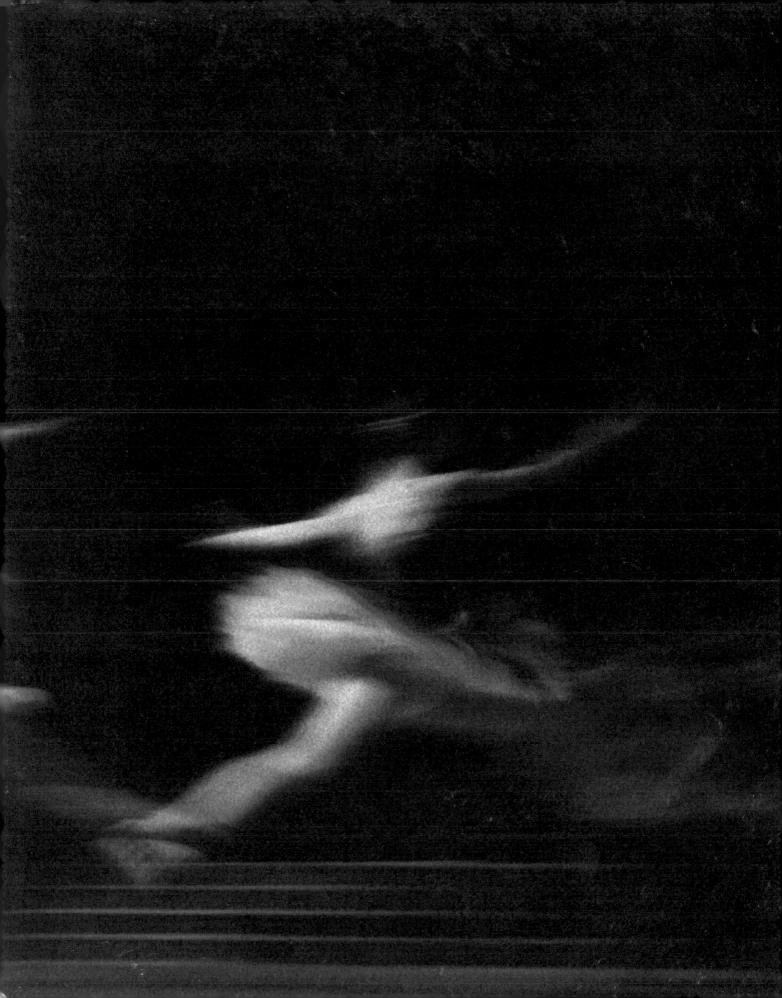

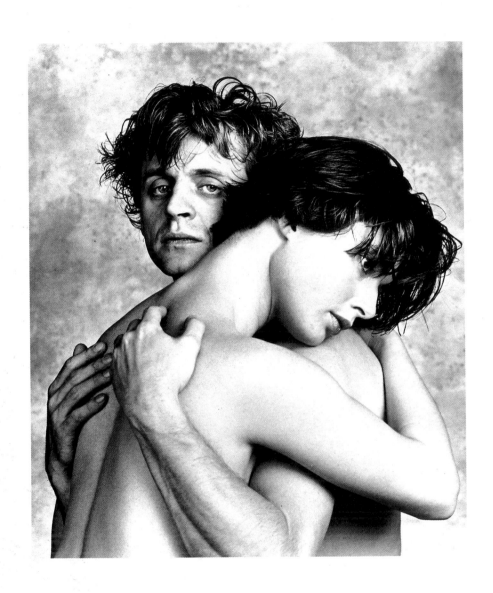

PRECEDING PAGES *Swan Lake*, The Bolshoi Ballet, Moscow, 1985.

ABOVE Isabella Rossellini and Mikhail Baryshnikov, 1984.

OPPOSITE Isabella Rossellini, 1984.

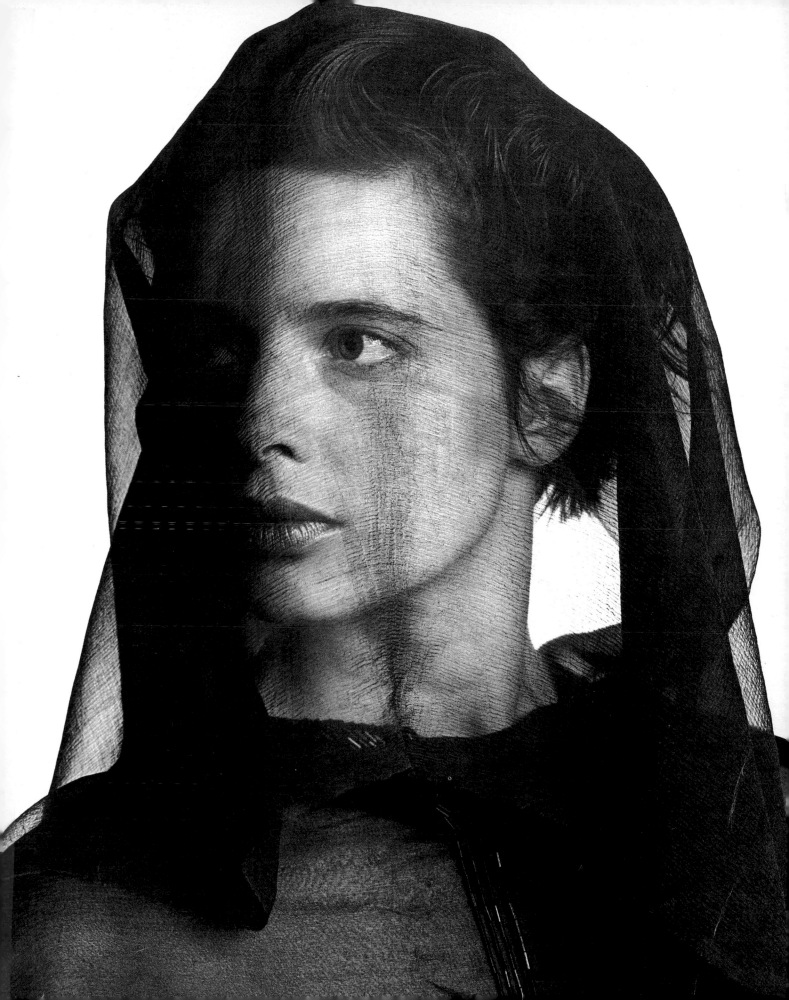

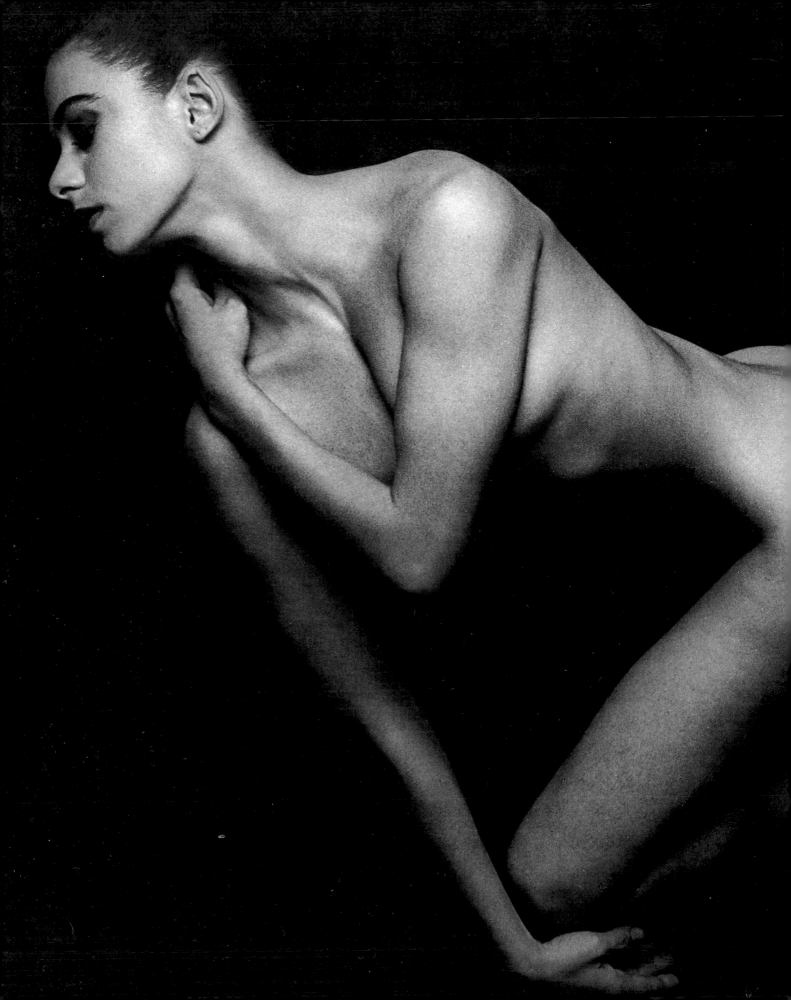

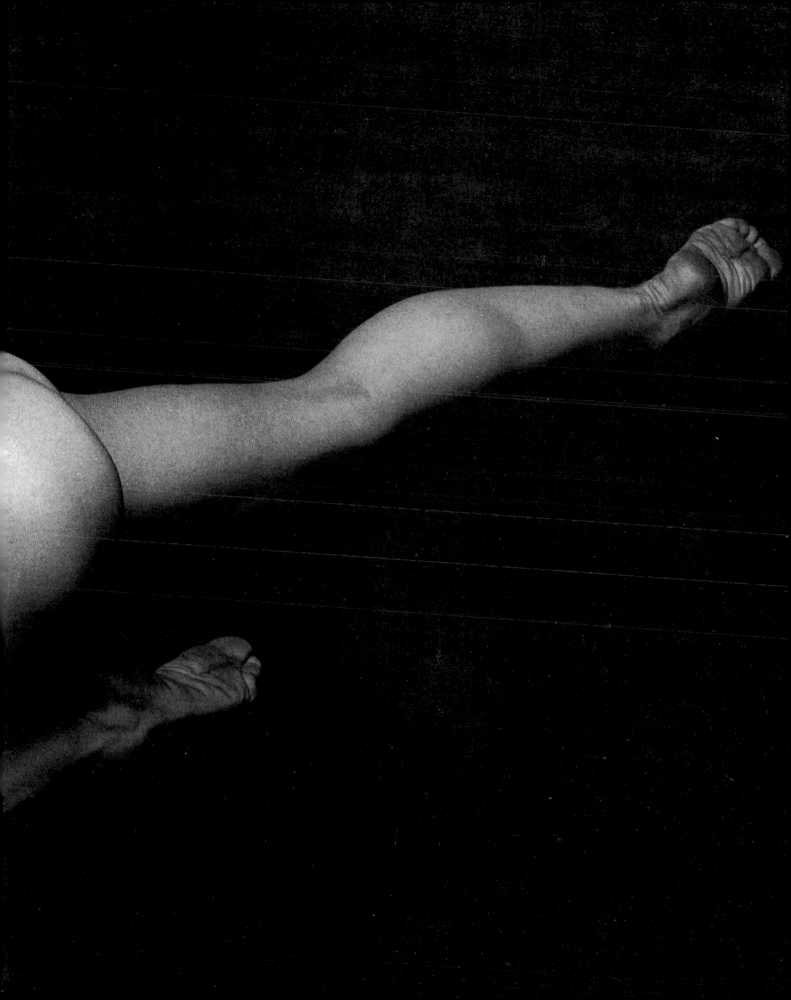

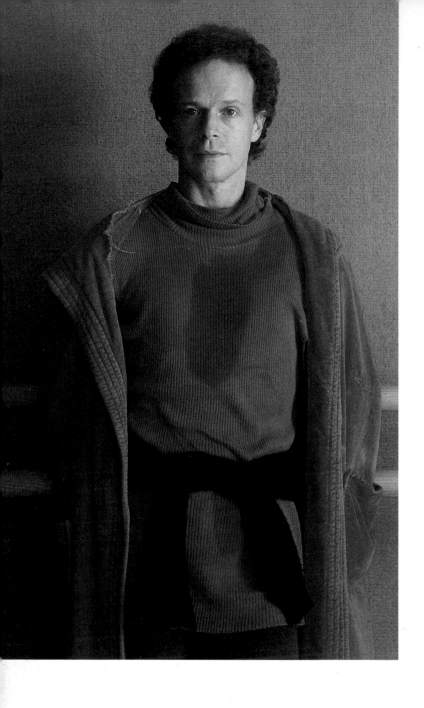

PRECEDING PAGES Alessandra Ferri, 1986.

ABOVE Anthony Dowell, Covent Garden, 1986.

OPPOSITE Arthur Mitchell, The Dance Theater of Harlem, 1984.

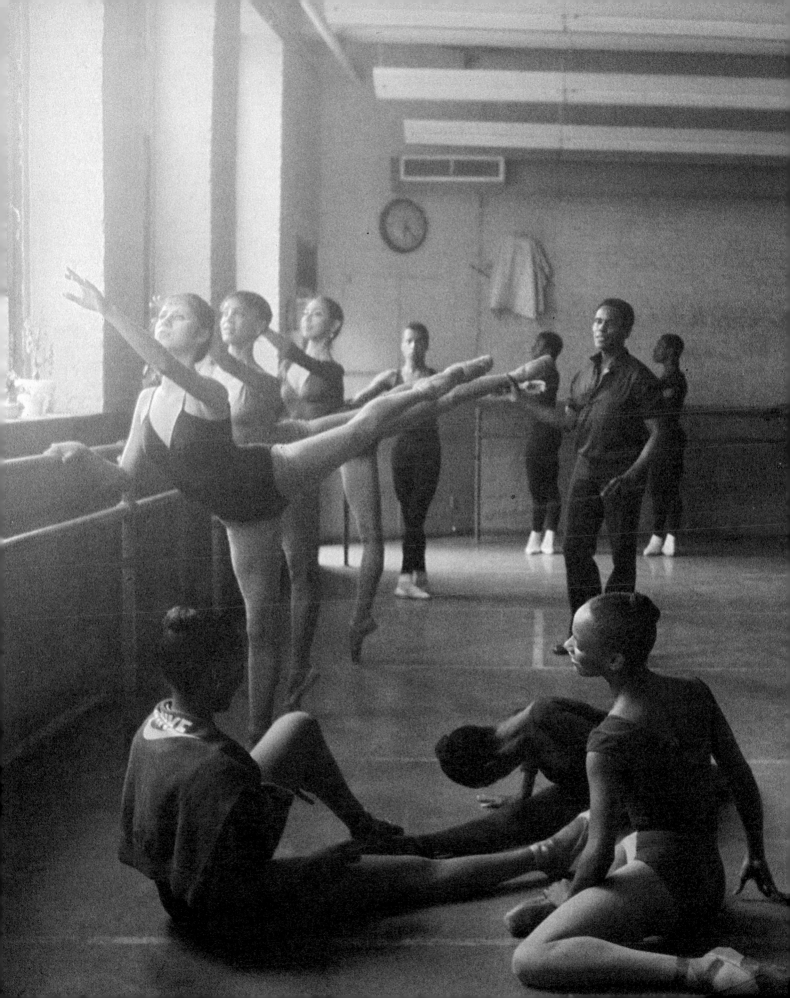

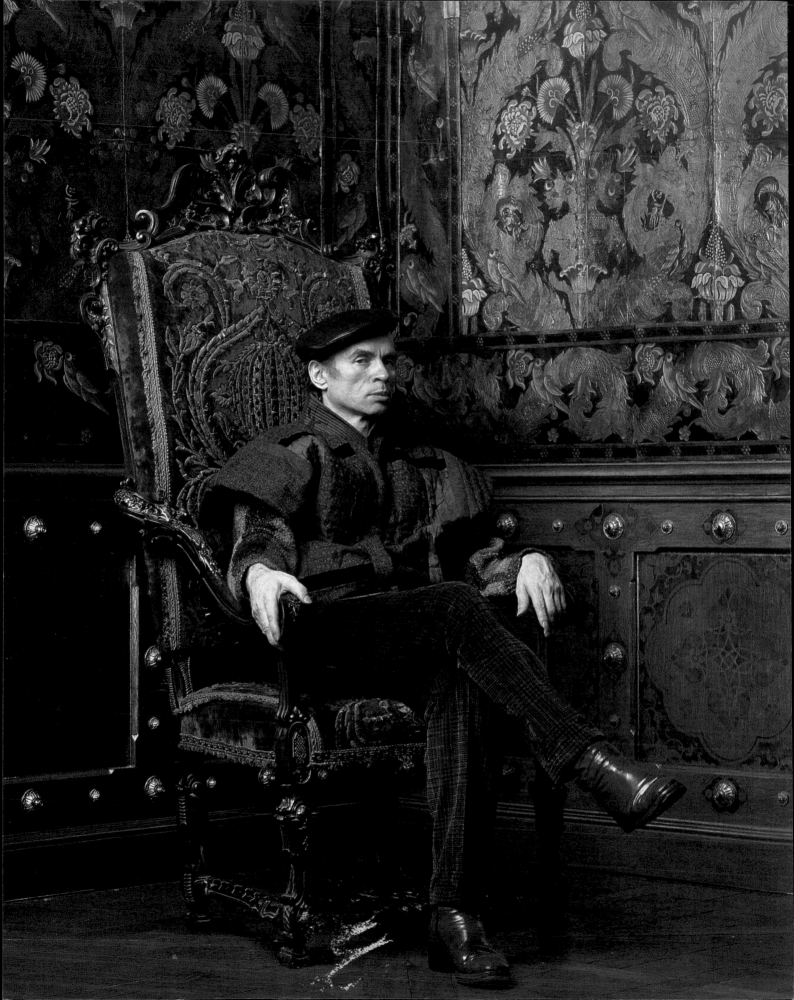

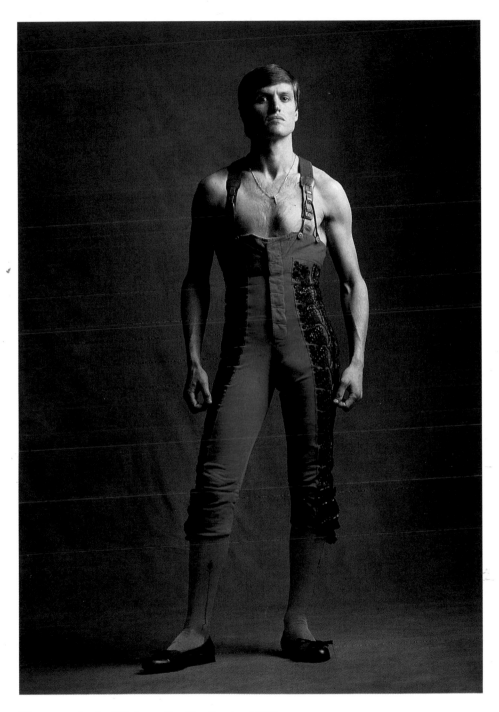

'Espartaco' – bullfighter, Seville, Spain, 1987.

Rudolph Nureyev in his Paris apartment, 1986.

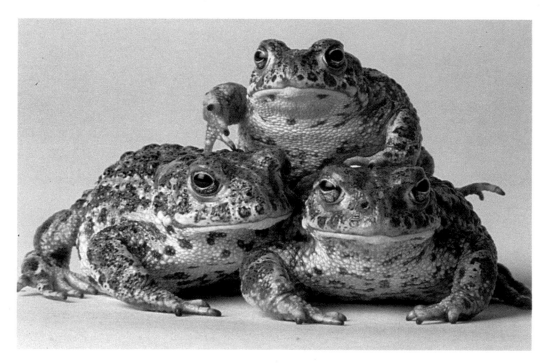

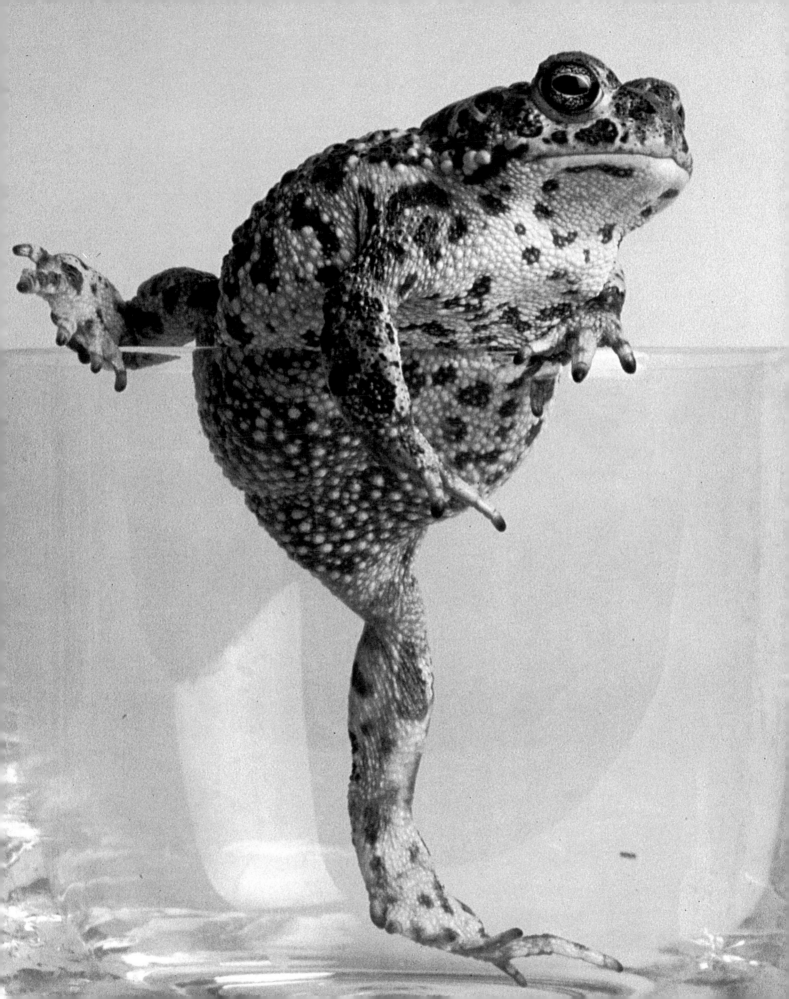

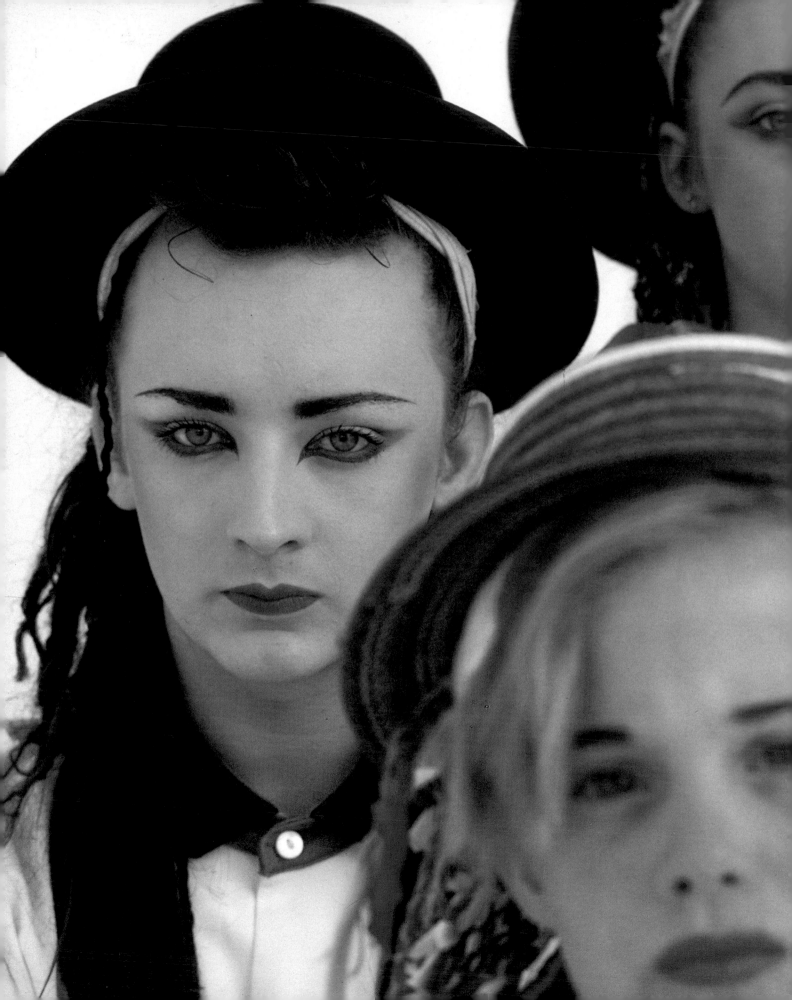

Boy George, 1984.

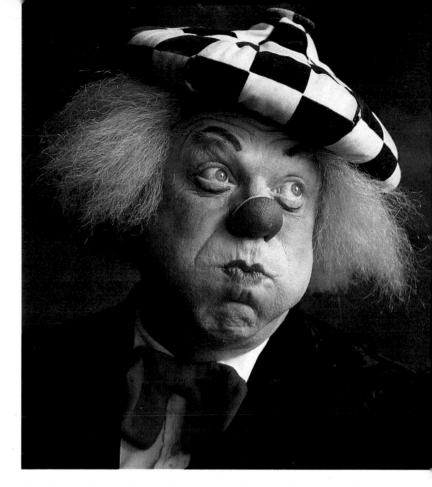

Oleg Popov, State Circus, Krasnodar, southern Russia, 1985.

Street accordionist and family, Mexico City, 1987.

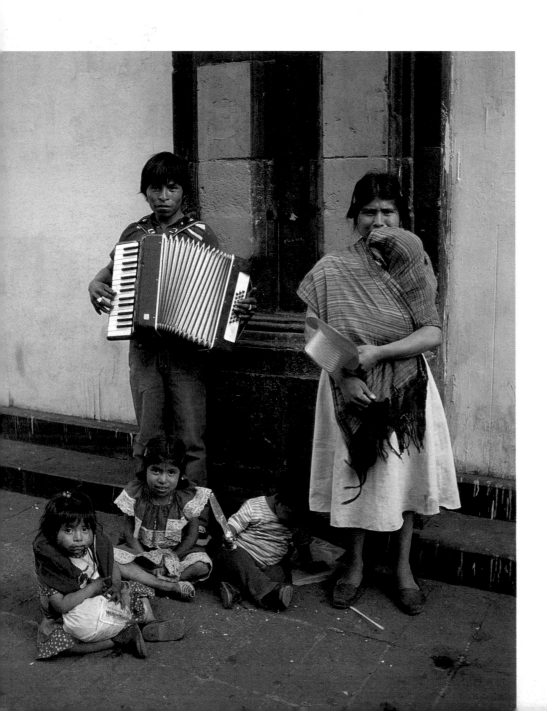

Paul McCartney, 1984.

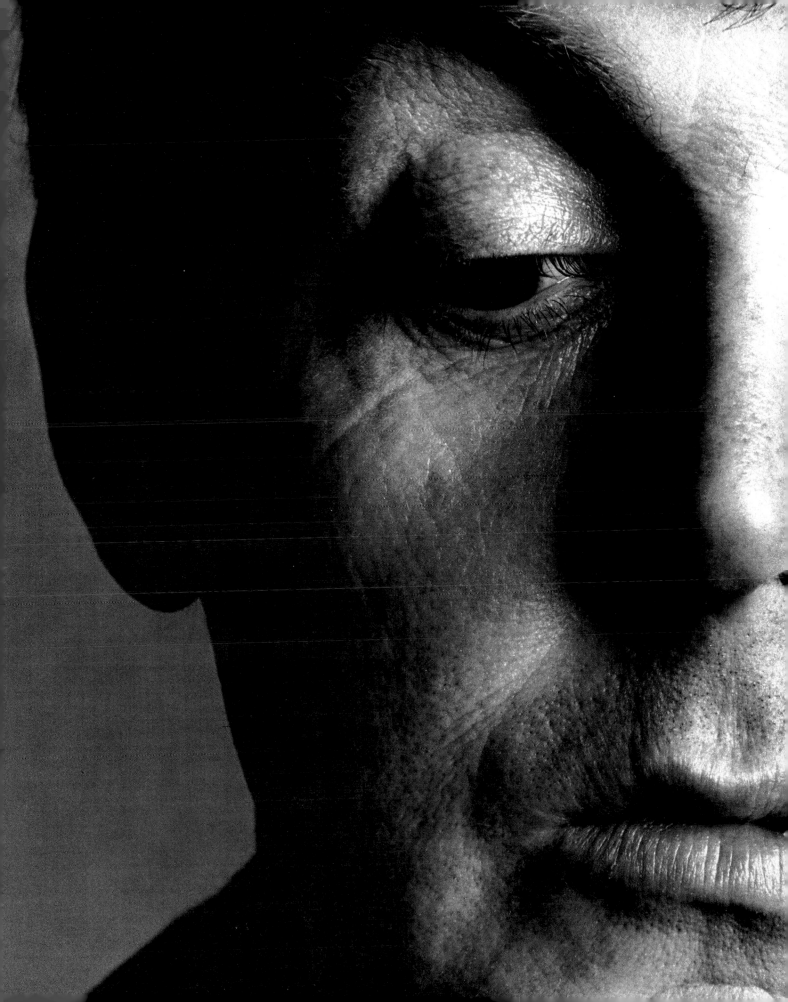

Steve Cram's feet, 1986.

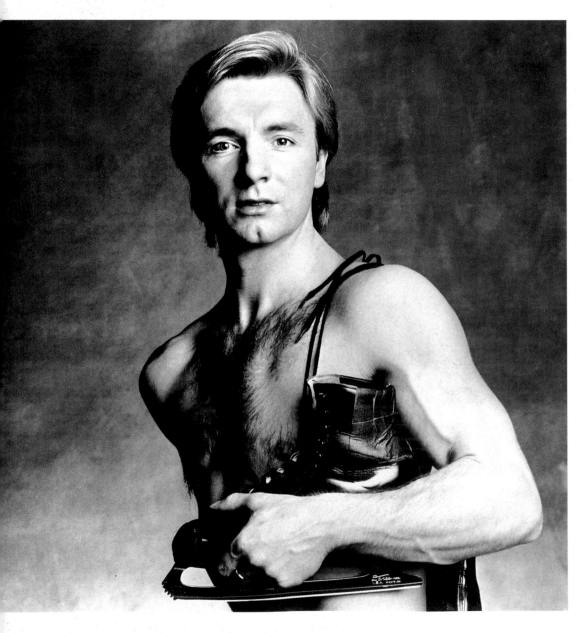

Christopher Dean, 1987.

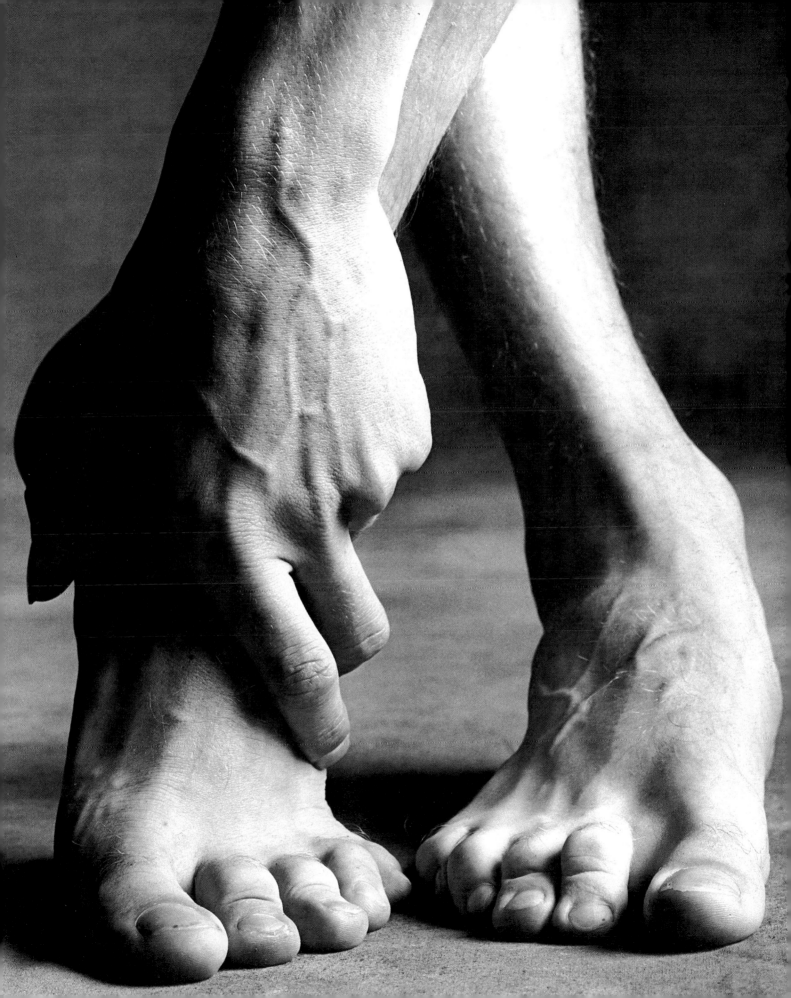

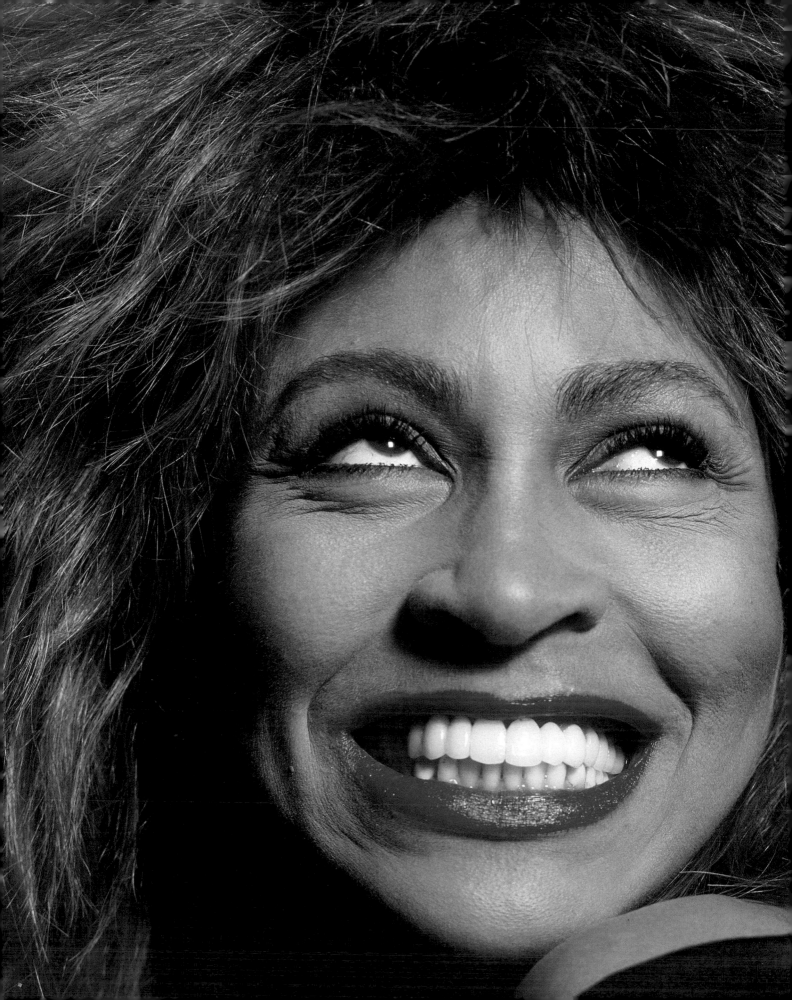

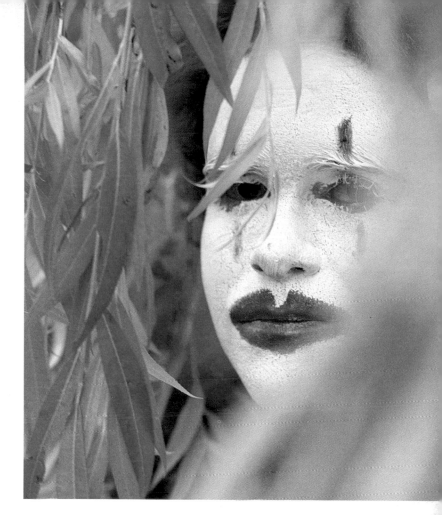

Elton John, 1984.

Tina Turner, 1985.

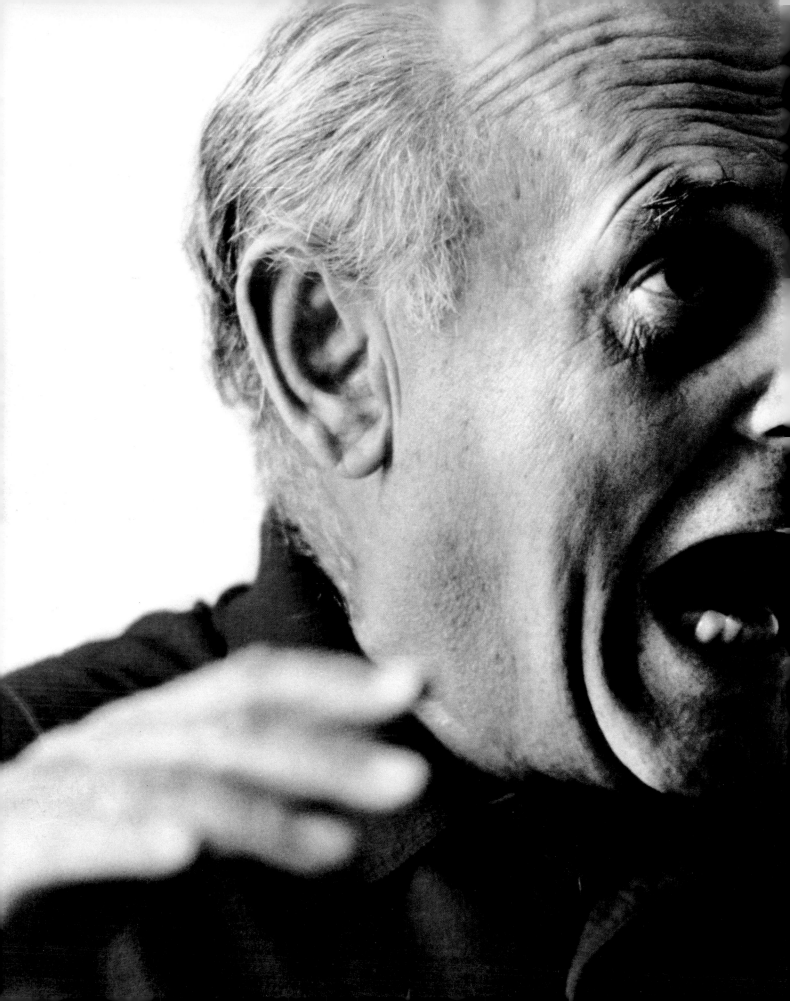

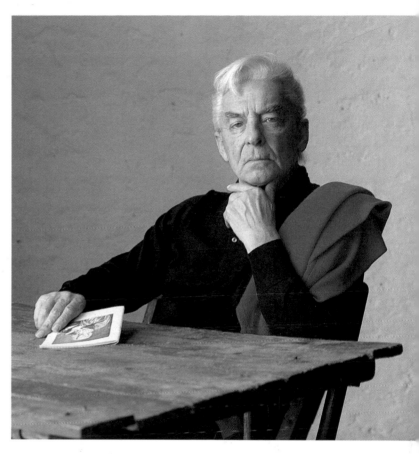

Herbert von Karajan, 1984.

Sir Georg Solti, 1984.

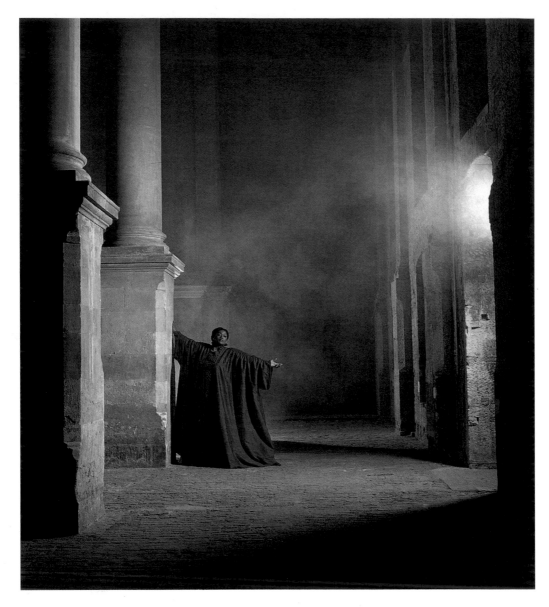

Jessye Norman, 1984.

Joan Armatrading's hand, 1986.

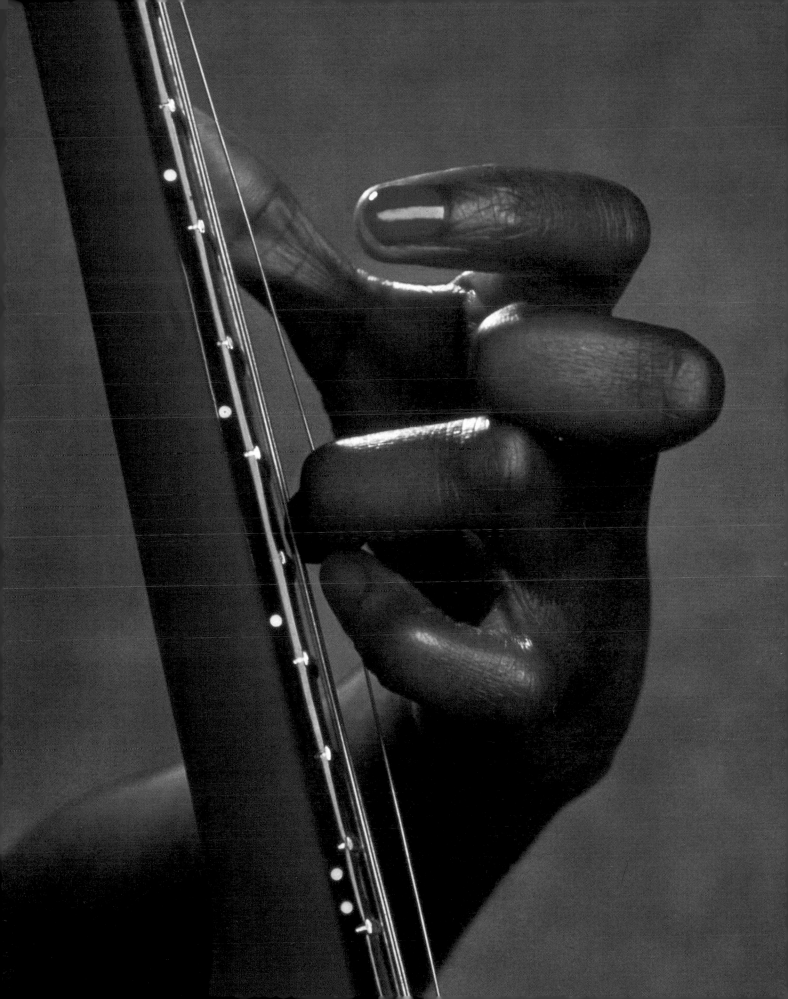

LEFT AND RIGHT Bob Geldof, 1986.

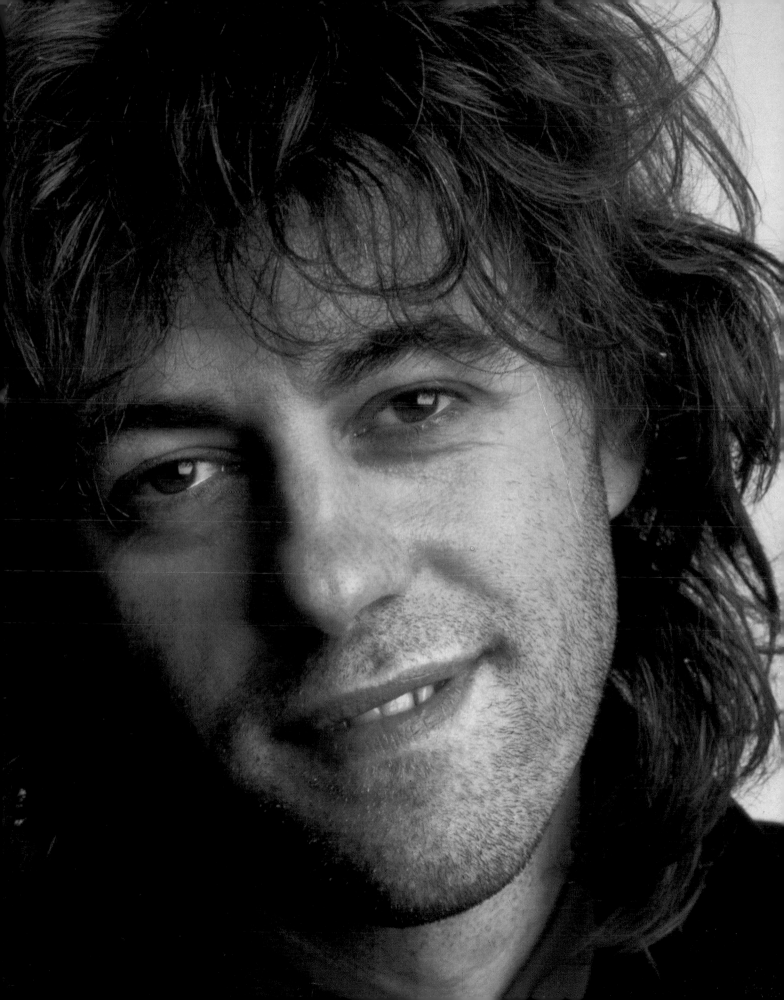

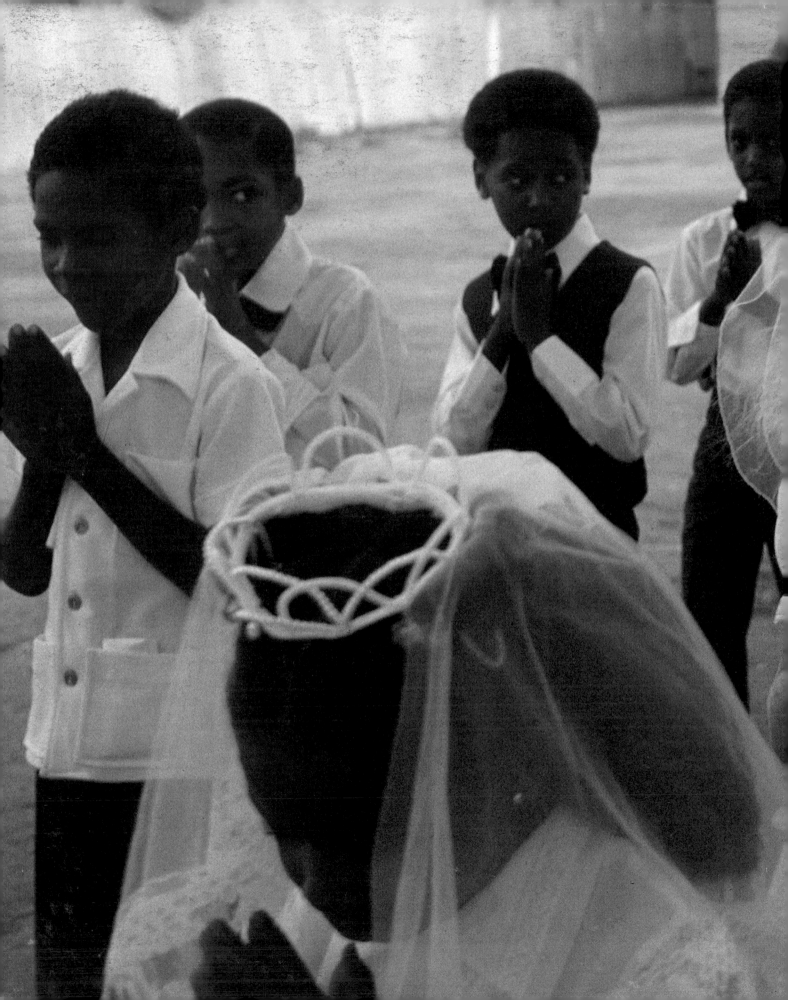

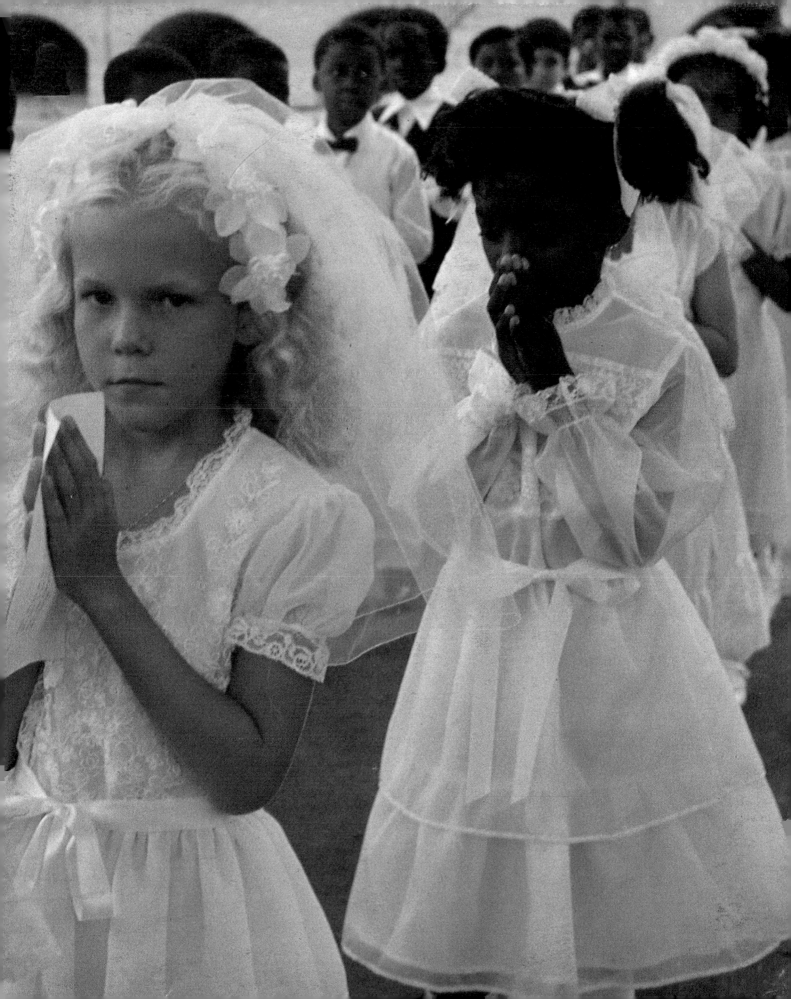

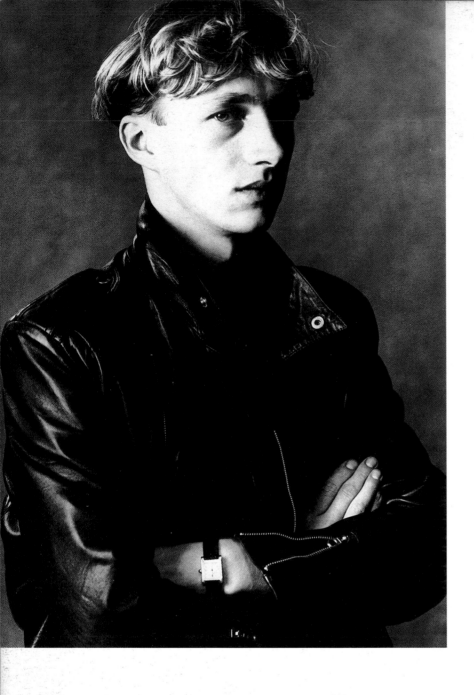

PRECEDING PAGES Confirmation, Antigua, 1984.

ABOVE Jasper Conran, 1984.

OPPOSITE Grace Coddington, 1987.

50

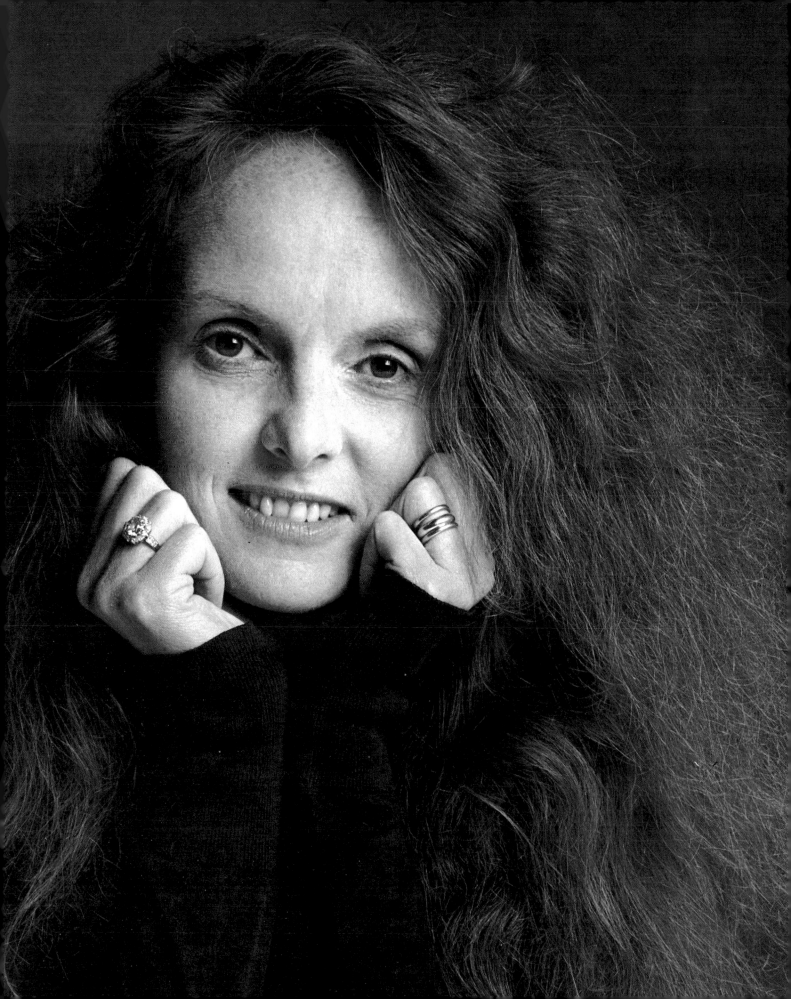

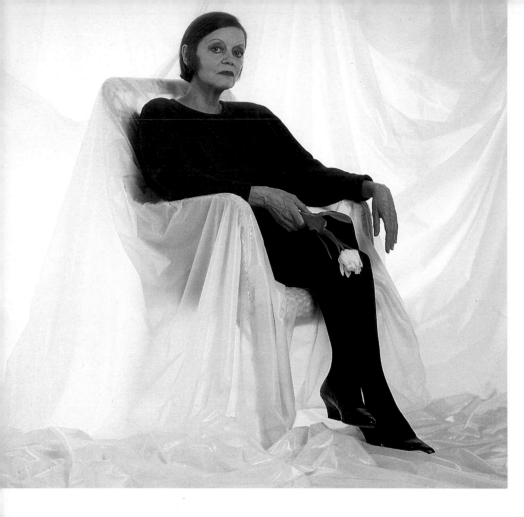

Jean Muir, 1985.

Mary Quant, 1986.

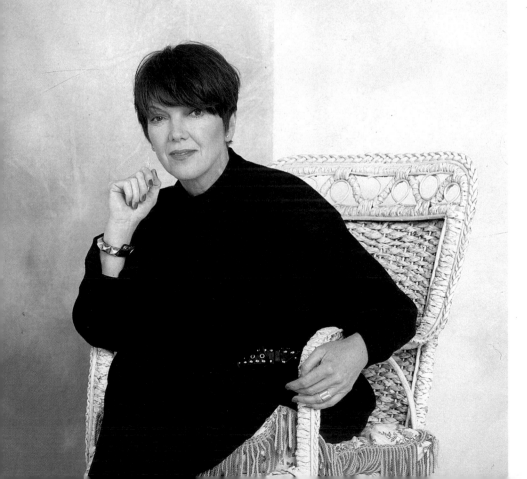

Madame Grès, Paris, 1984.

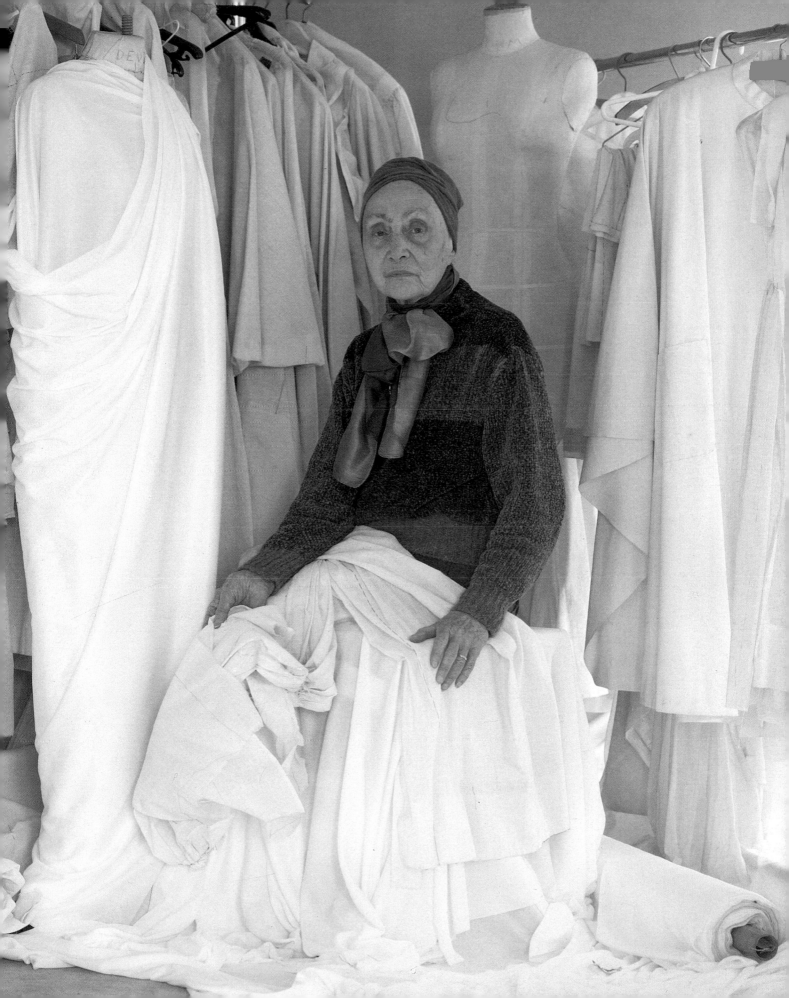

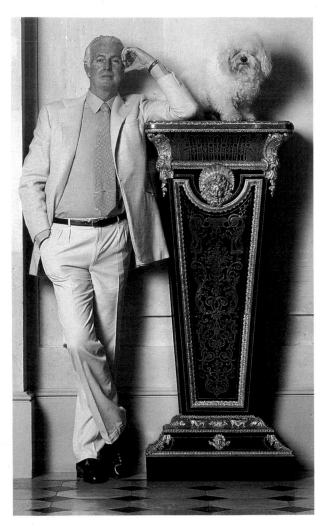

Givenchy, 1986.

Yves St Laurent, 1987.

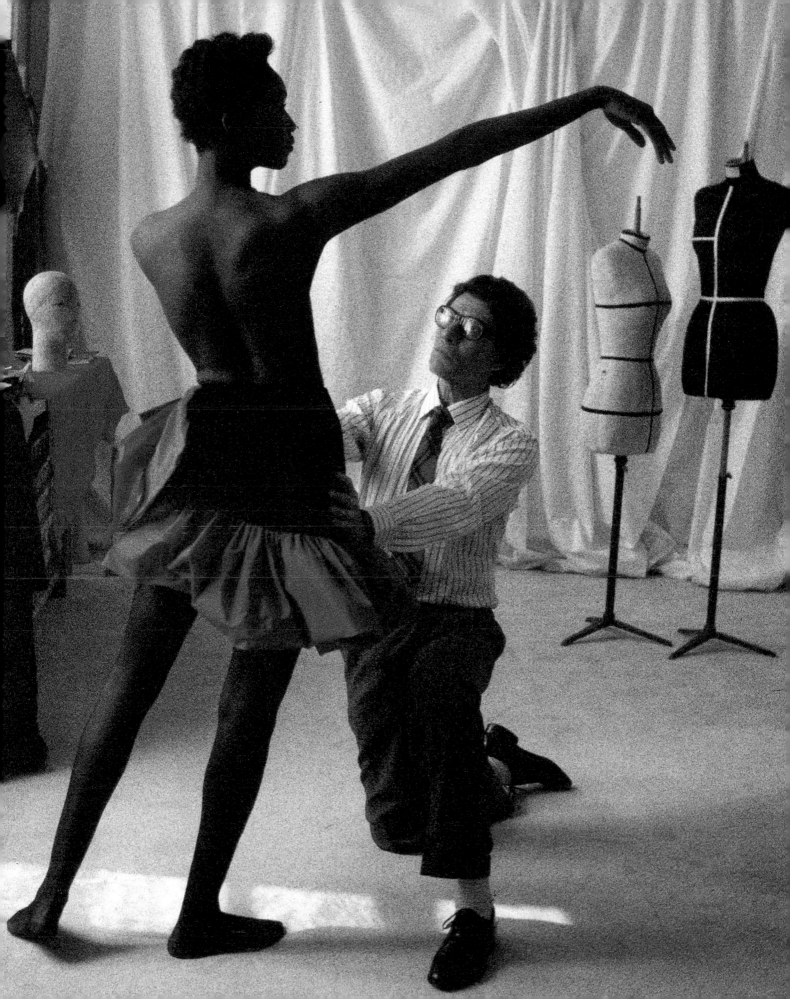

BELOW AND RIGHT The Spring Collections.
French *Vogue*, 1986.

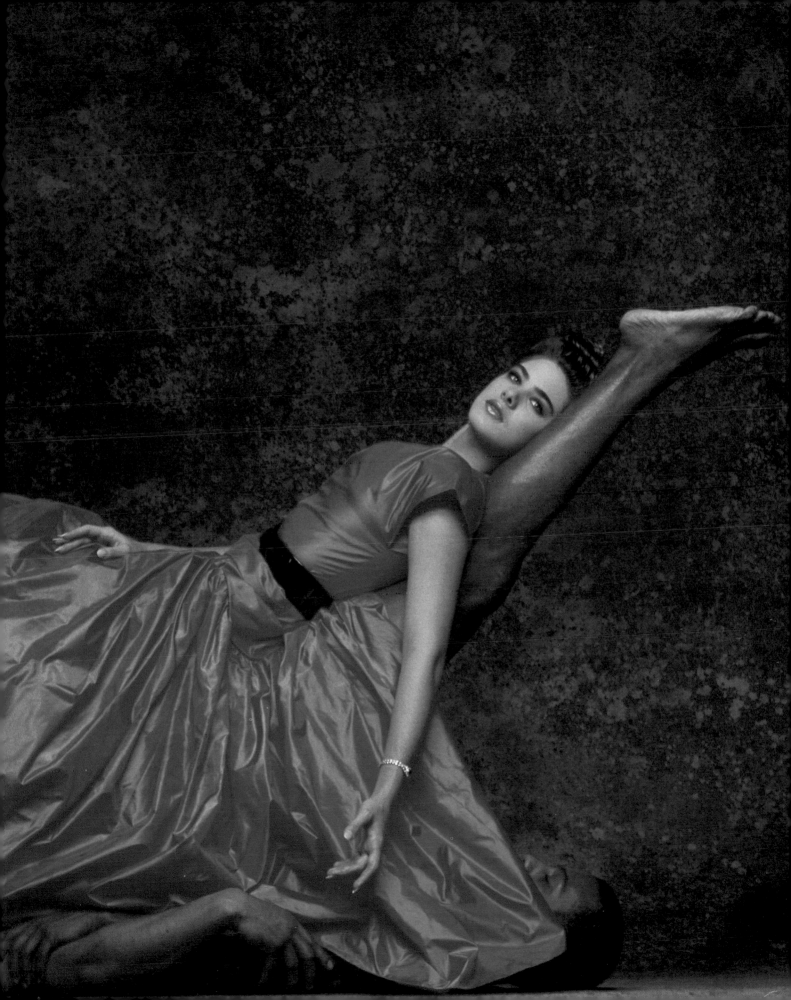

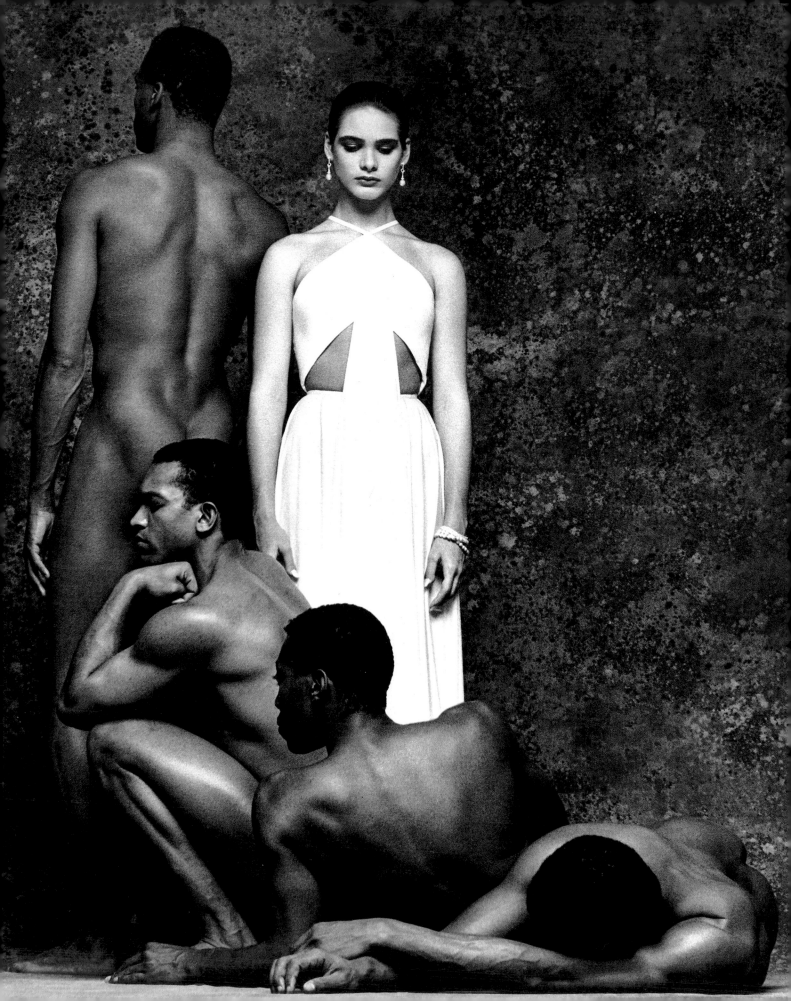

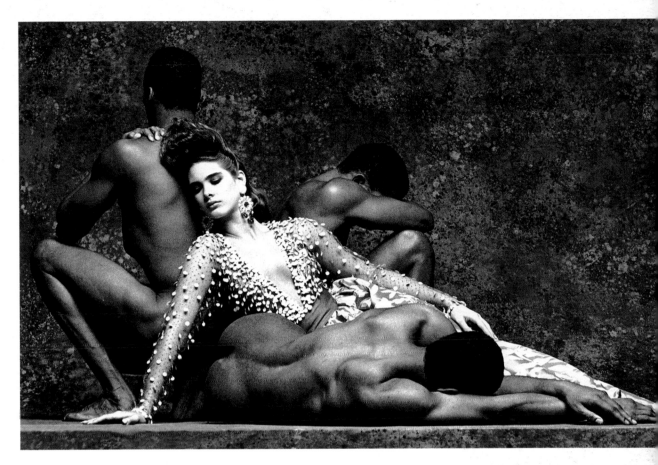

opposite and above The Spring Collections,
French *Vogue*, 1986.

BELOW AND OPPOSITE The Spring Collections,
French *Vogue*, 1986.

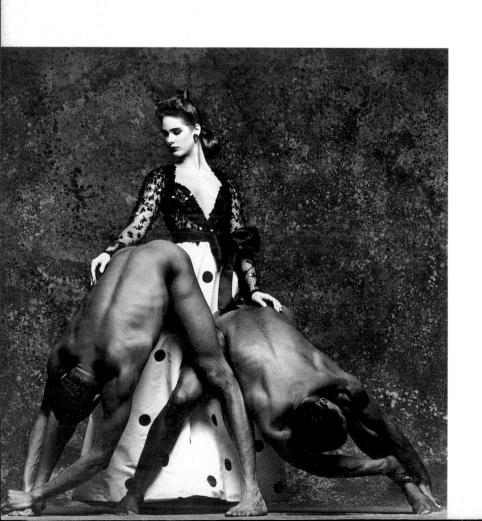

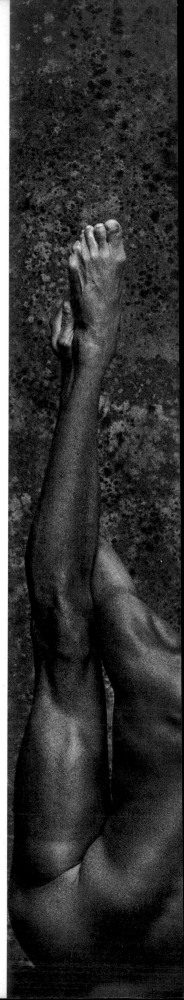

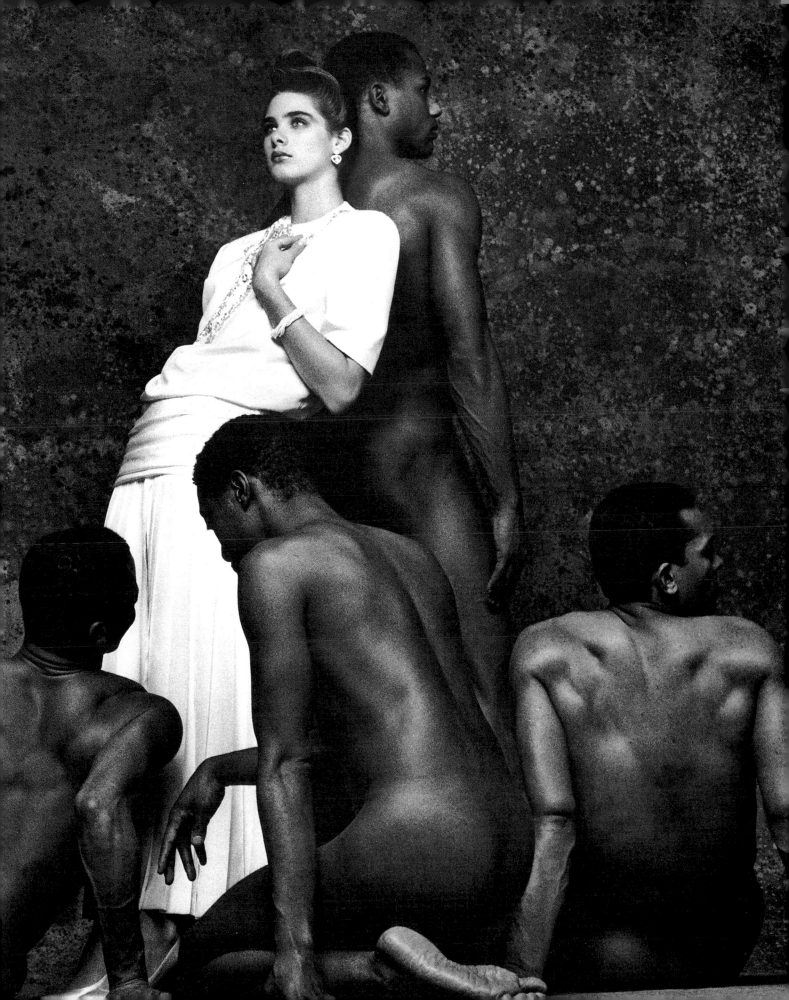

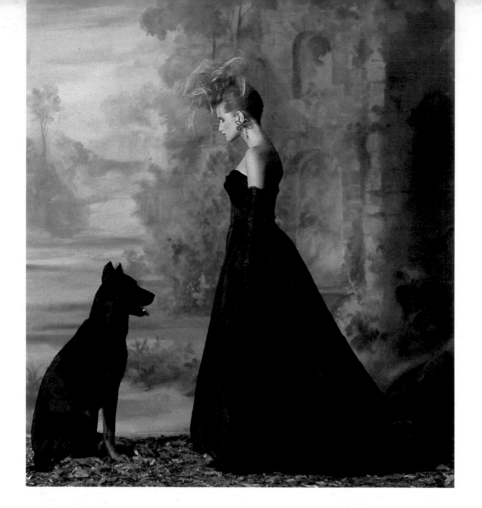

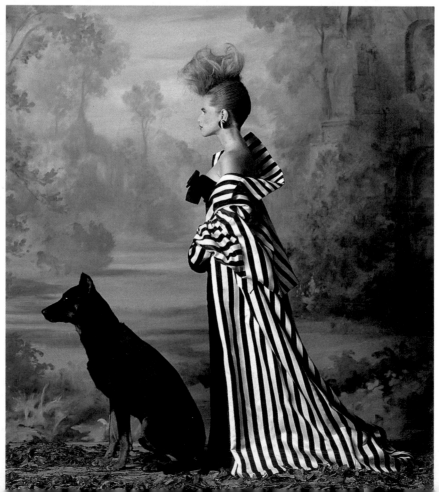

ABOVE, LEFT AND OPPOSITE
Isabelle Pascoe,
the Autumn Collections,
British *Vogue*, 1985.

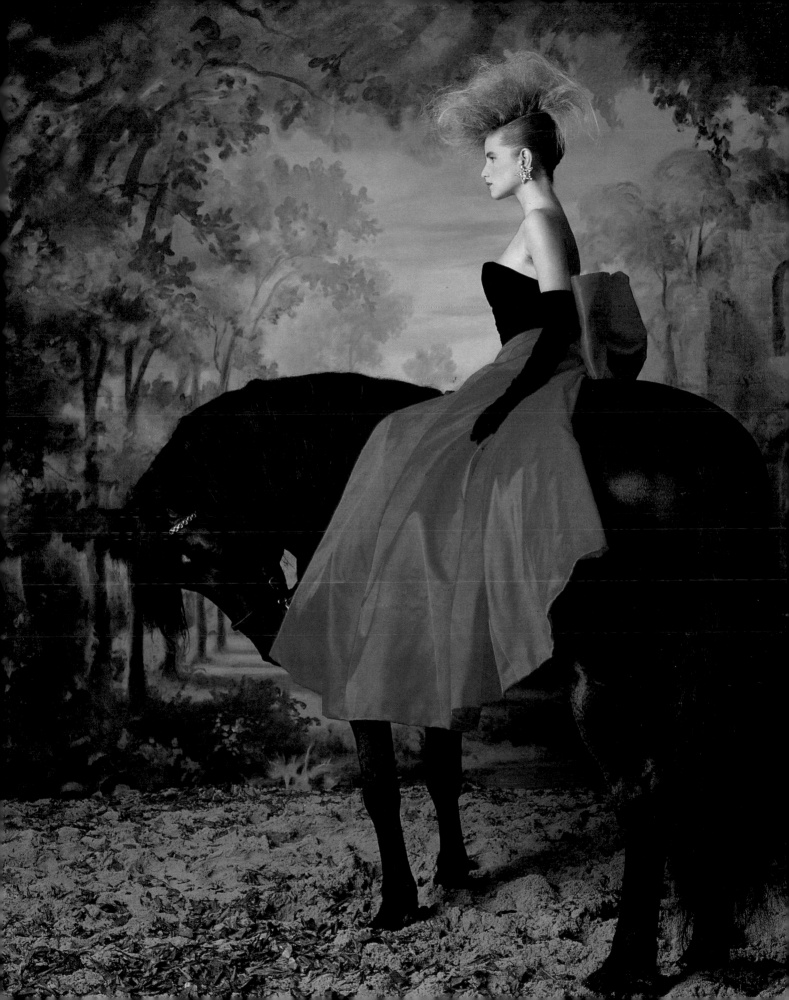

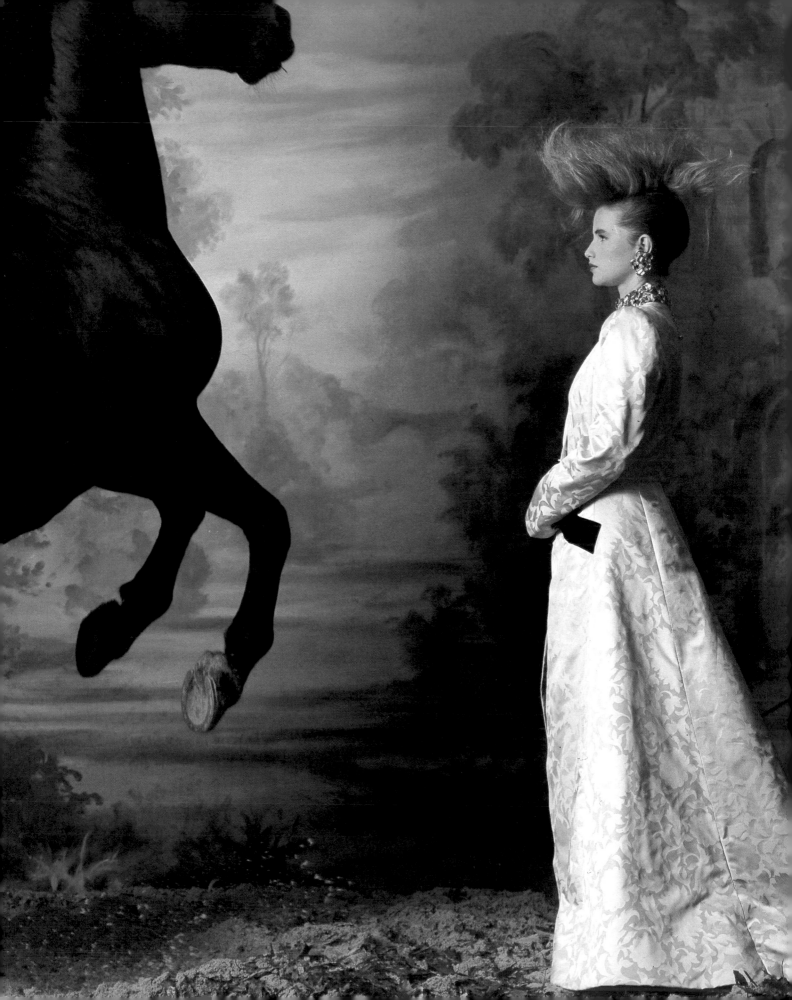

Maggie Smith in an Issey Miyake outfit, 1986.

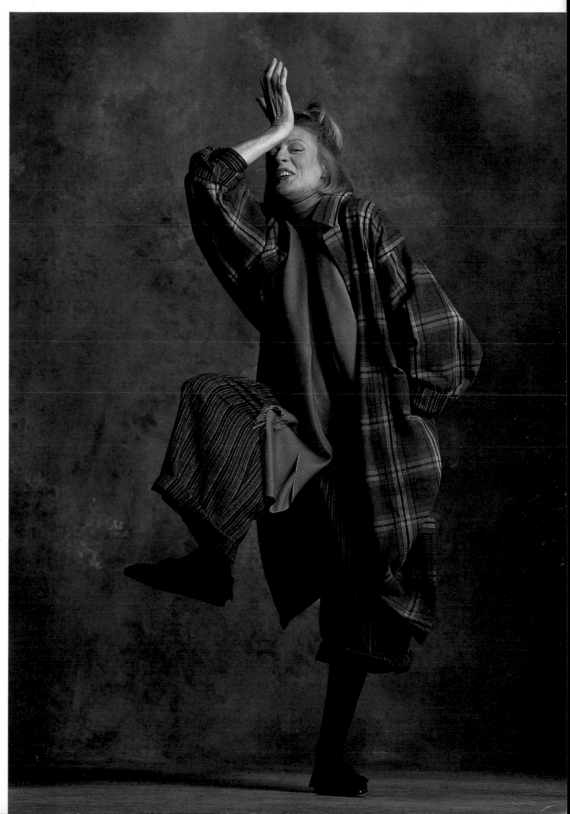

Isabelle Pascoe,
the Autumn Collections,
British *Vogue*, 1985.

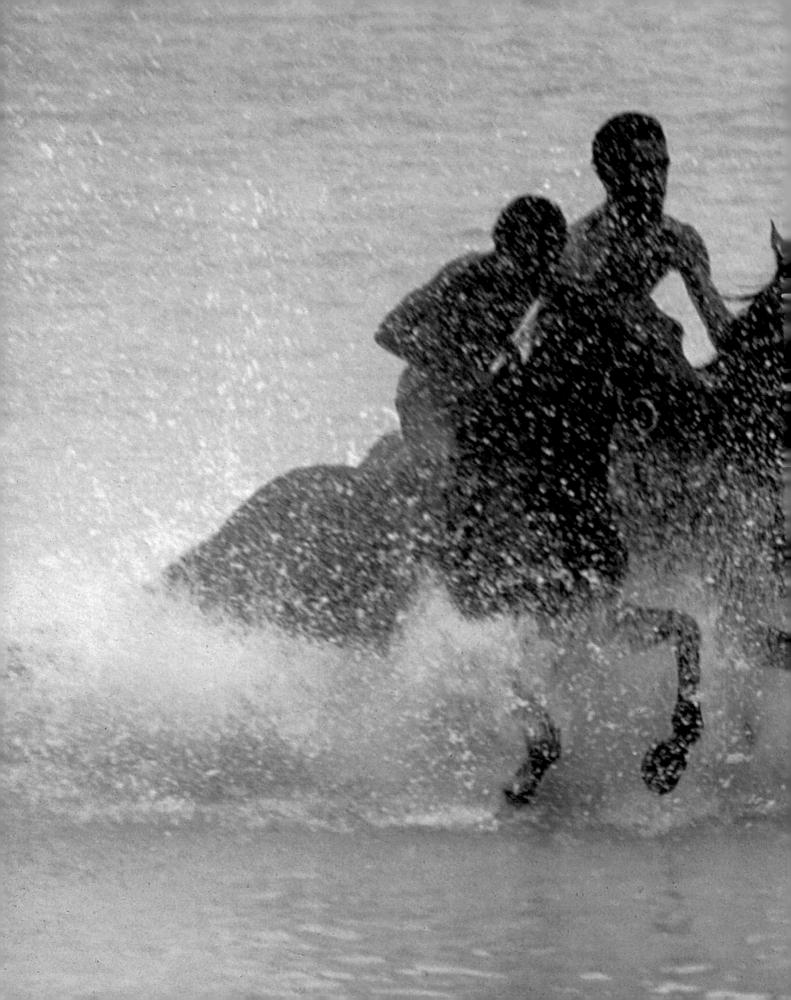

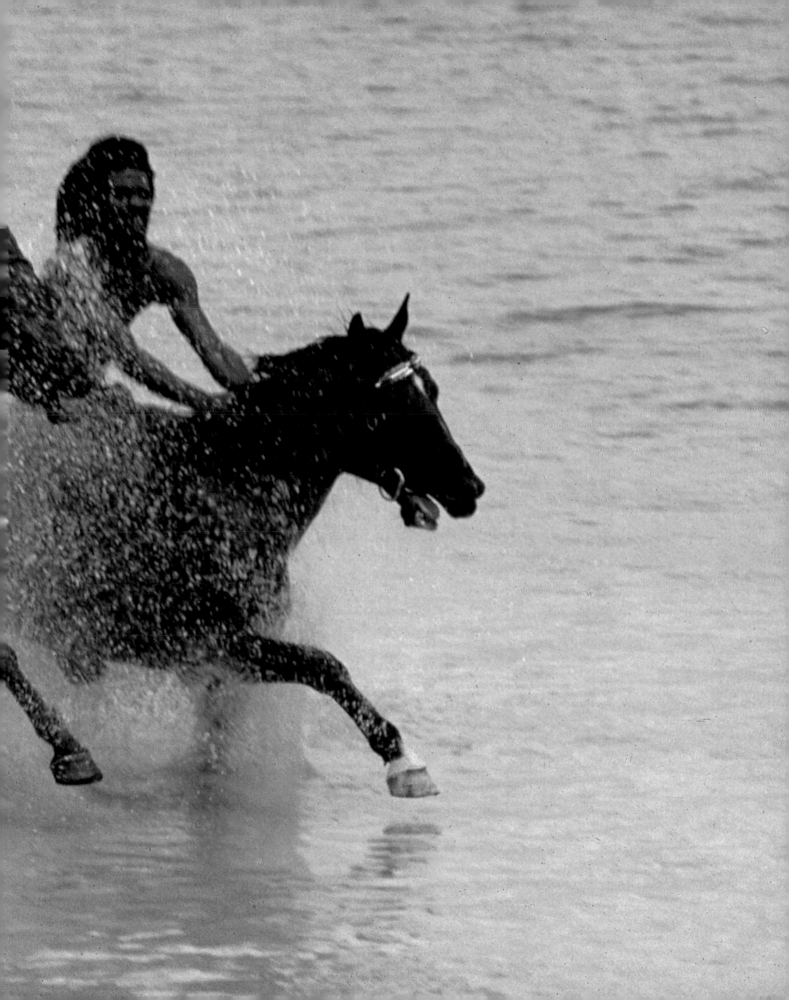

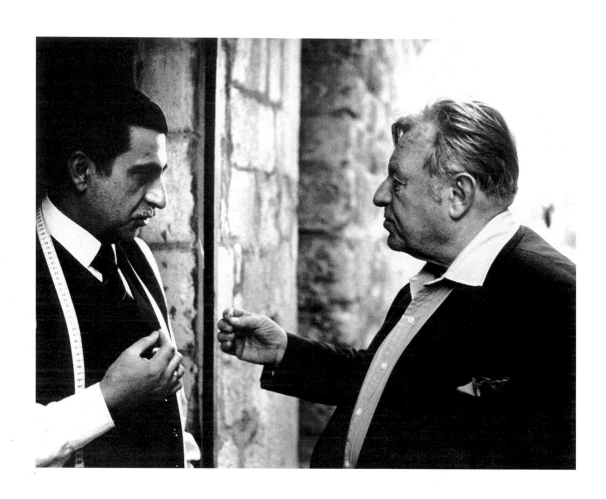

PRECEDING PAGES Racehorses, Antigua, 1984.

ABOVE Mr Sammy Barsum, tailor, with Mayor Teddy Kollek,
Jerusalem, 1985.

OPPOSITE Israeli soldier, Tel Aviv. 1985.

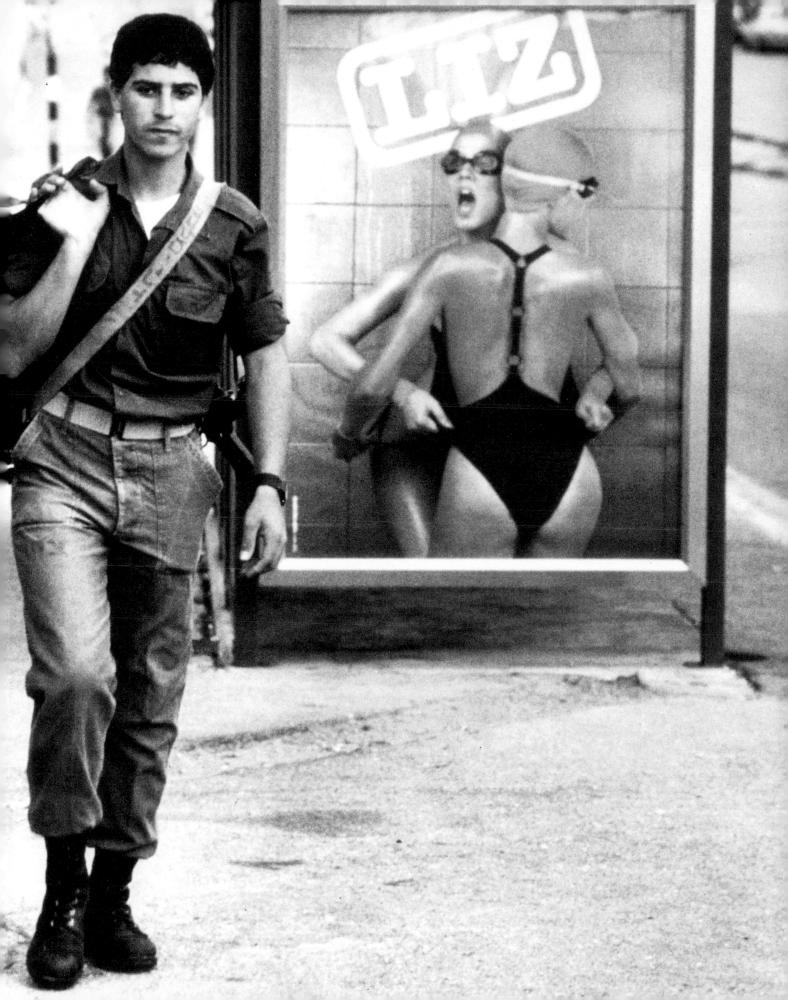

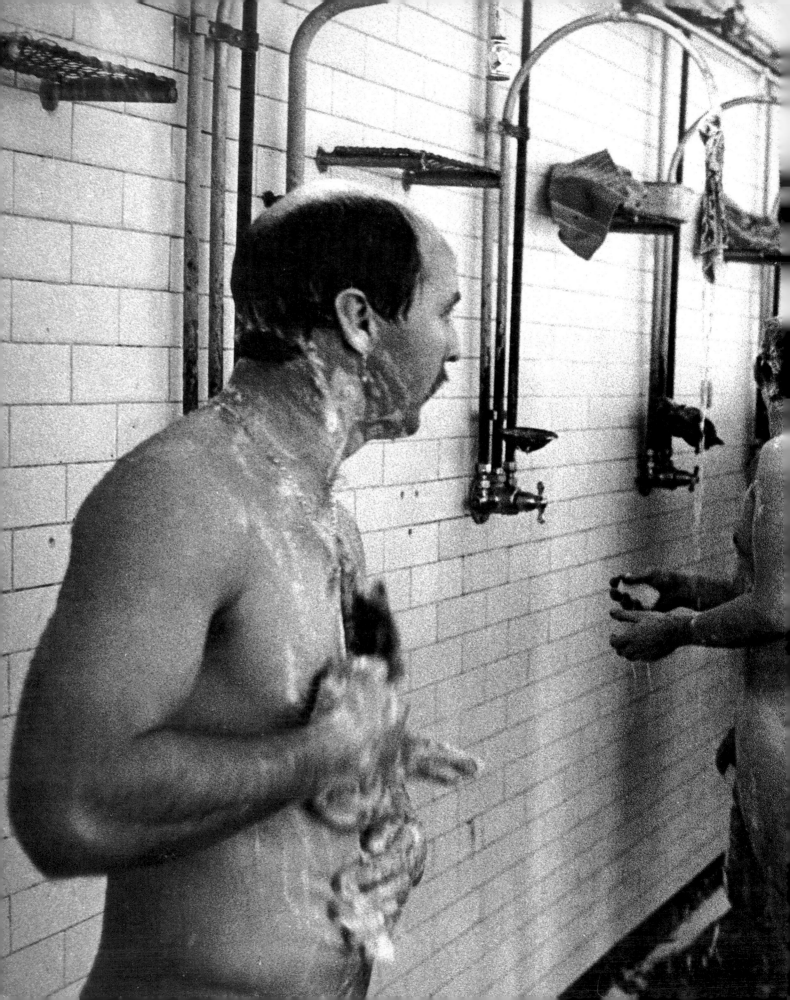

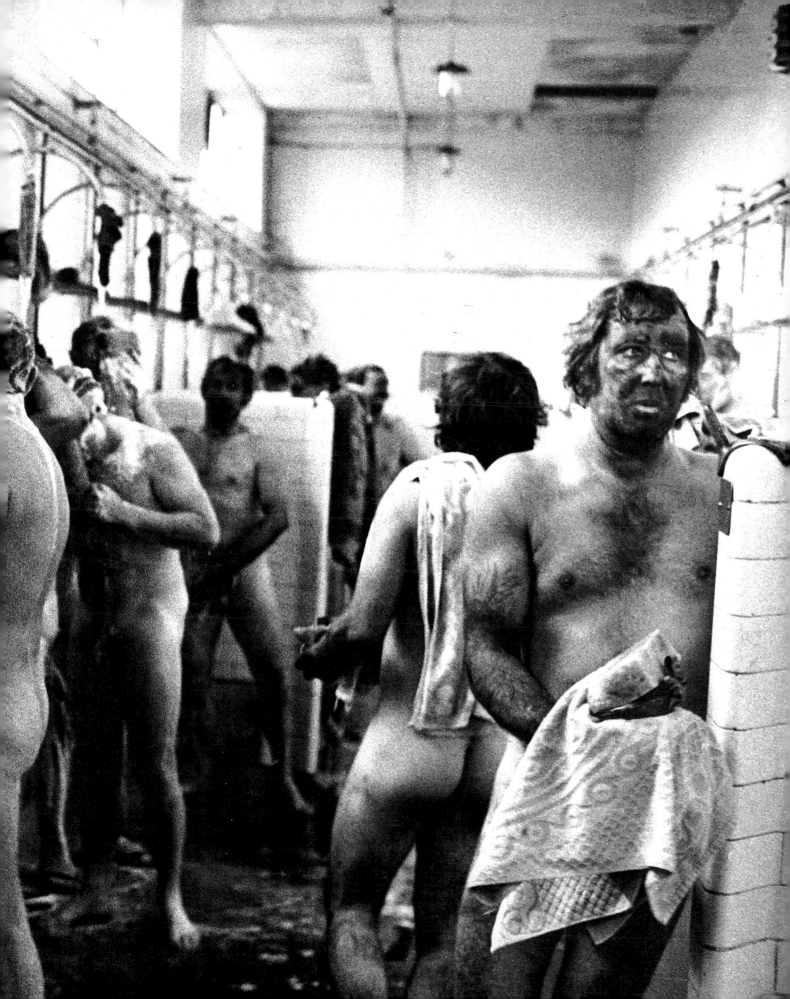

PRECEDING PAGES Miners' washroom, Maerdy colliery, Rhondda, South Wales, 1986.

BELOW Street corner, Tel Aviv, 1985.

OPPOSITE Transvestite, Berlin, 1986.

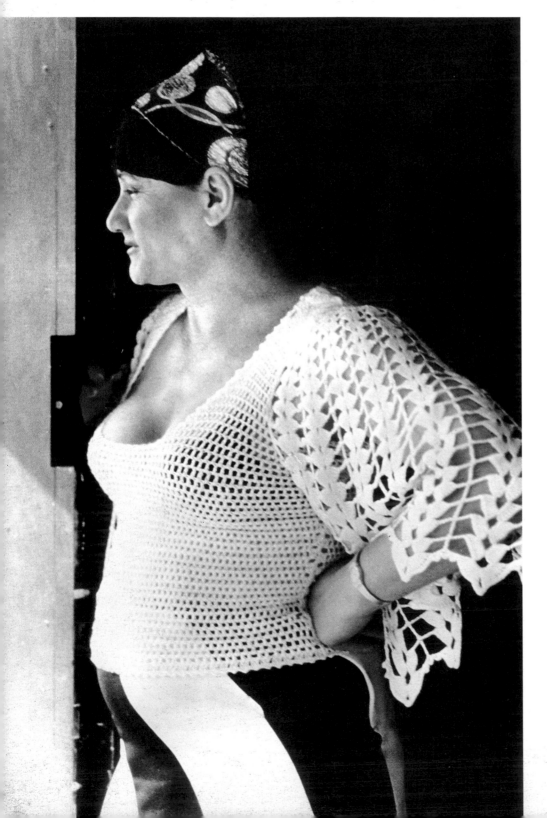

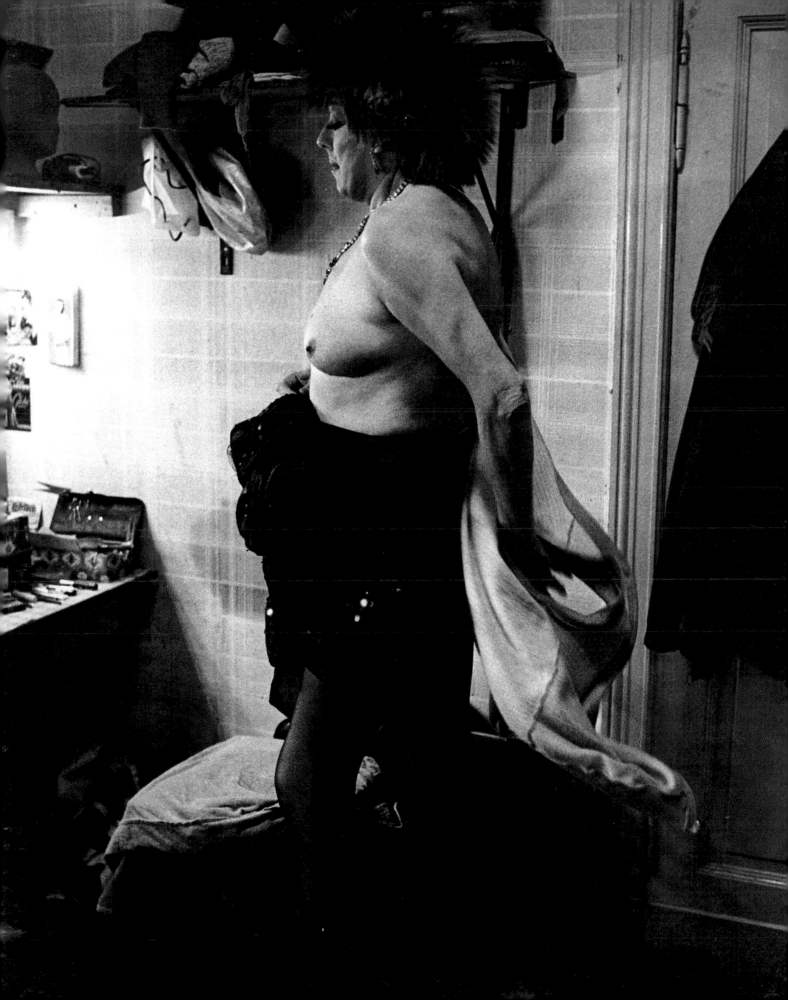

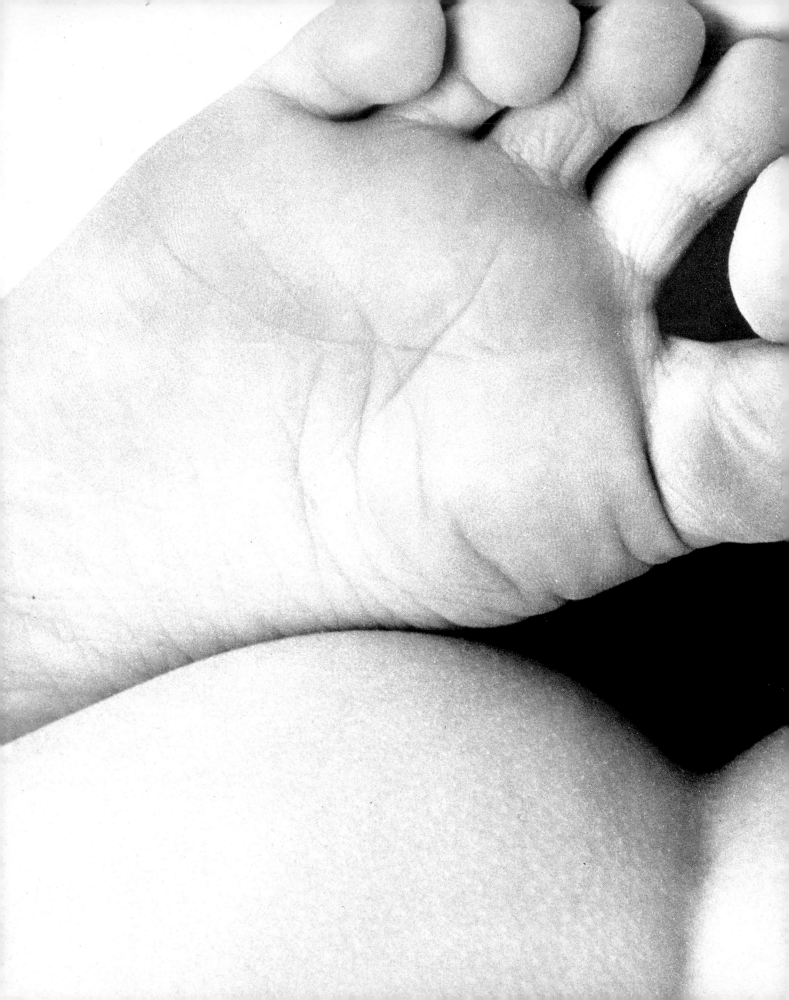

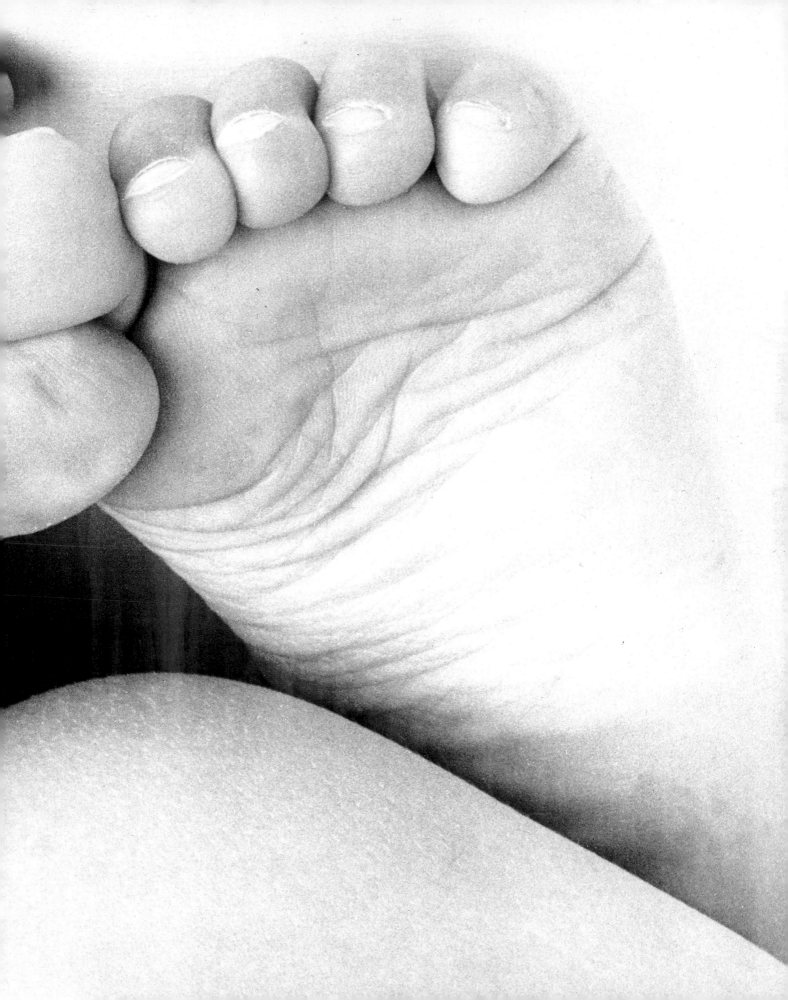

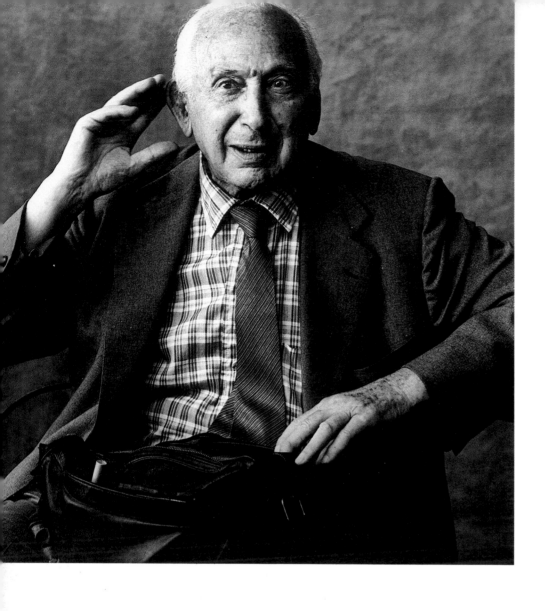

PRECEDING PAGES Child's feet, 1986.

ABOVE André Kertész, 1984.

OPPOSITE Mr and Mrs David Bailey, 1986.

76

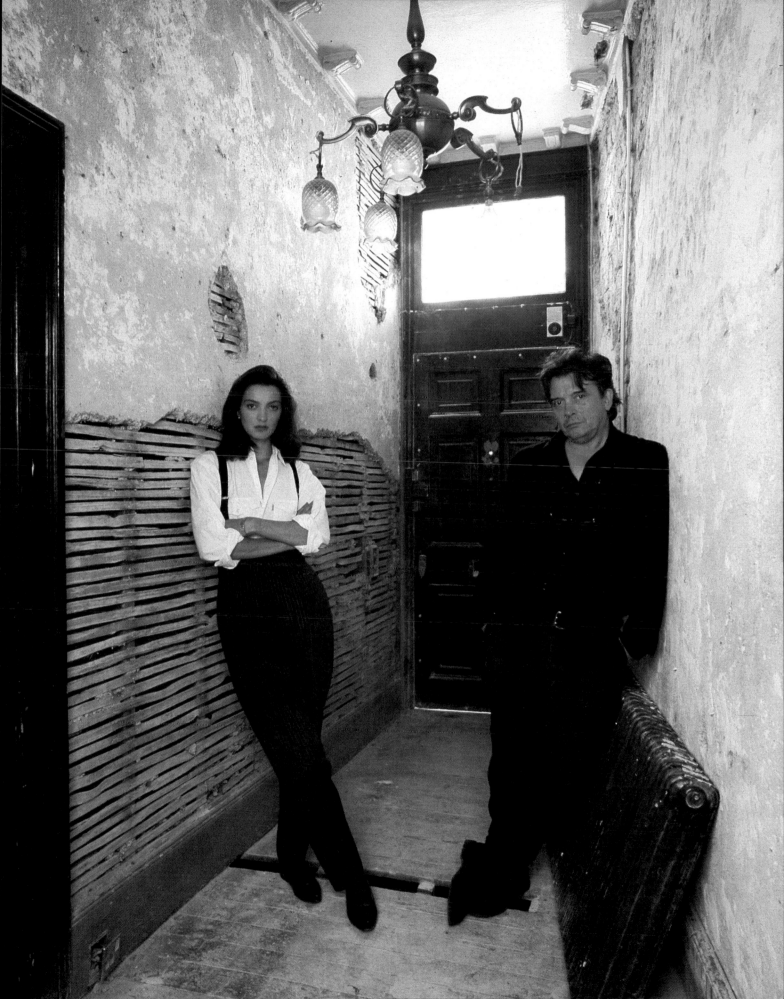

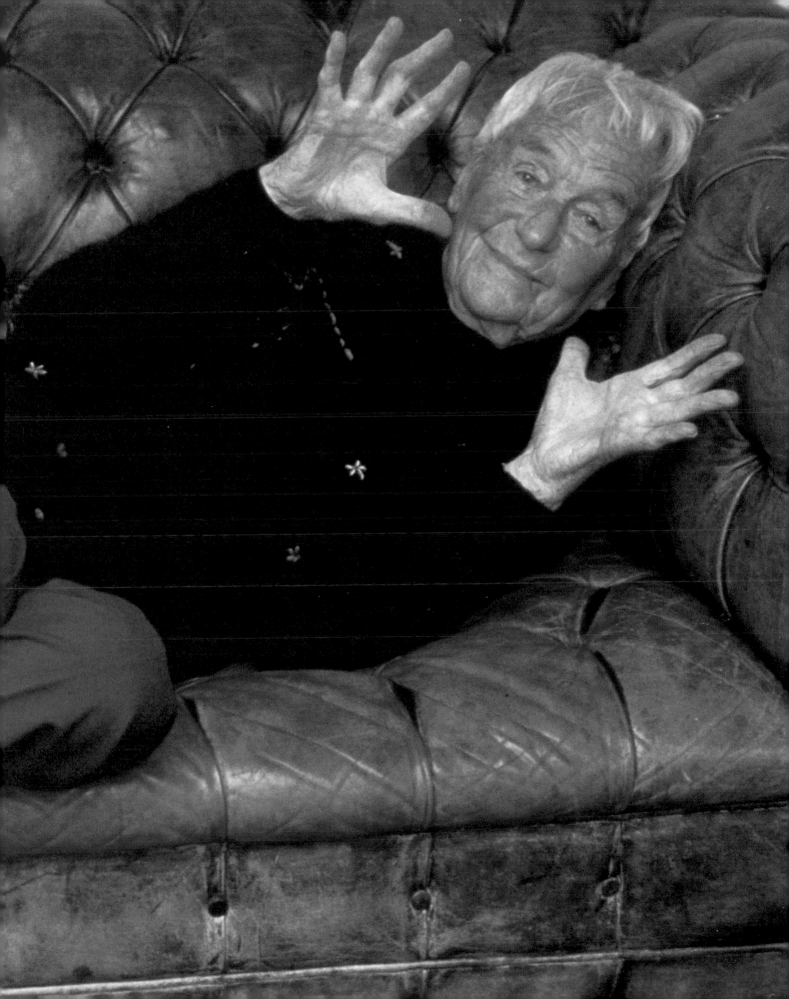

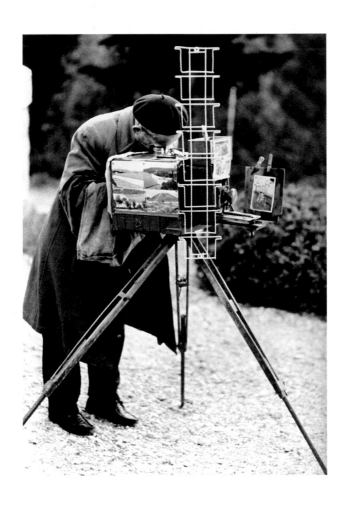

PRECEDING PAGES Jacques-Henri Lartigue, 1984.

ABOVE Street photographer, Greece, 1984.

OPPOSITE Henri Cartier-Bresson, Provence, 1985.

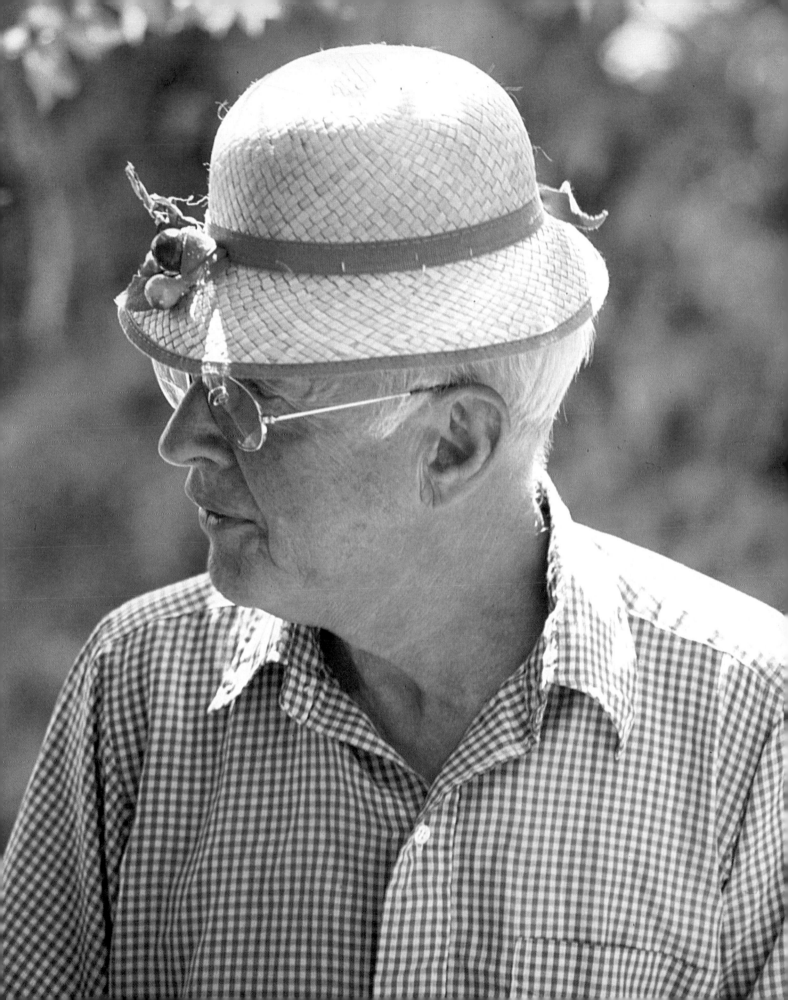

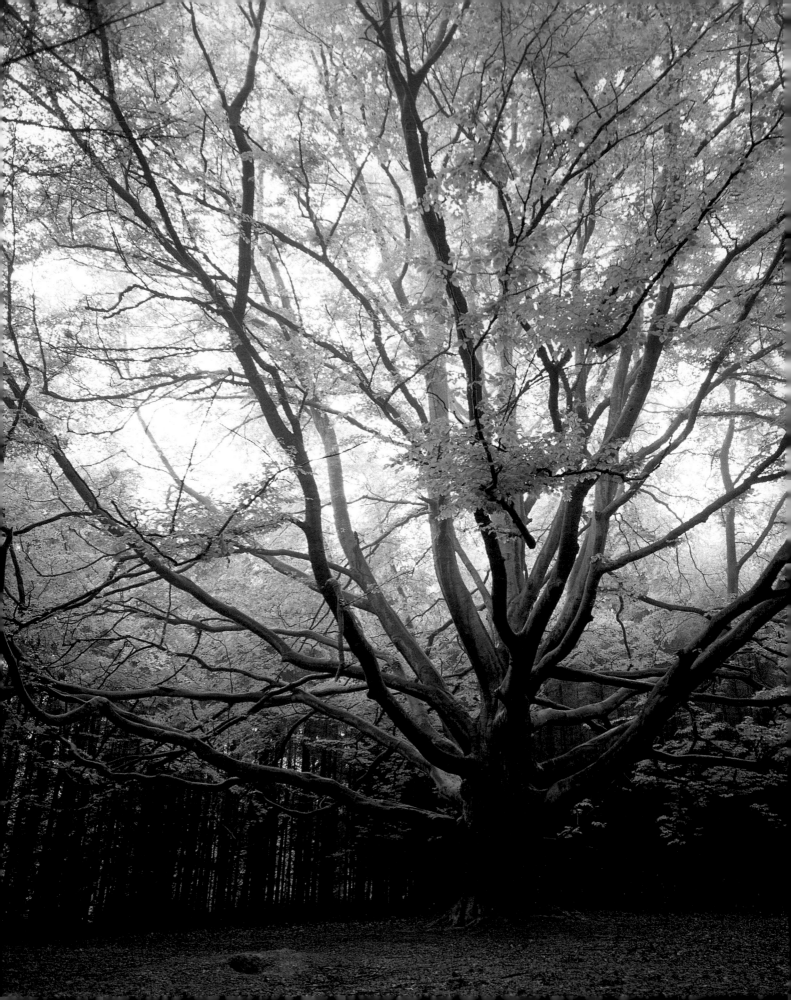

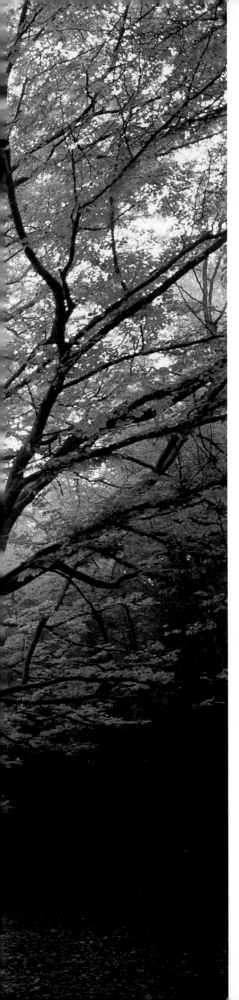

Beech tree surrounded by conifers,
Germany, 1984.

83

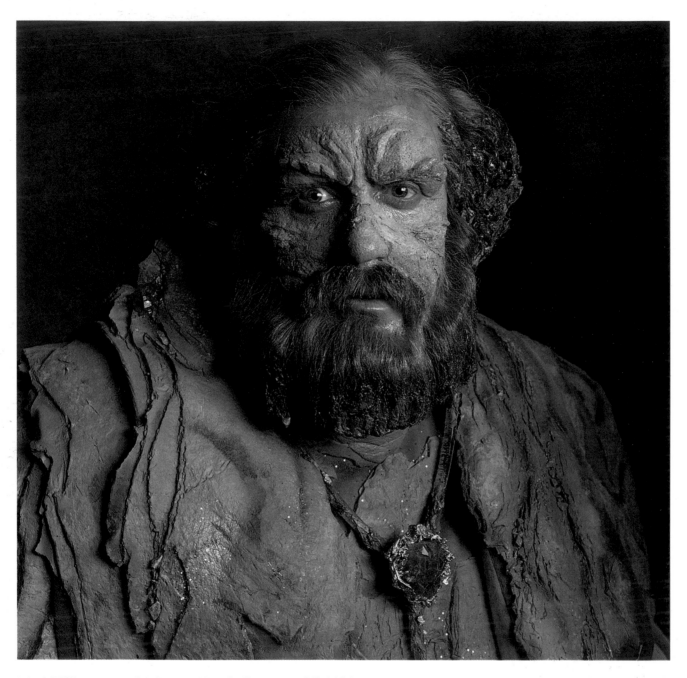

Nicol Williamson as the Gnome King in *Return to OZ*, 1984.

Nancy Reagan, 1985.

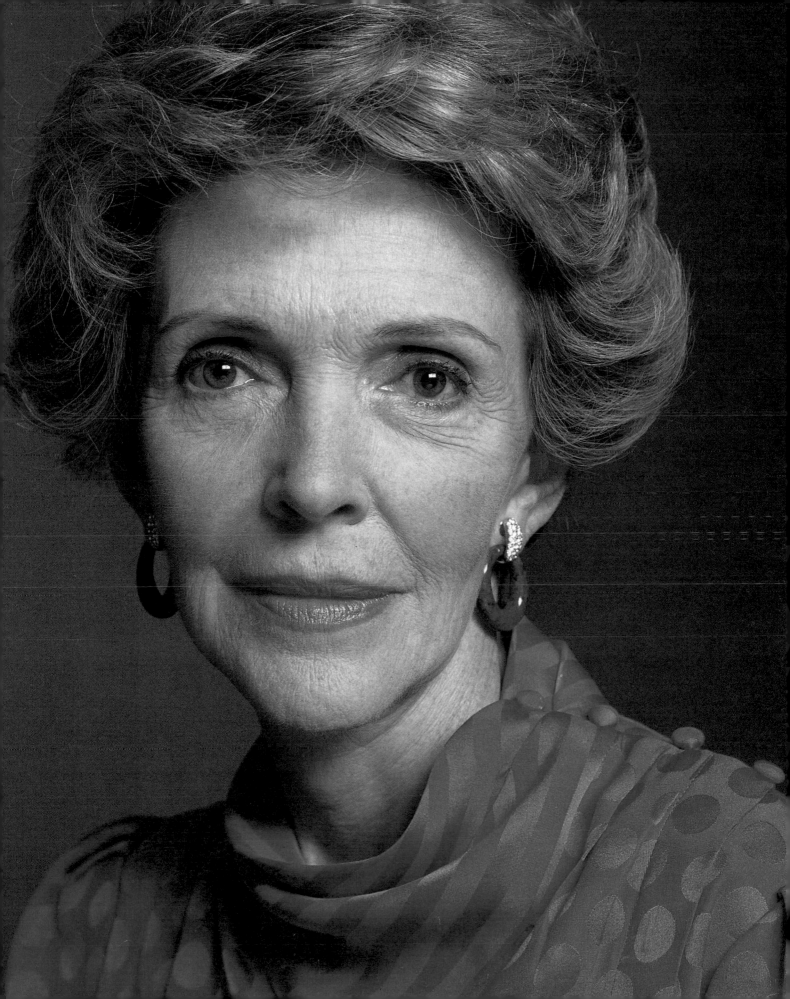

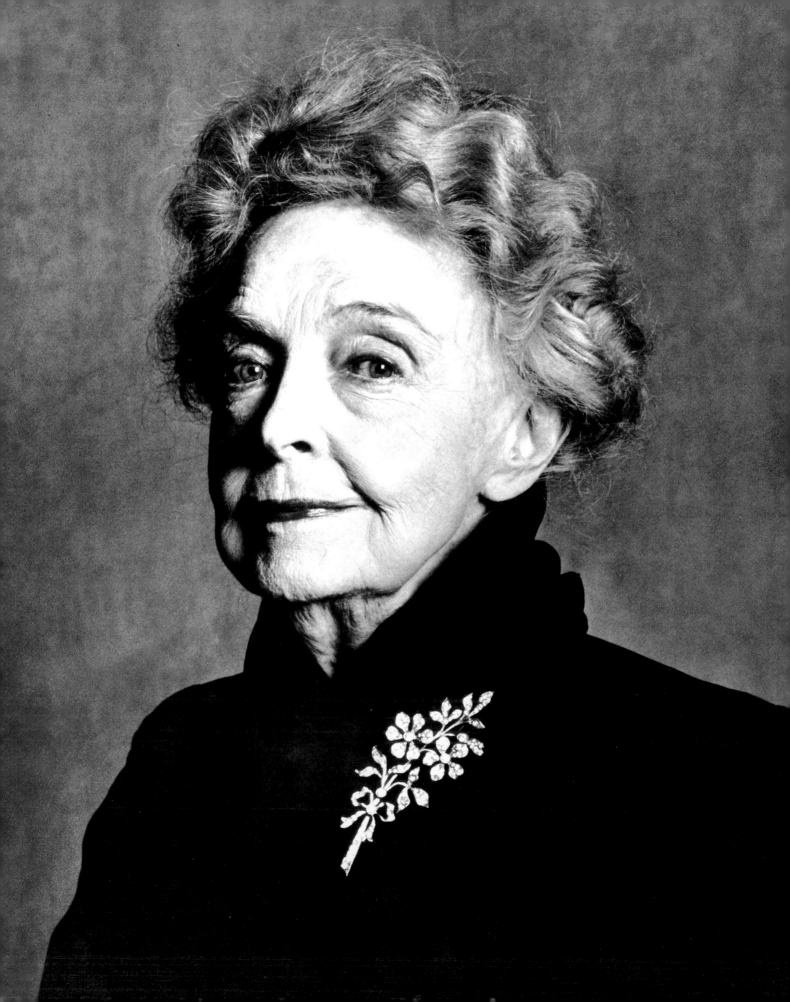

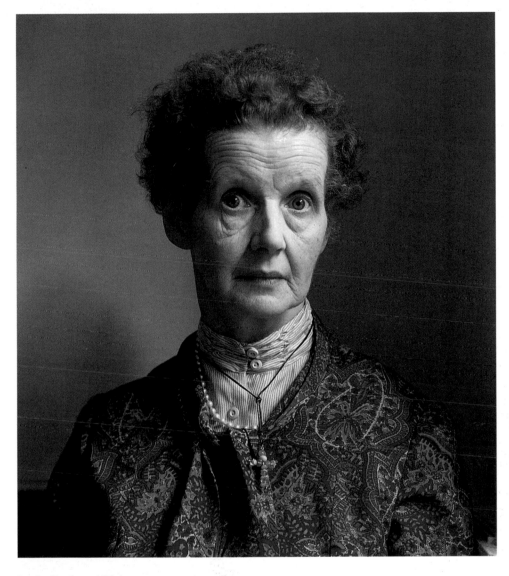

Lady Ryder, 1984.

Lillian Gish, 1984.

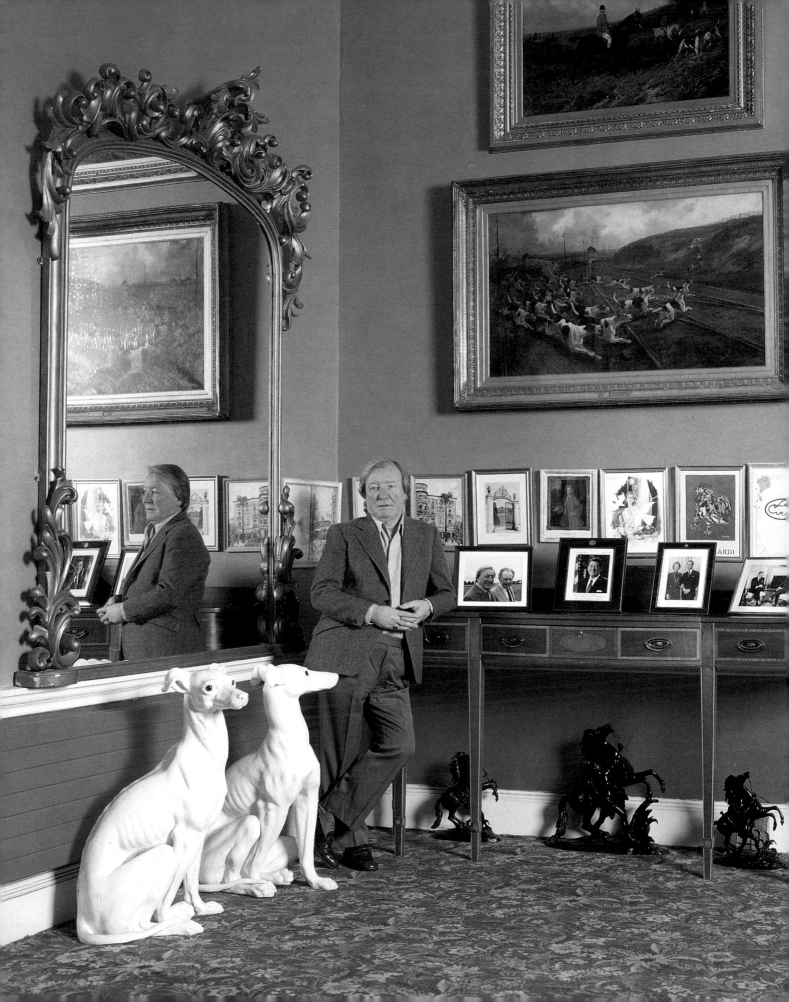

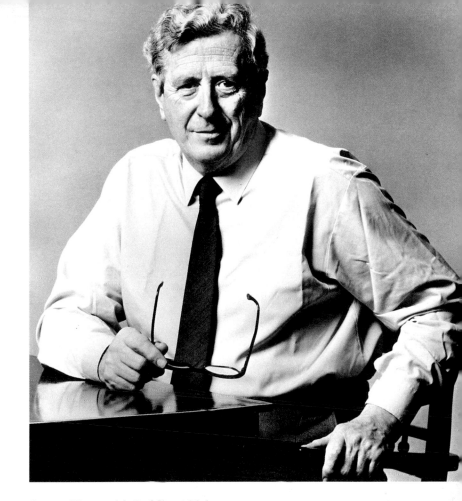

Garret Fitzgerald, Dublin, 1986.

Charles Haughey, Dublin, 1986.

89

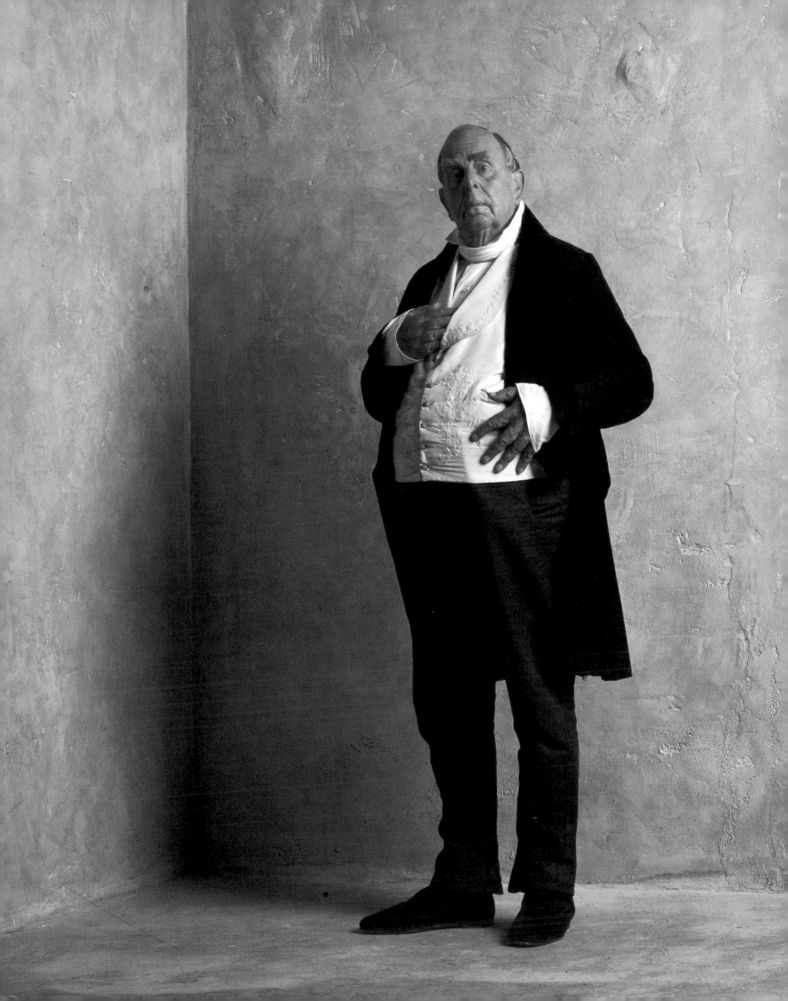

Some of the cast of *Little Dorrit*, 1986.

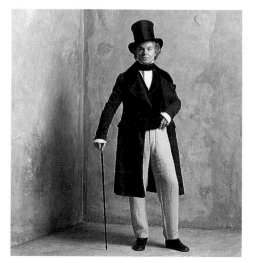
Derek Jacobi as Arthur Clennam

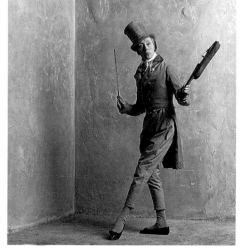
Murray Melvin as the Dancing Master

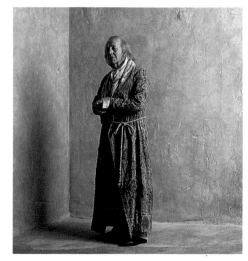
Alec Guinness as William Dorrit

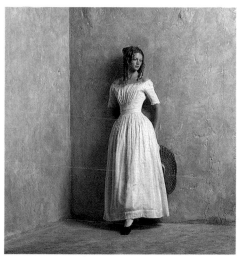
Sophie Ward as Minnie Meagles

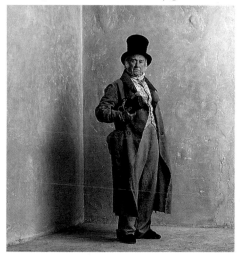
Cyril Cusack as Frederick Dorrit

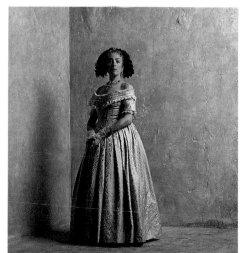
Eleanor Bron as Mrs Merdle

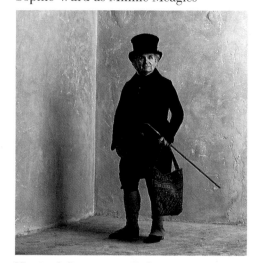
Howard Goorney as Bob

Robert Morley as Lord Decimus Barnacle

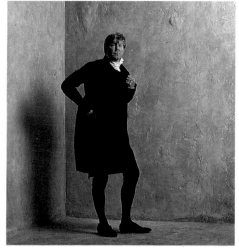
Alan Bennett as the Bishop

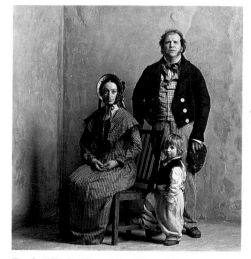
Ruth Mitchell as Mrs Plornish
Christopher Whittingham as Plornish
Harry Whittingham as Young Plornish

Some of the cast of *Little Dorrit*, 1986.

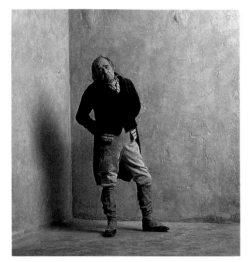

Max Wall as Flintwinch

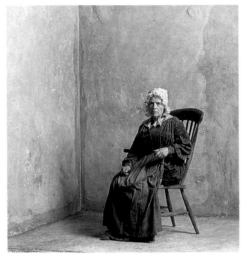

Patricia Hayes as Affery

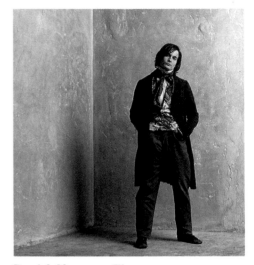

Daniel Chatto as Tip

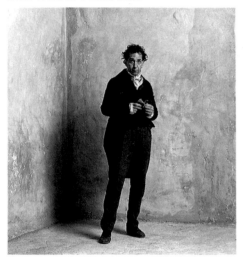

Roshan Seth as Mr Pancks

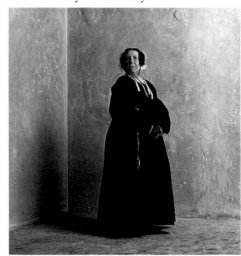

Kathy Staff as Mrs Tickit

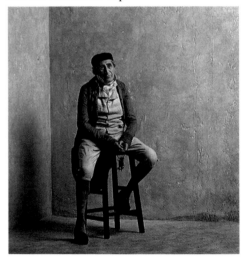

Edward Burnham as Daniel Doyce

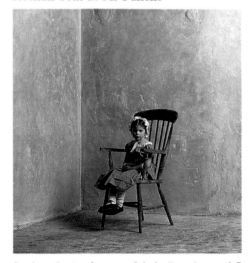

Sarina Carruthers as Little Dorrit aged 5

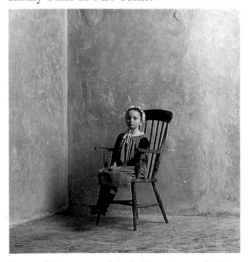

Susan Tanner as Little Dorrit aged 12

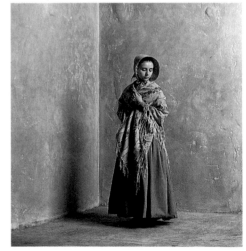

Sarah Pickering as Little Dorrit

Joan Greenwood as Mrs Clennam

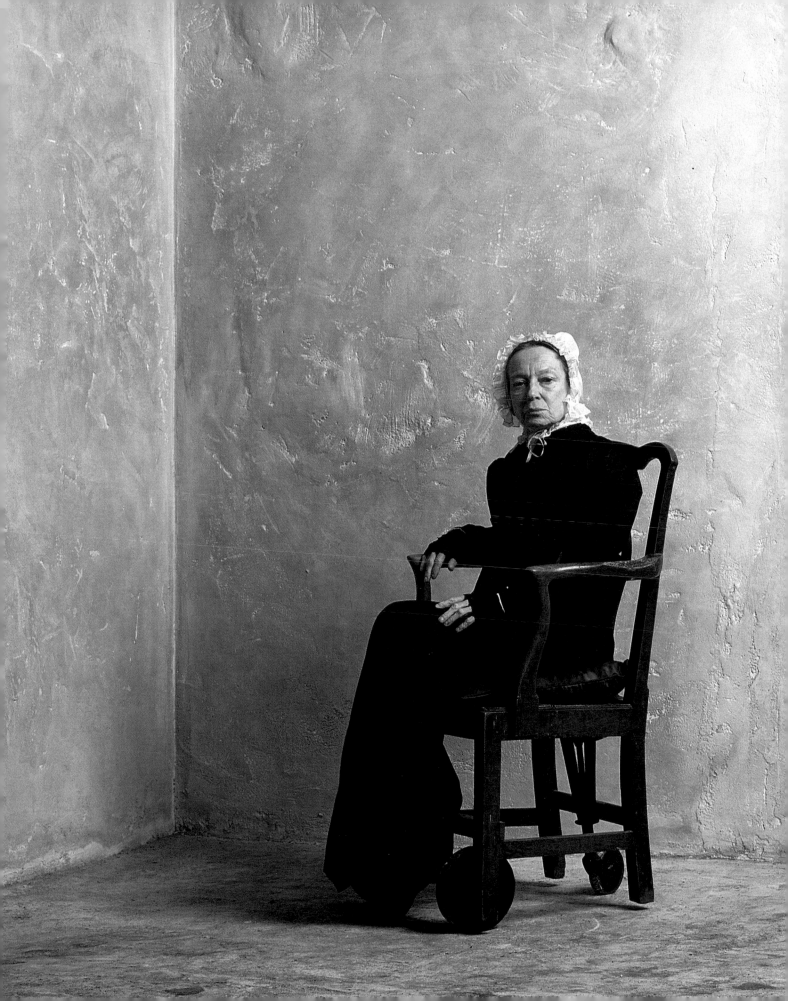

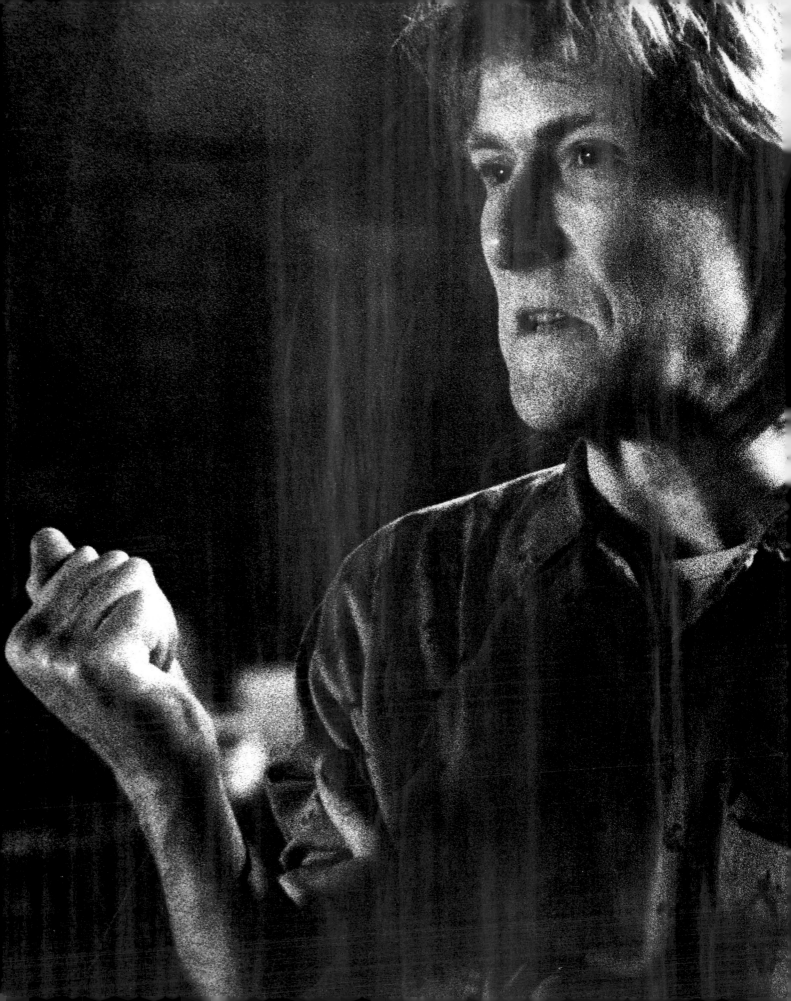

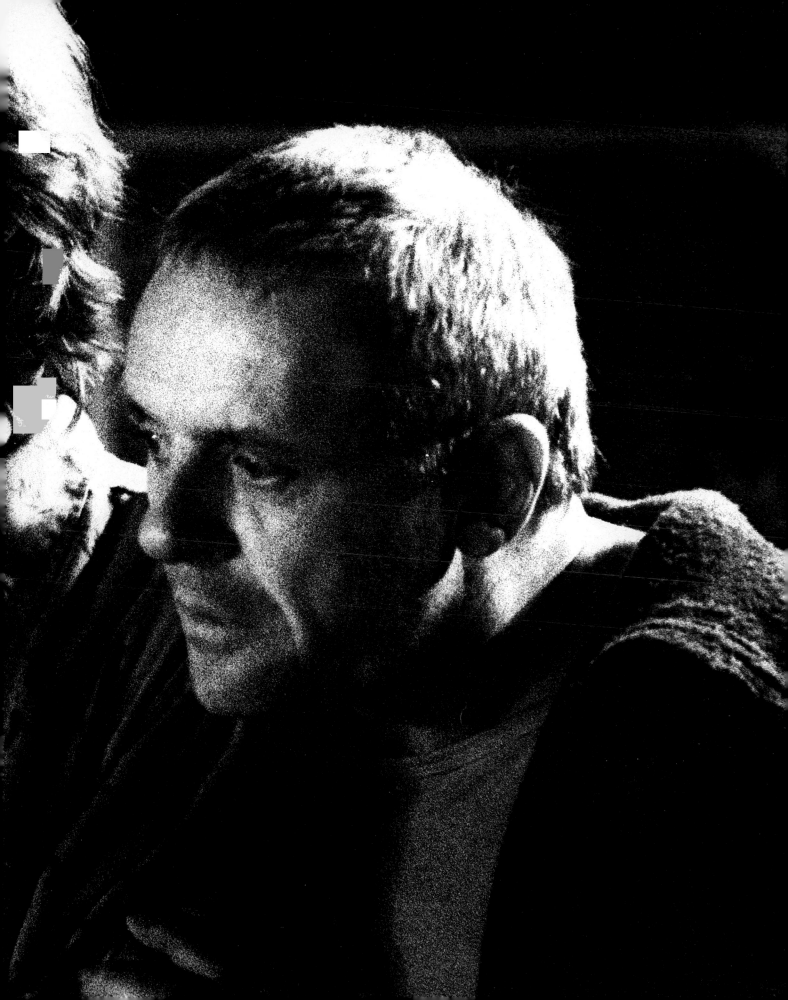

PRECEDING PAGES Bill Nighy and Anthony Hopkins in *King Lear*, the
National Theatre, 1986.

BELOW Alan Bennett, 1984.

OPPOSITE Bob Hoskins, 1986.

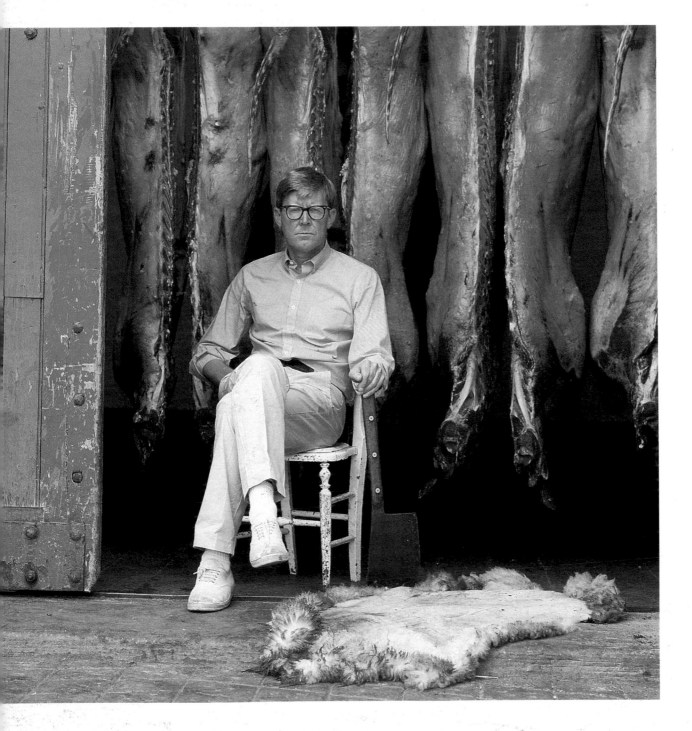

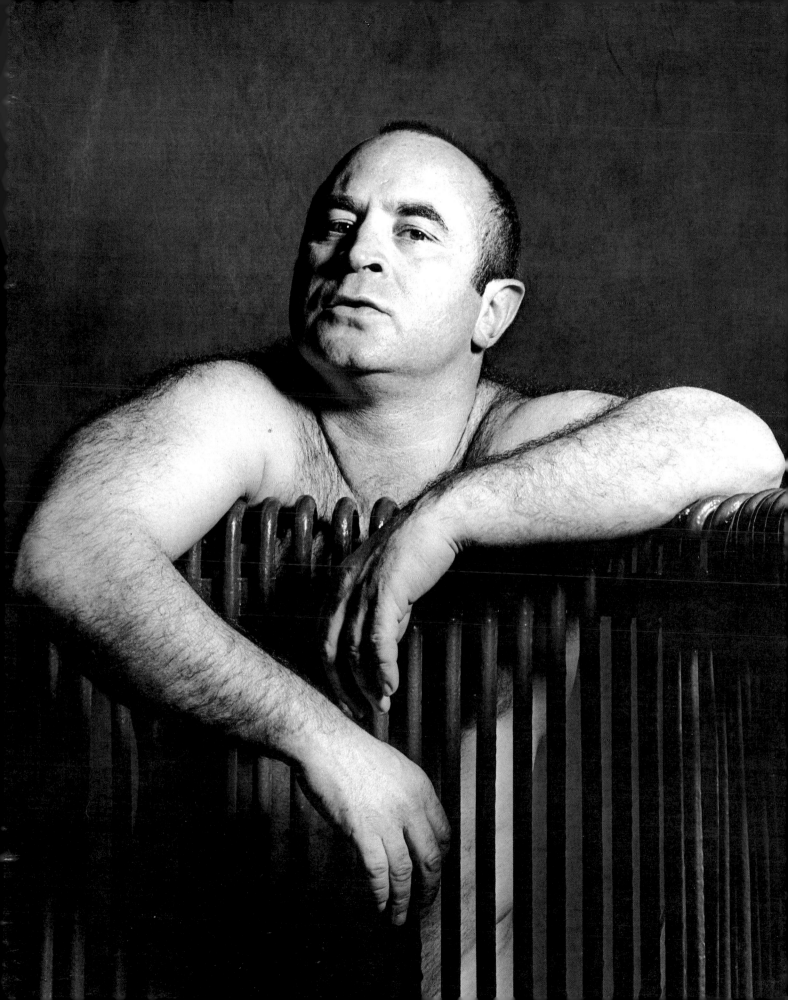

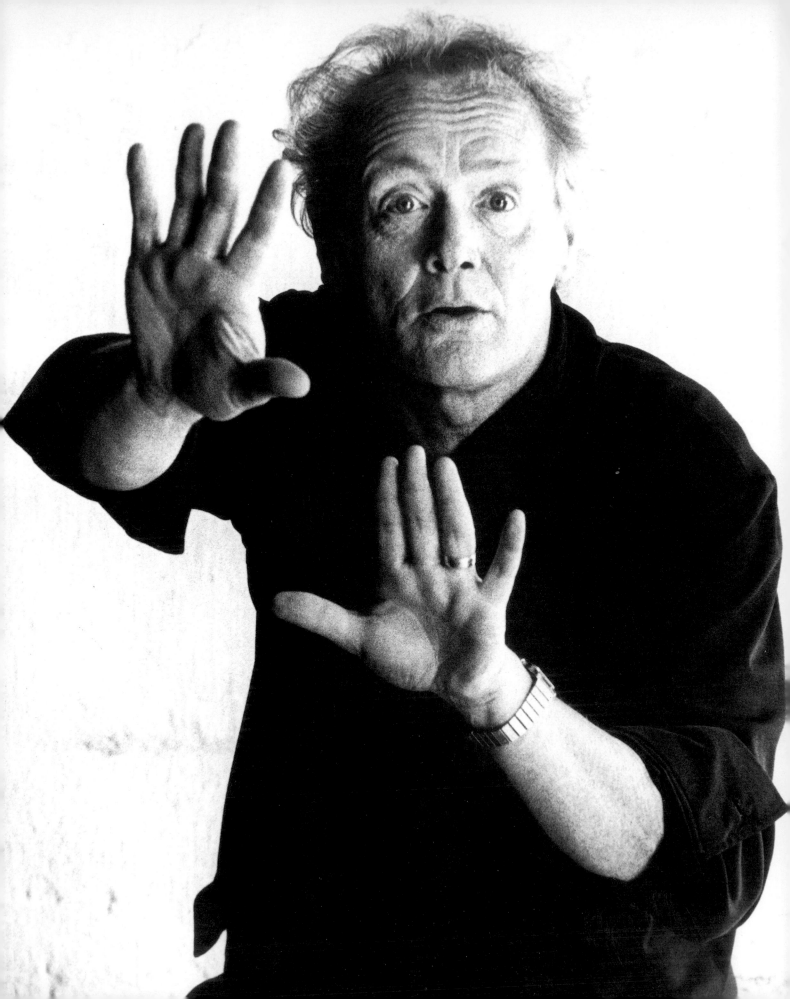

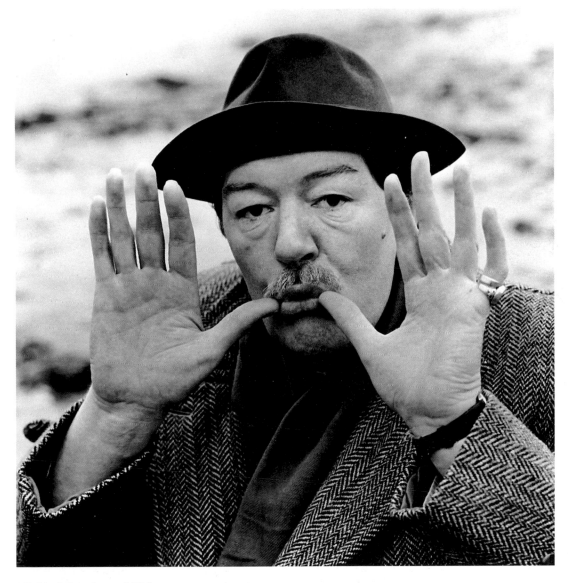

Michael Gambon, 1986.

Klaus Tennstedt, 1985.

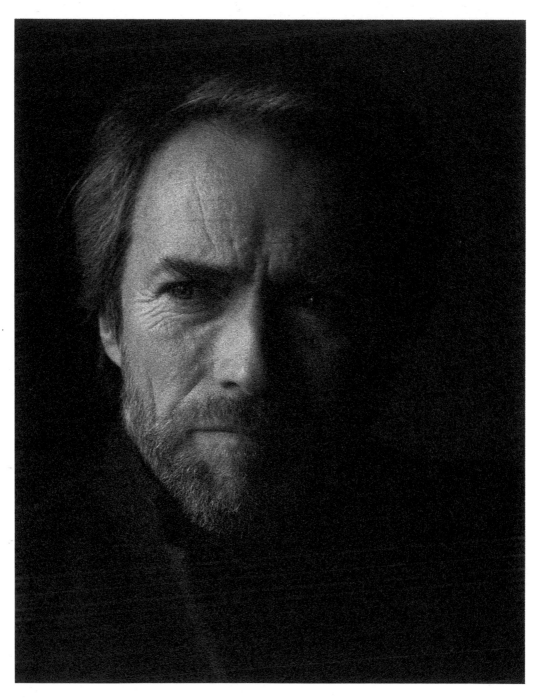

Clint Eastwood, 1985.

Lord Olivier, 1986.

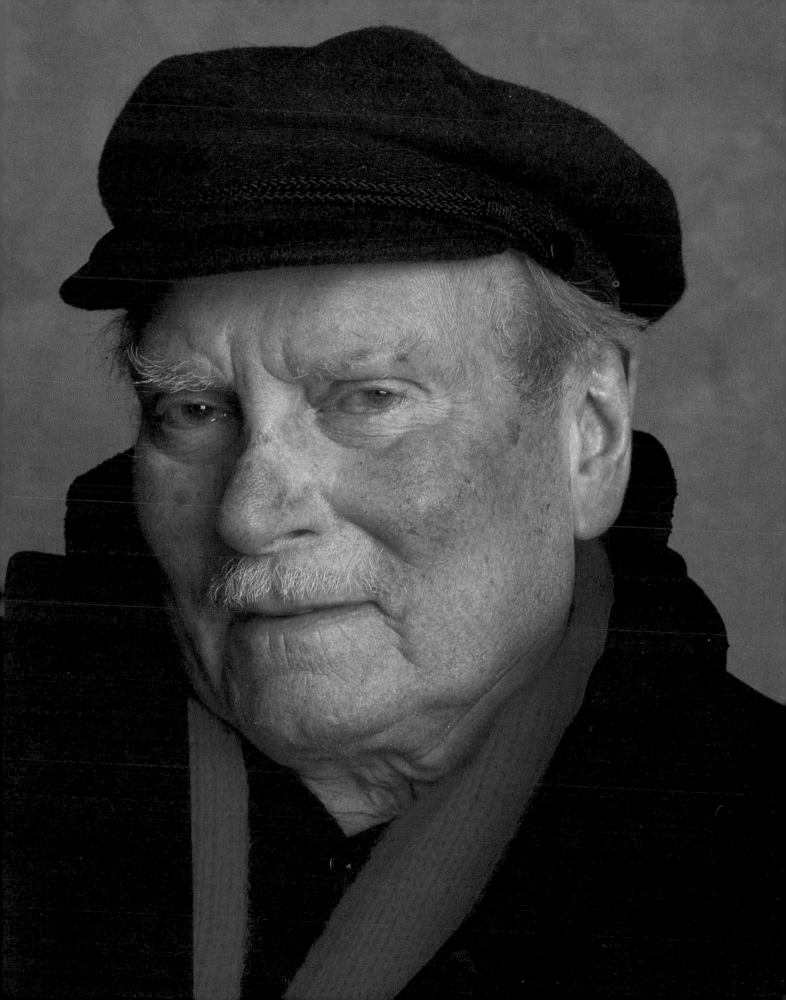

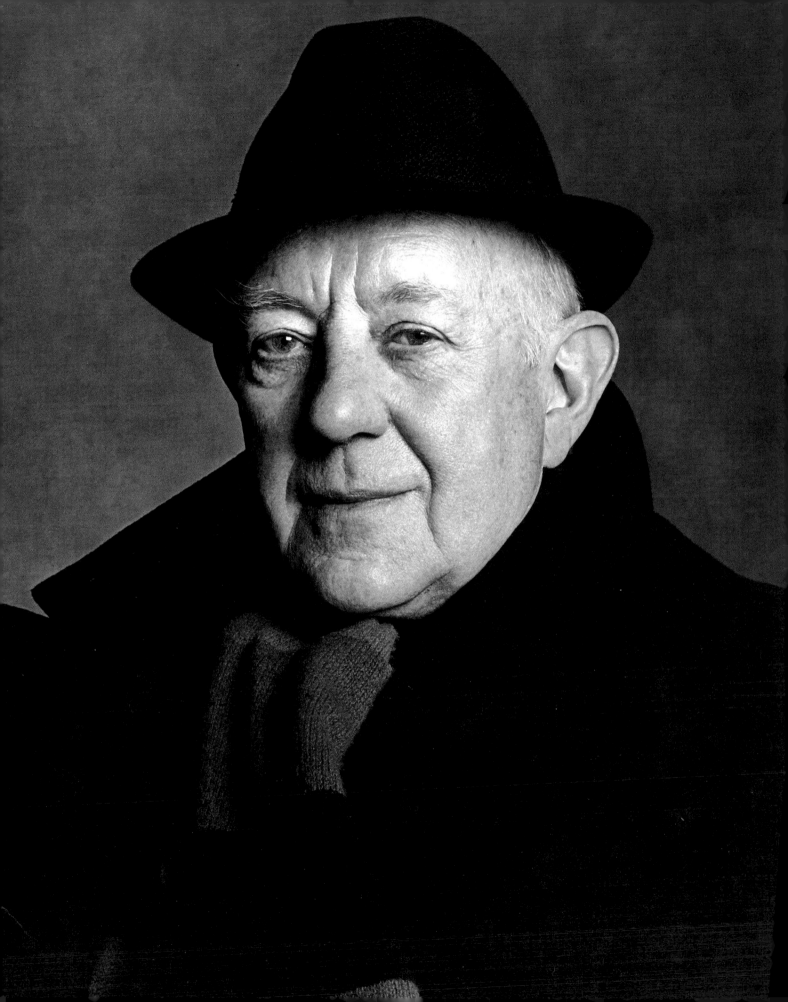

Anthony Sher as Richard III, 1985.

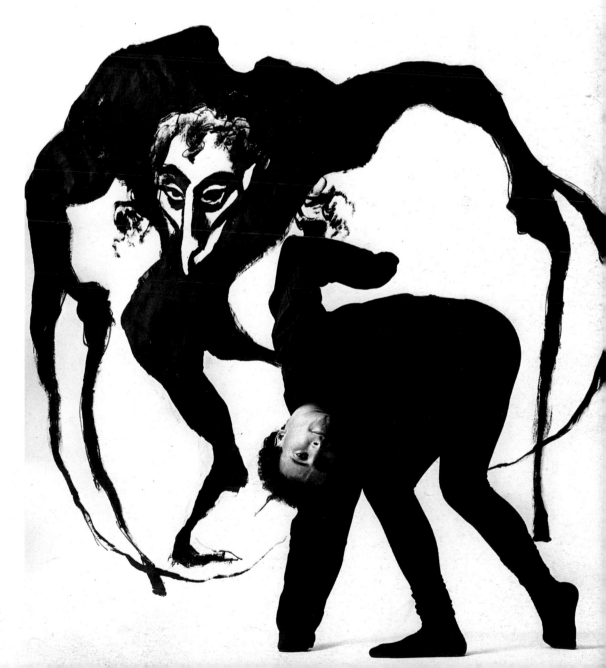

Sir Alec Guinness, 1985.

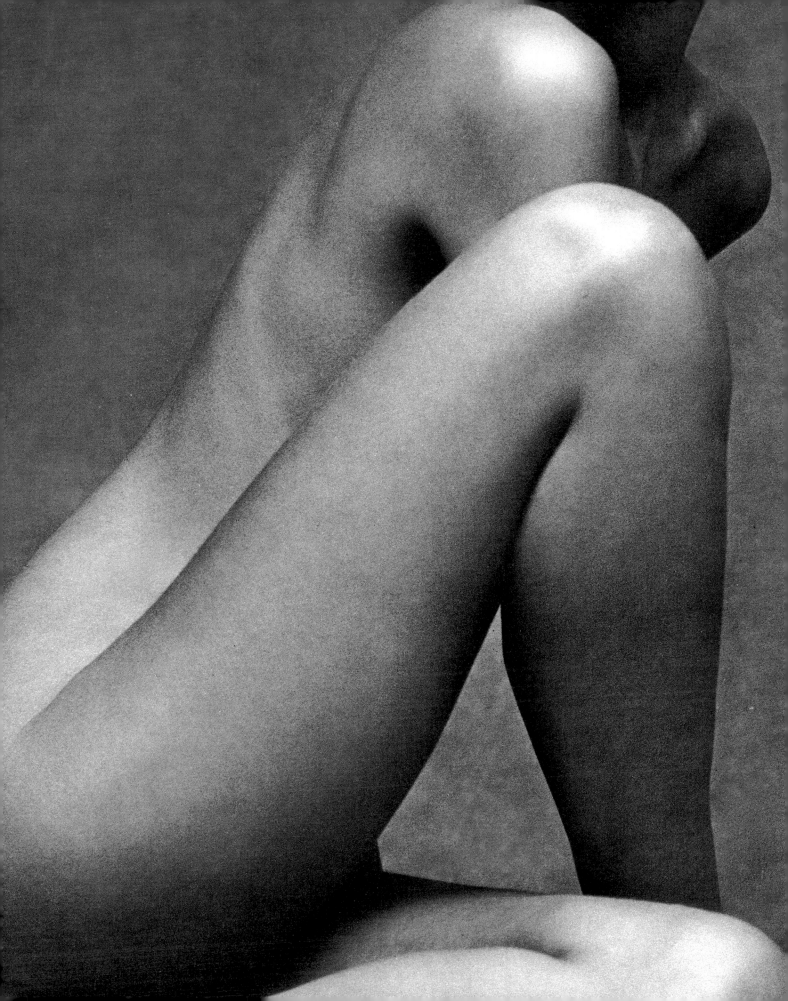

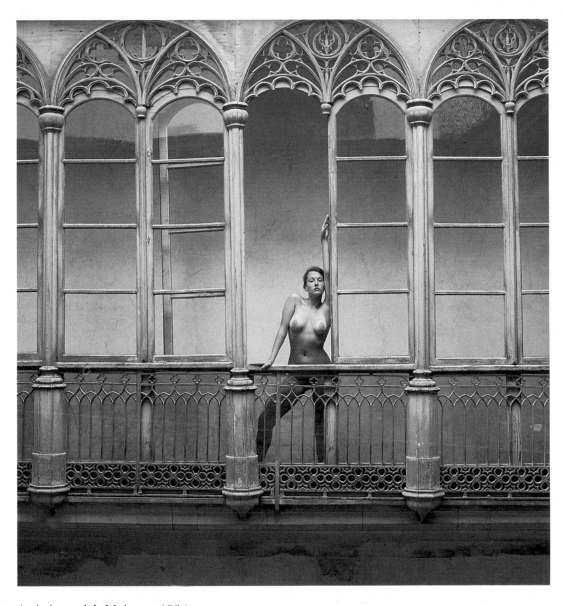

Artist's model, Majorca, 1984.

Nude, 1986.

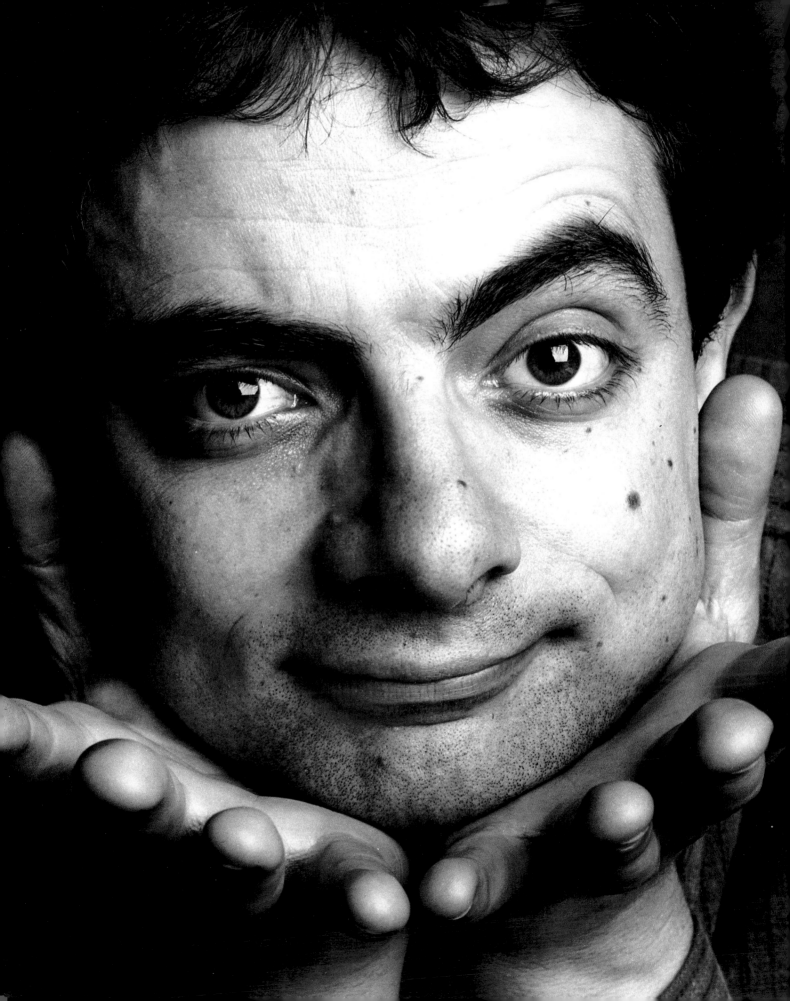

Rowan Atkinson, 1986.

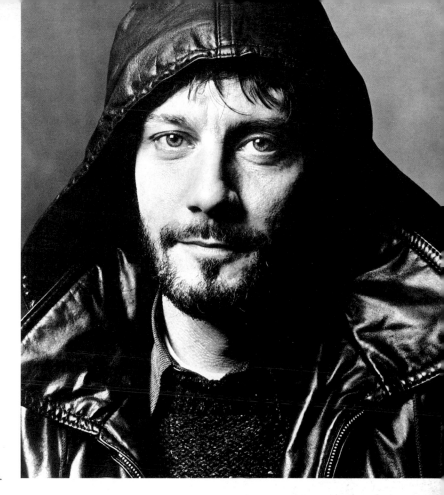

Roland Joffe, 1985.

Roger Rees, 1984.

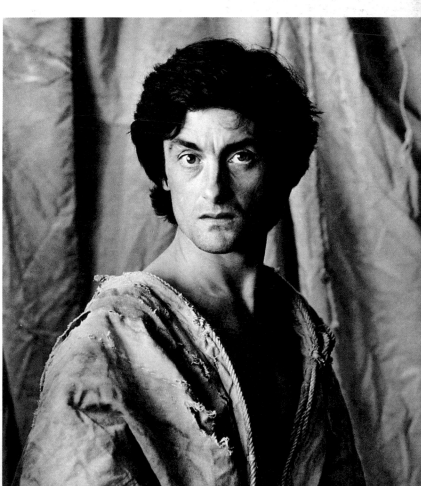

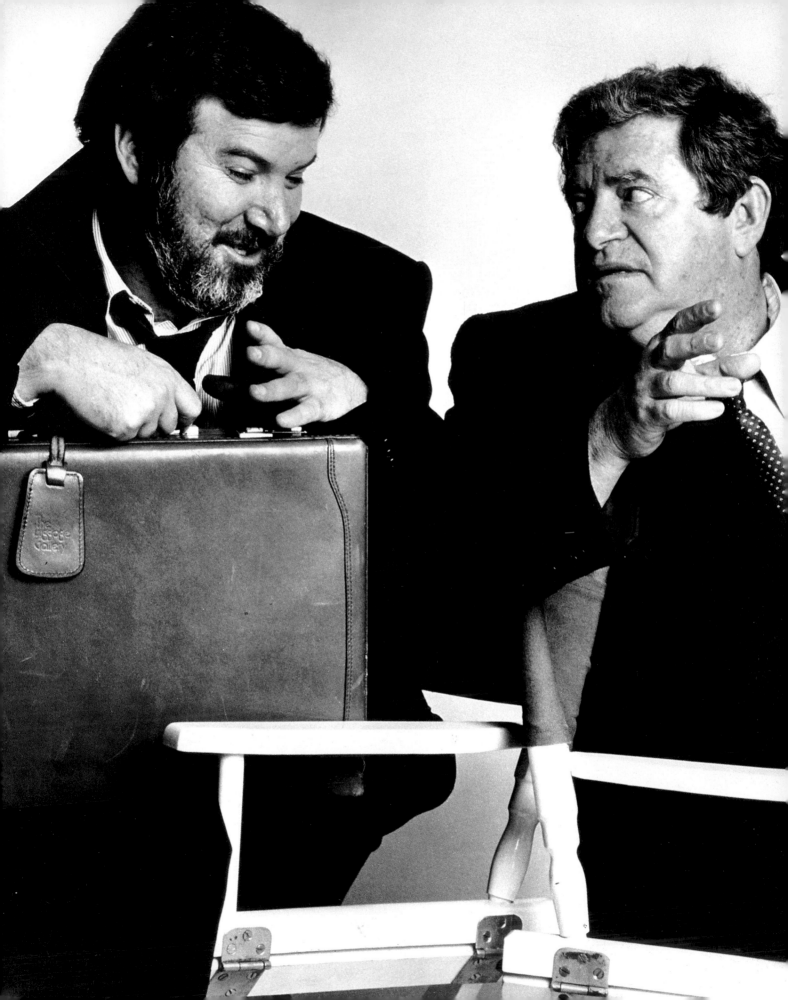

Yoram Globus and Menachem Golan, 1984.

James Ivory and Ismail Merchant, 1984.

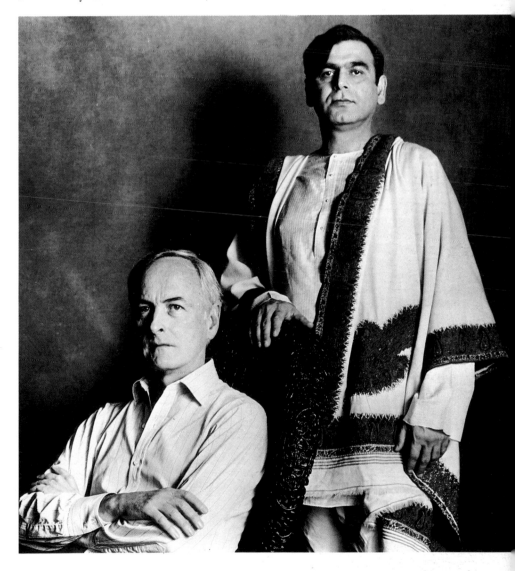

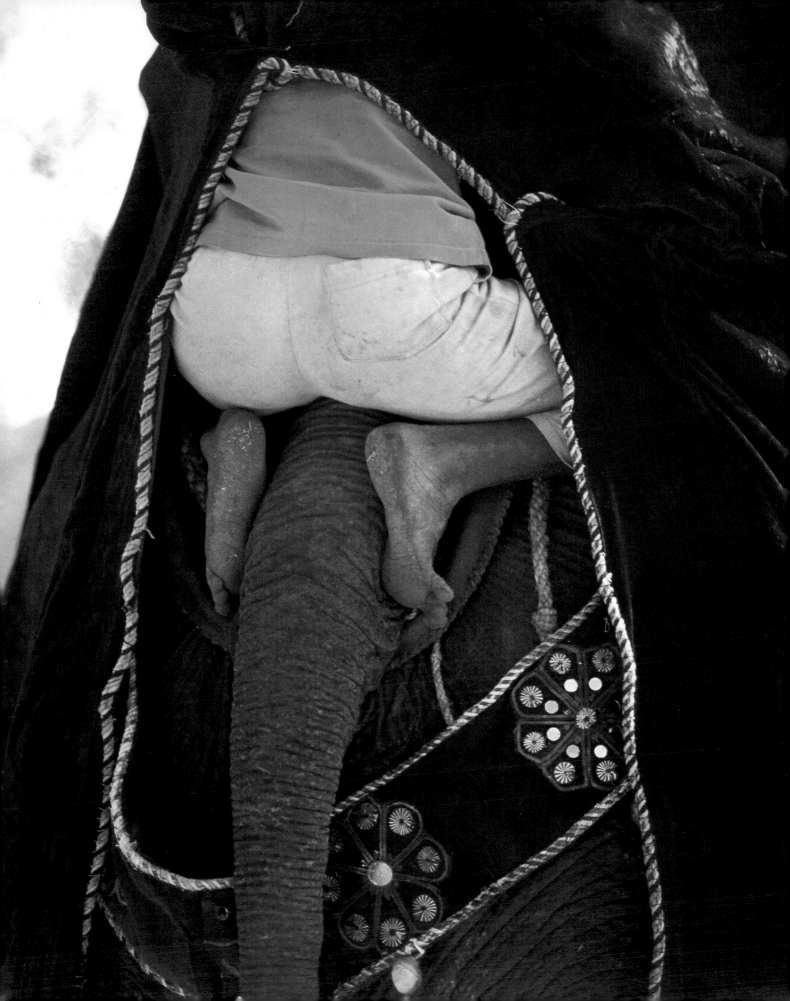

OPPOSITE AND BELOW *A Passage to India*, 1984.

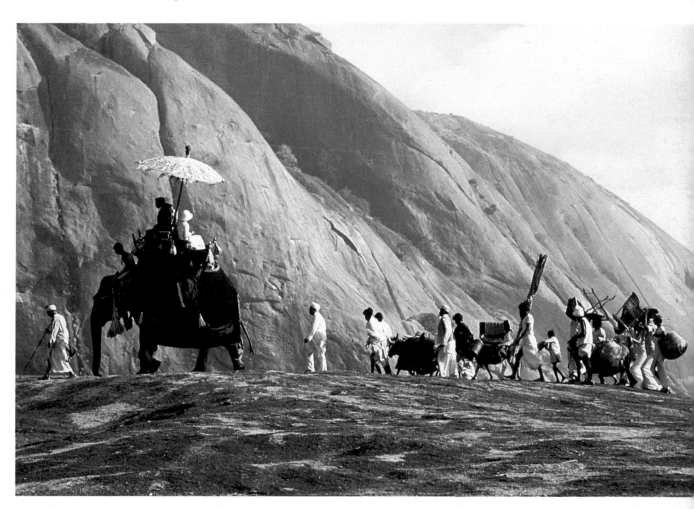

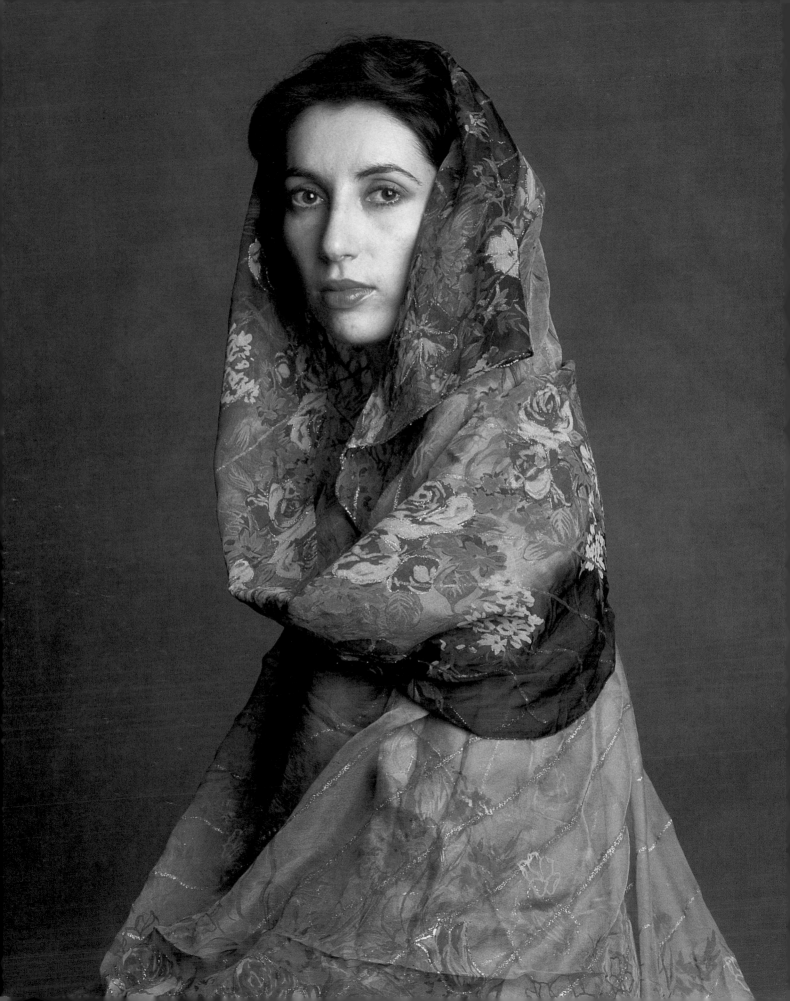

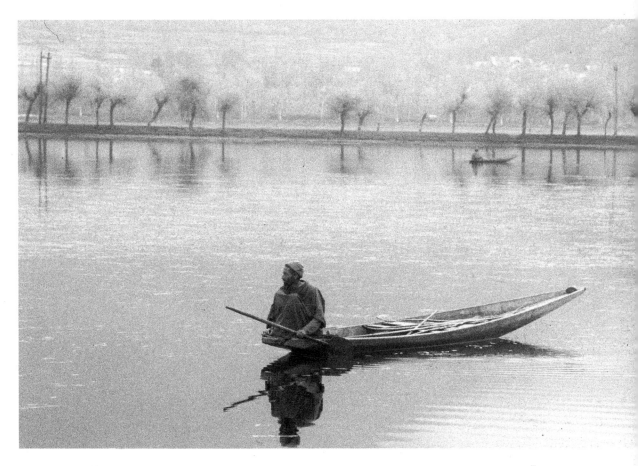

Lake Dal, India, 1984.

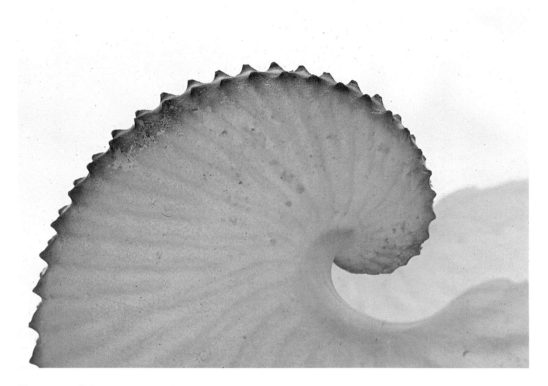

Egg case of *Argonauta*, 1984.

*Allium siculum*, 1985.

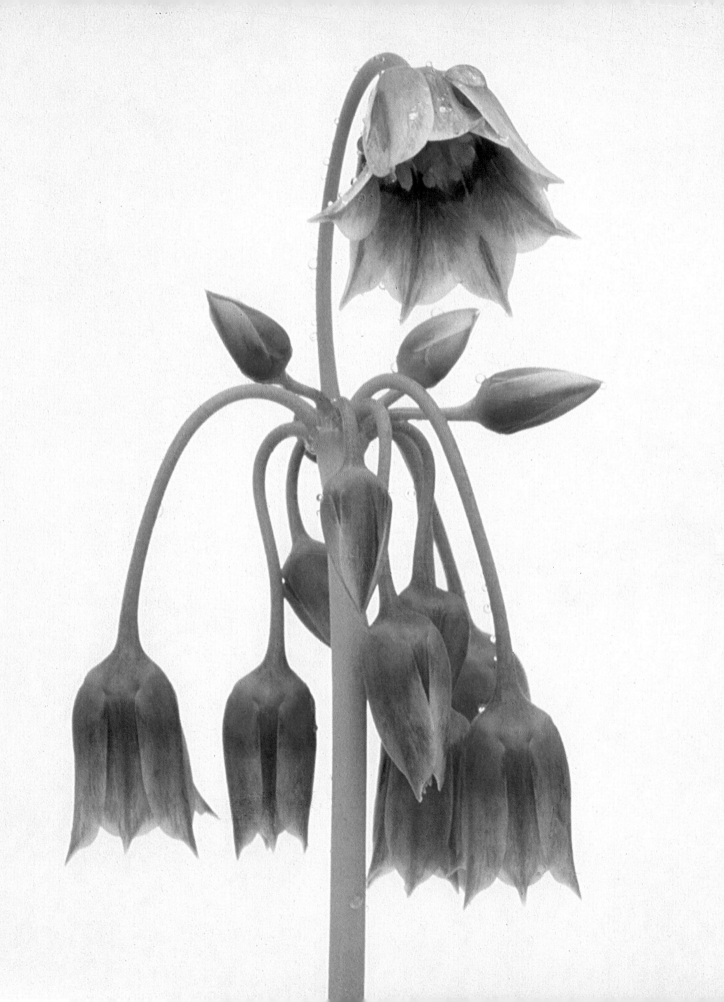

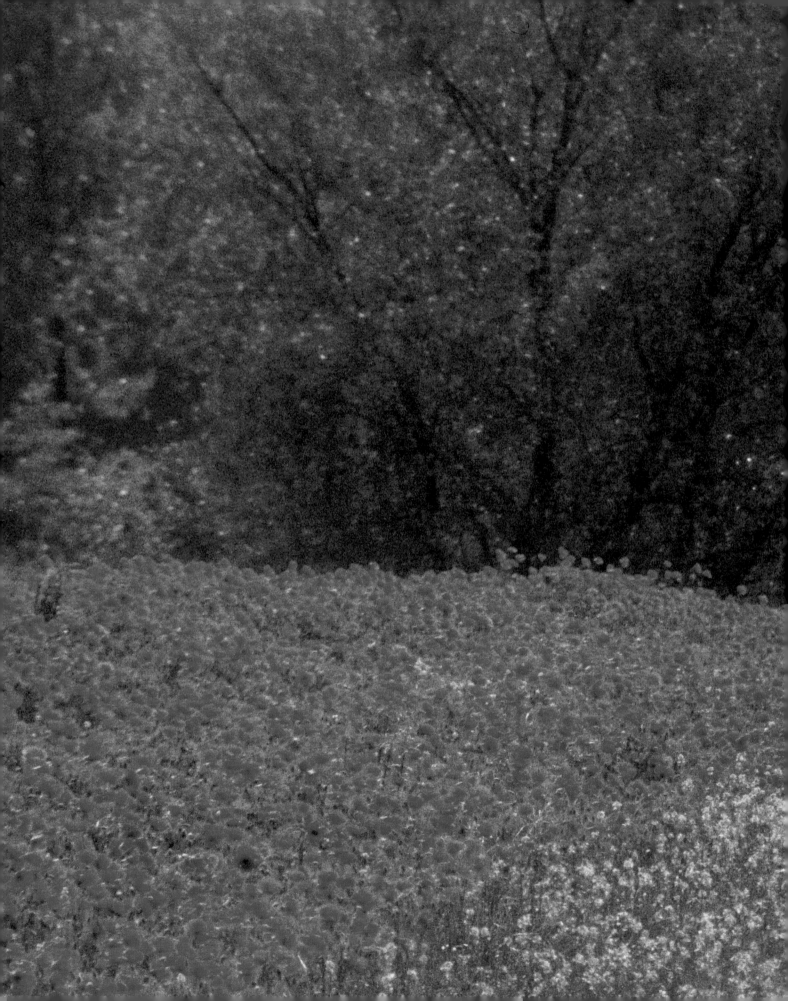

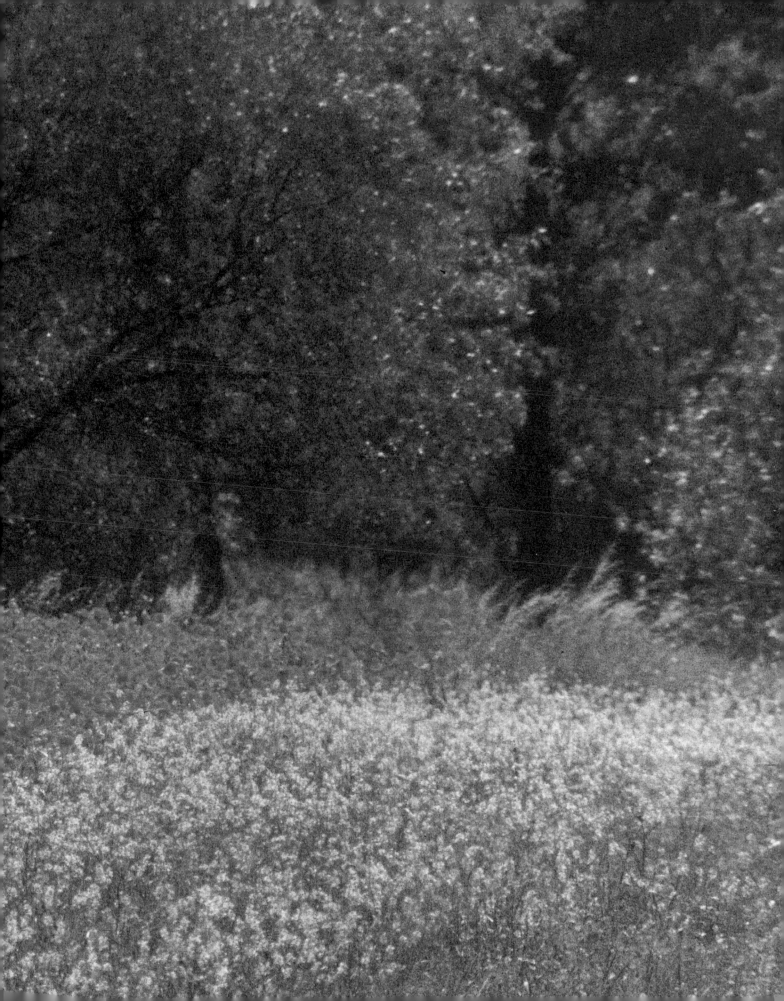

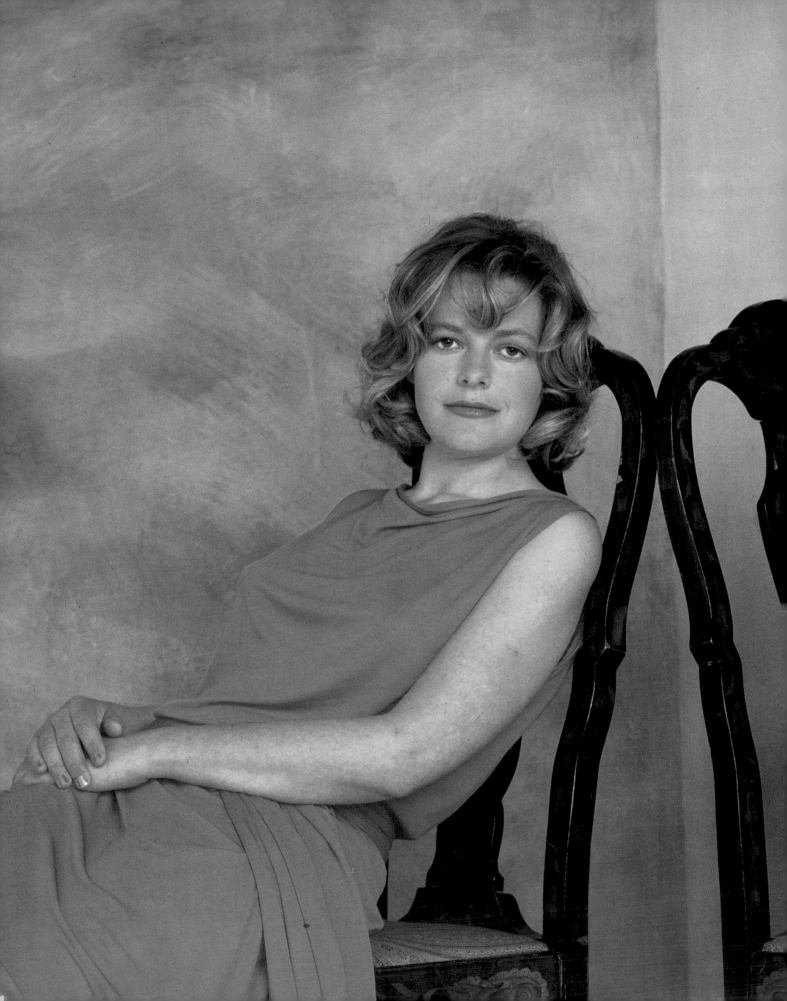

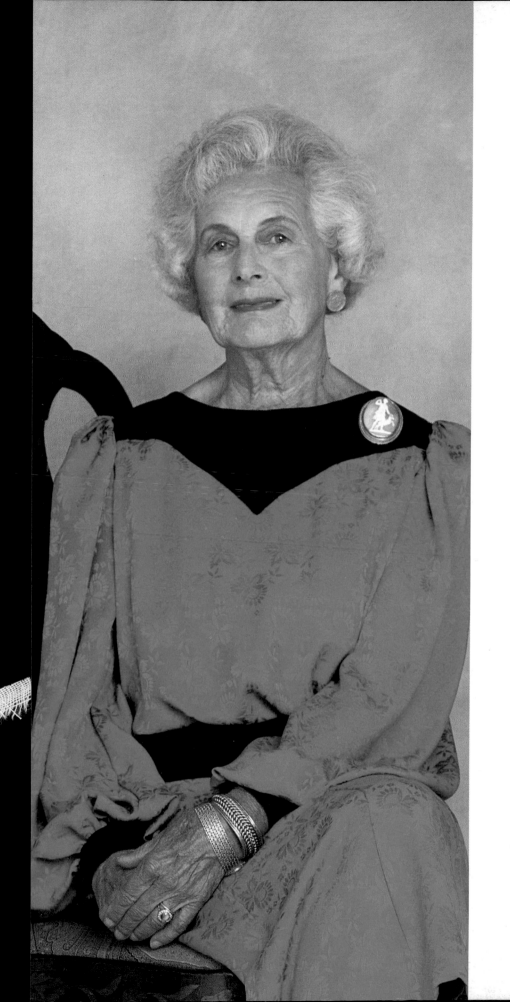

PRECEDING PAGES Poppies, Flanders, 1984.

LEFT Flora Fraser and her grandmother, Lady Longford, 1986.

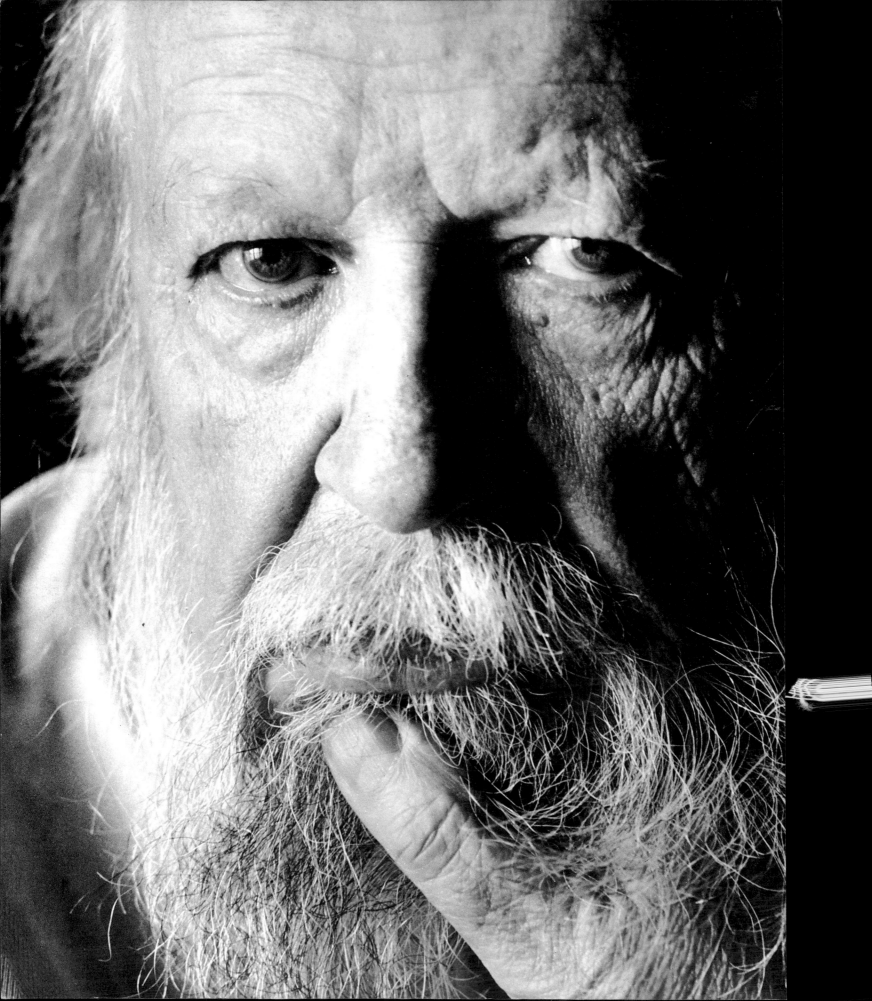

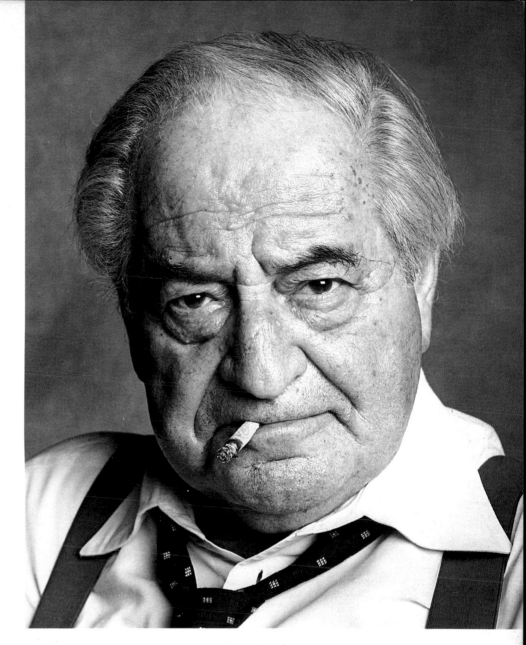

Sam White, 1986.

William Golding, 1984.

121

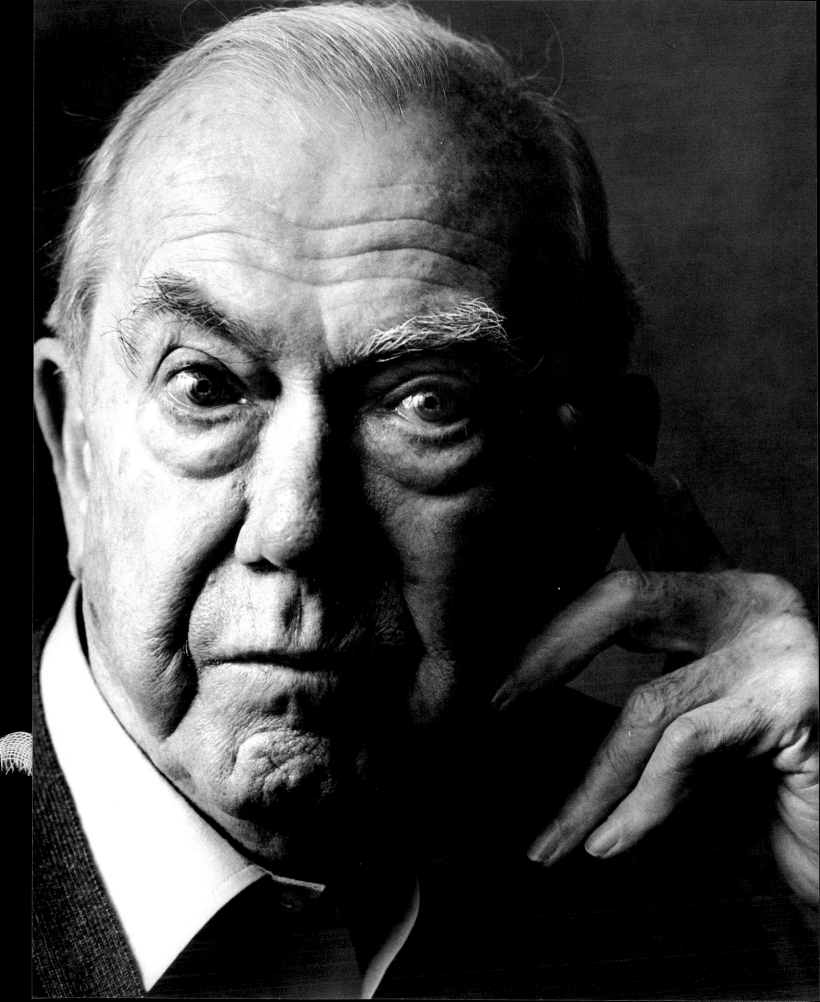

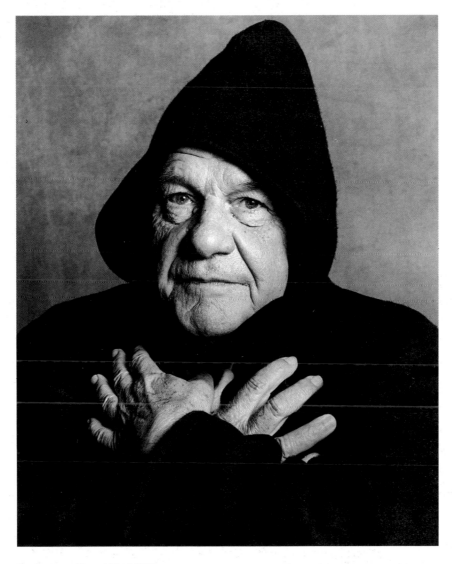

Lawrence Durrell, 1985.

Graham Greene, 1984.

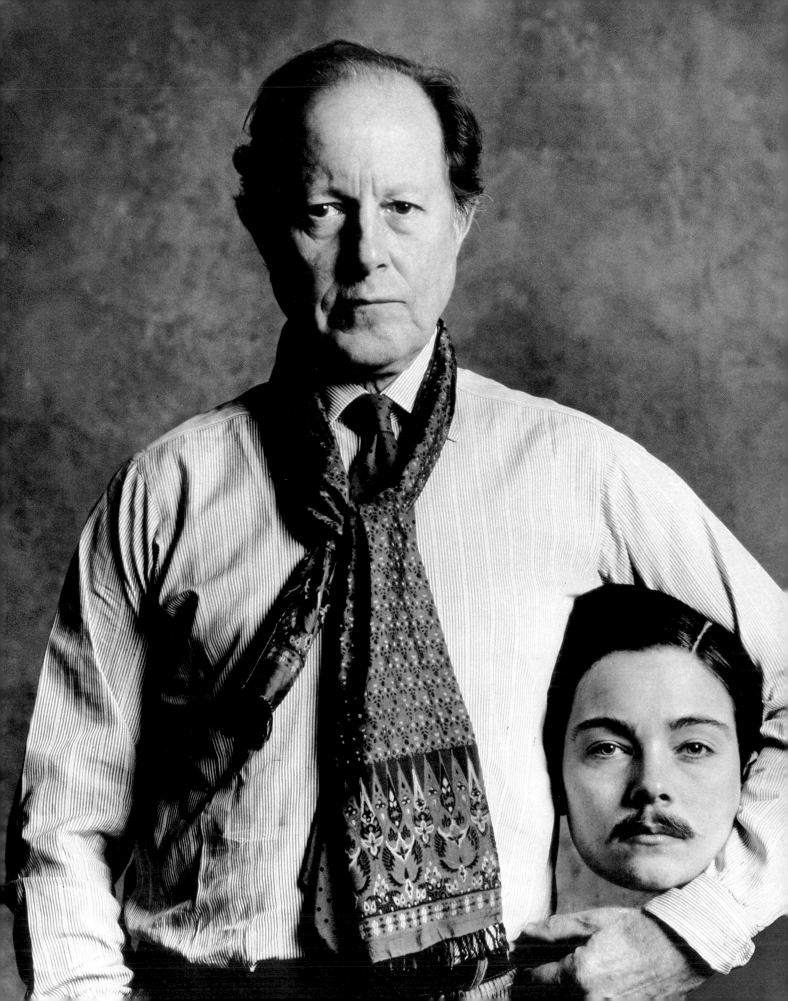

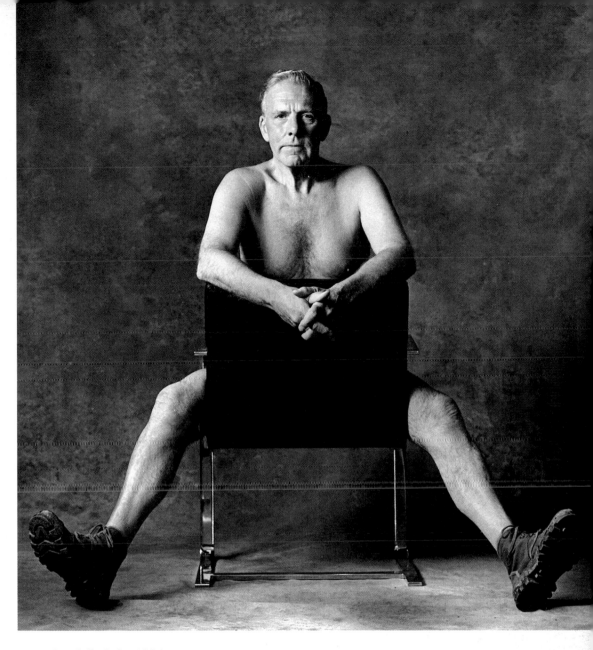

Peter Boydell, Q.C., 1984.

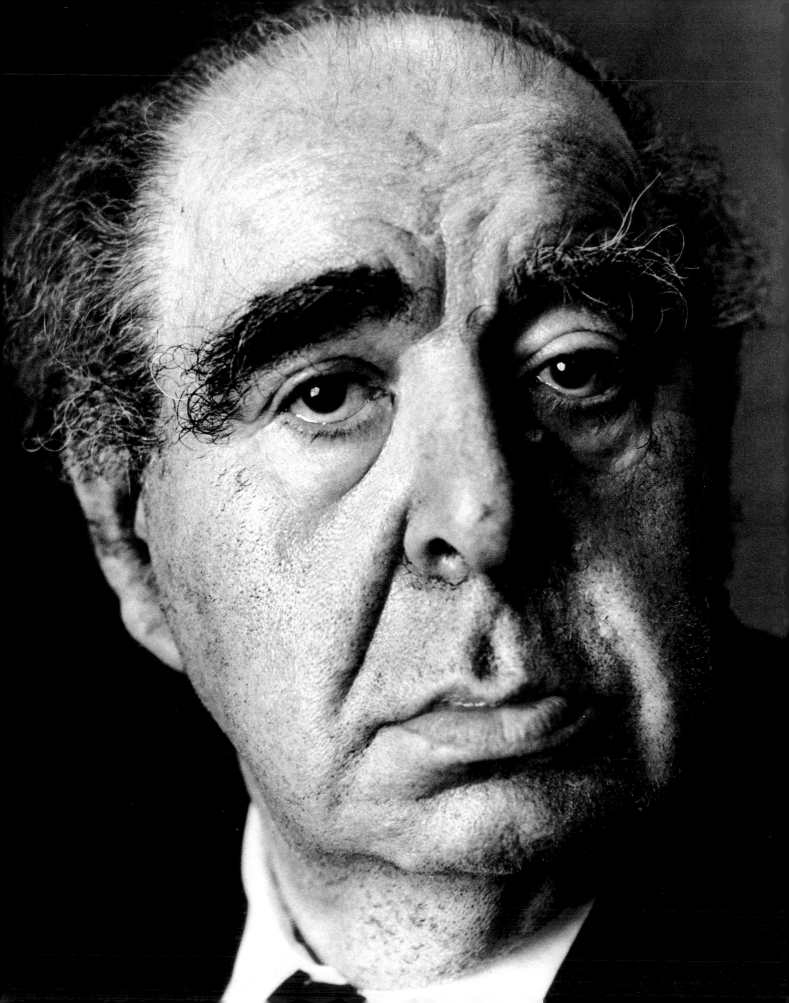

LEFT Lord Goodman, 1984.

RIGHT Lord Alexander Rufus
Isaacs, 1986.

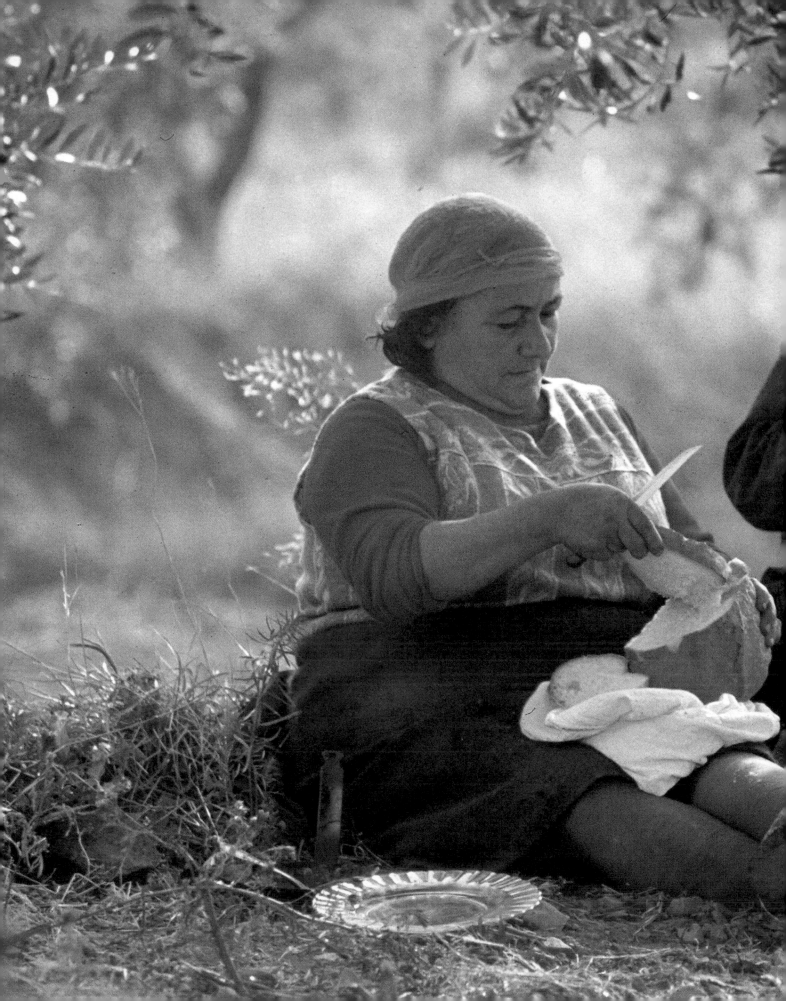

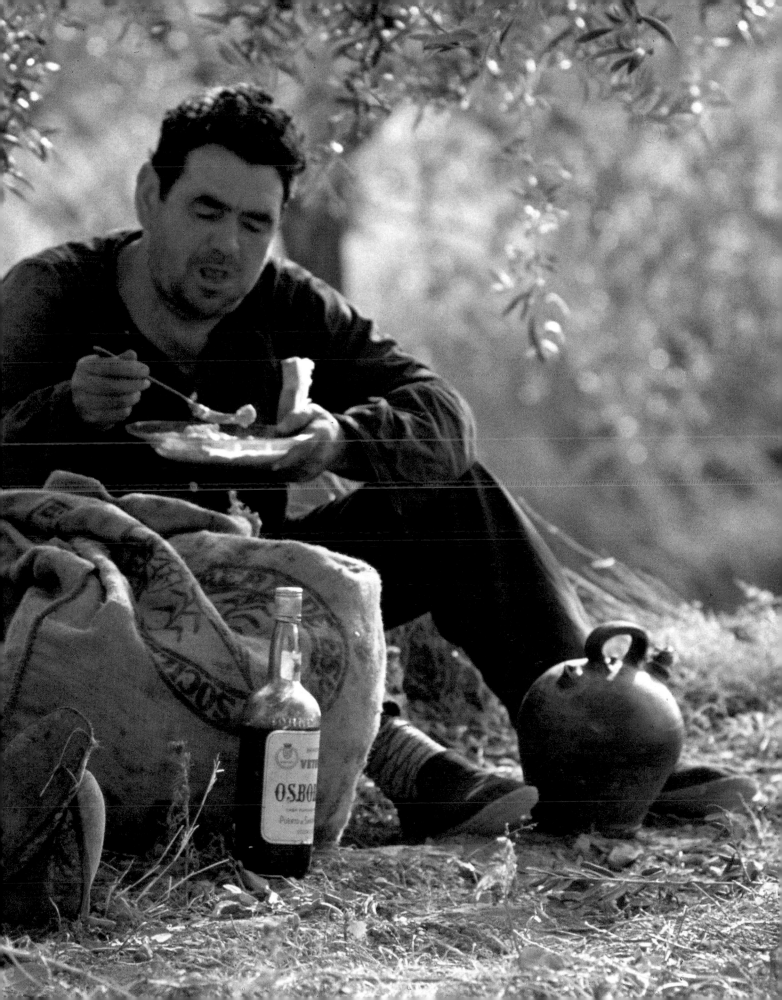

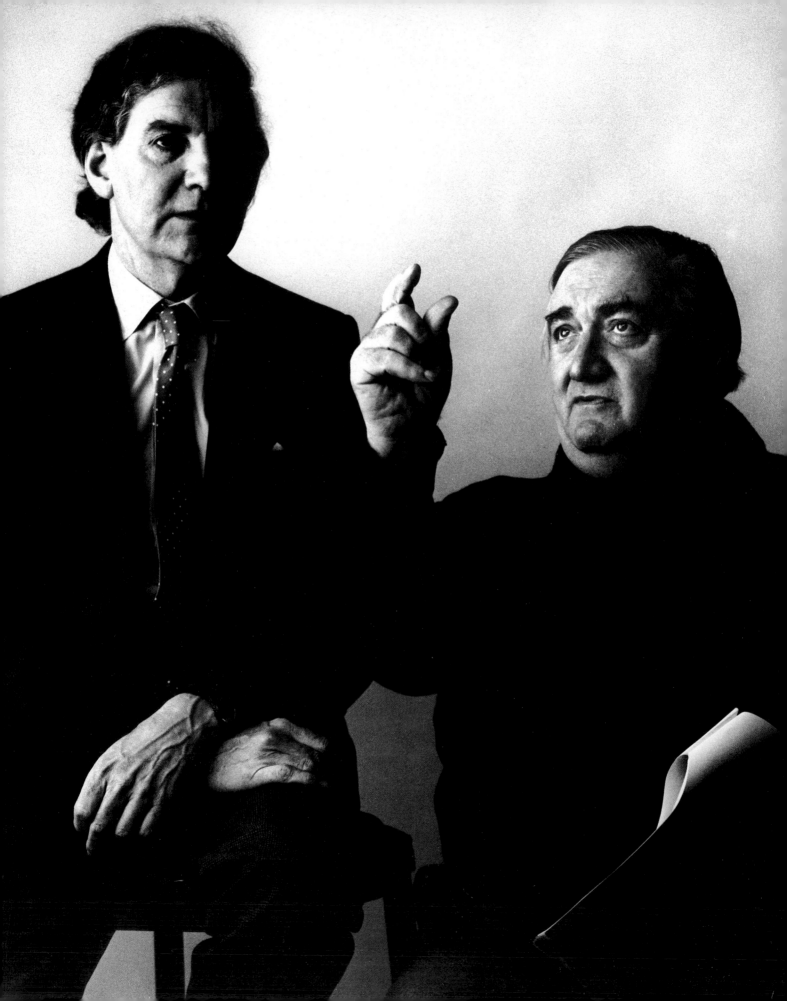

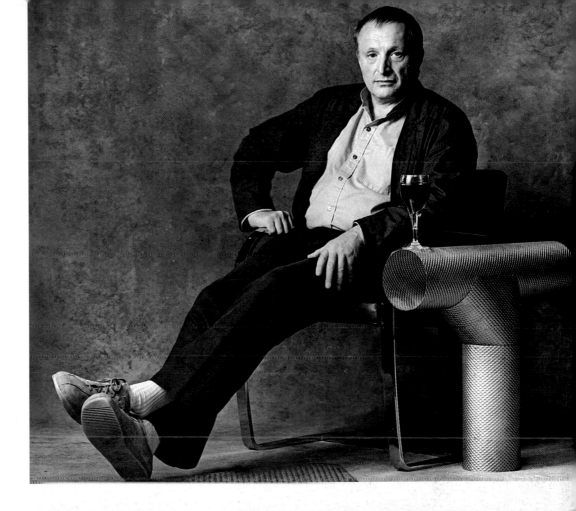

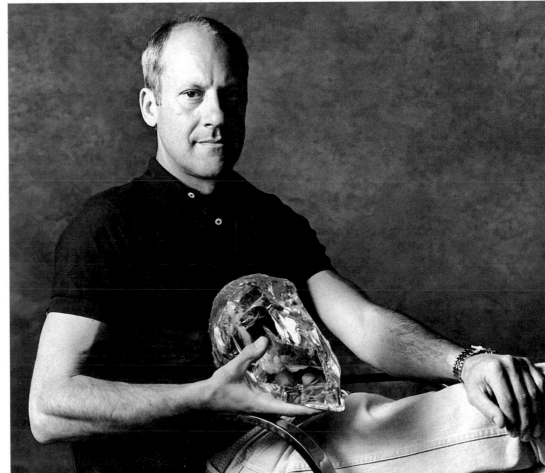

PRECEDING PAGES
Olive-pickers, Greece, 1984.

LEFT Professor Alan Bowness
and James Stirling, 1984.

ABOVE RIGHT
Richard Rodgers, 1984.

RIGHT Norman Foster, 1984.

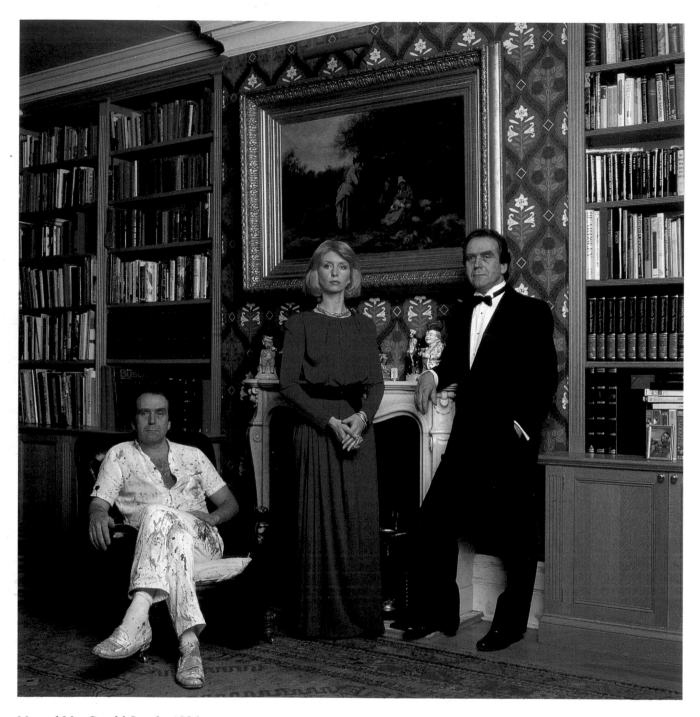

**Mr and Mrs Gerald Scarfe, 1986.**

Gerald Scarfe, 1986.

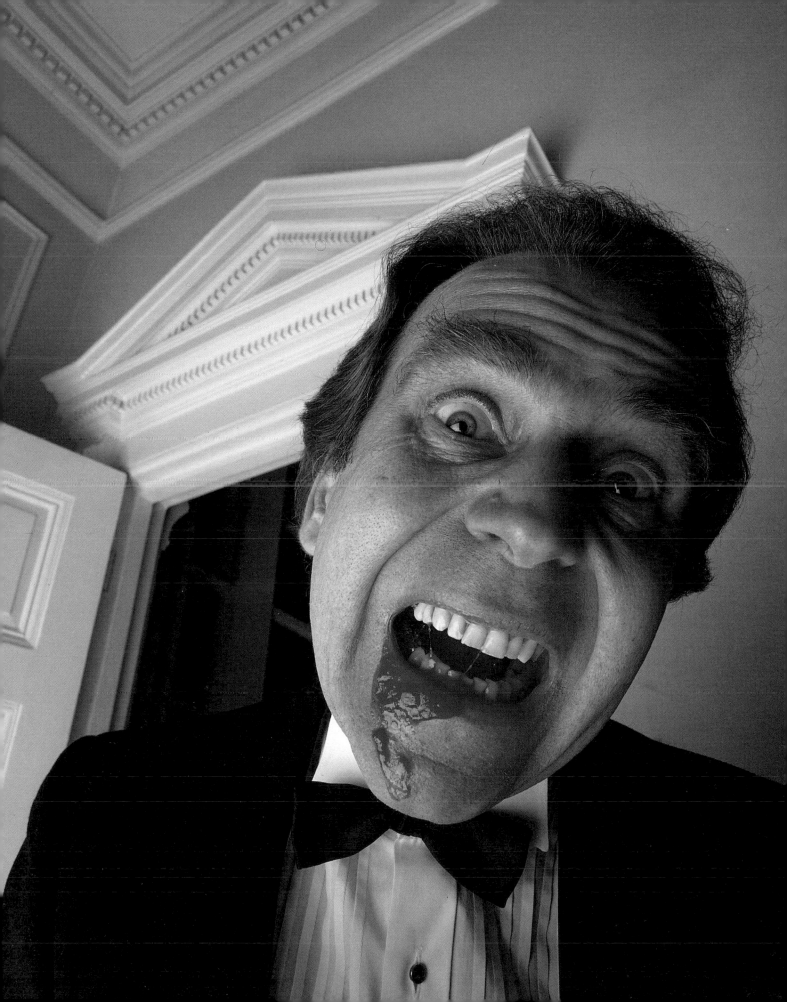

Dame Elizabeth Frink, 1986.

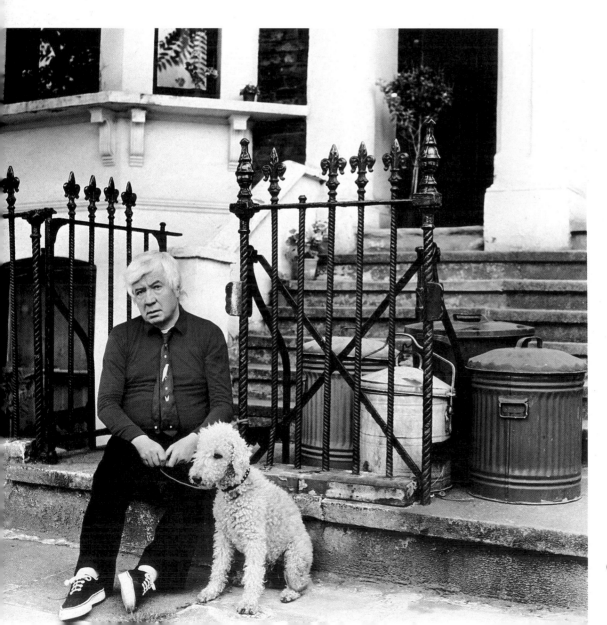

Craigie Aitchison, 1984.

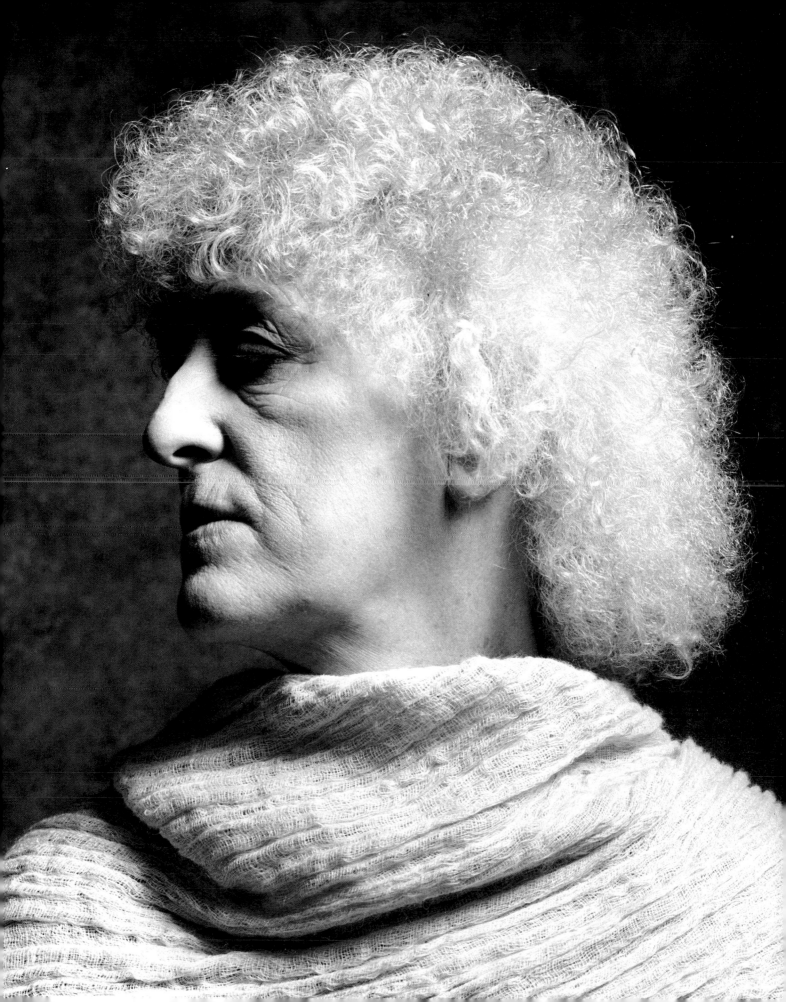

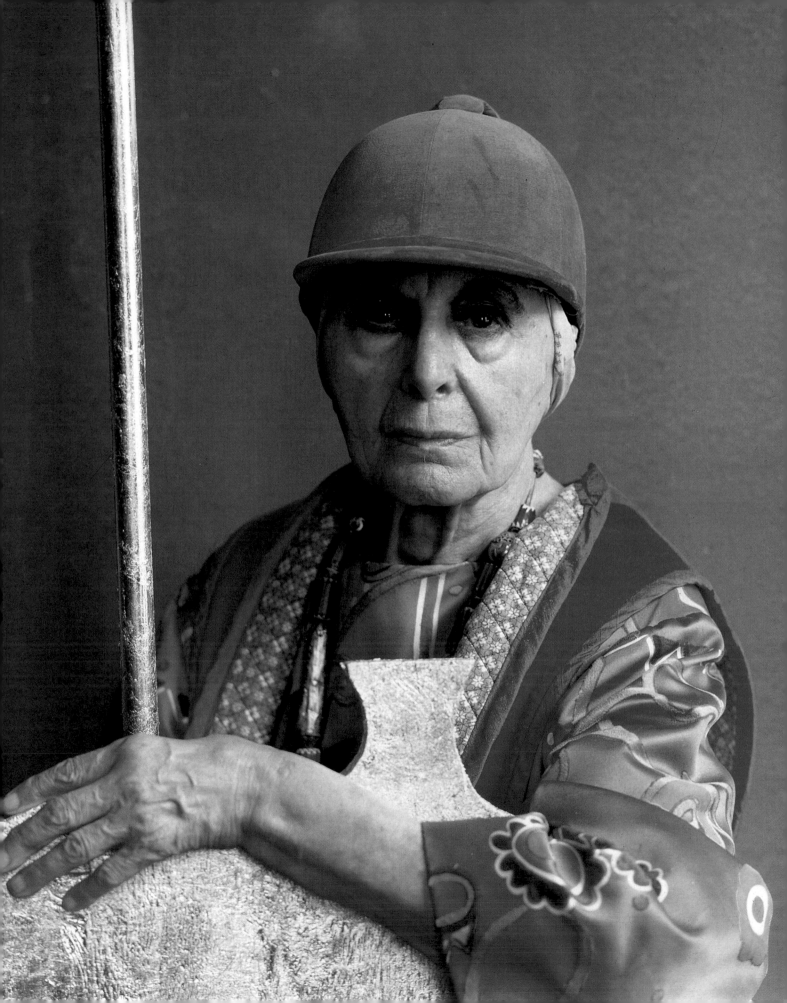

Louise Nevelson, 1985.

Allen Jones, 1986.

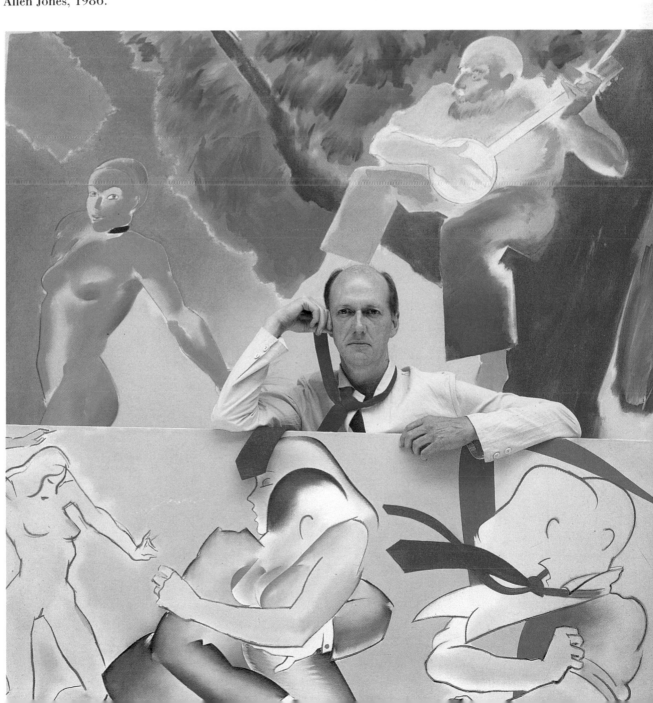

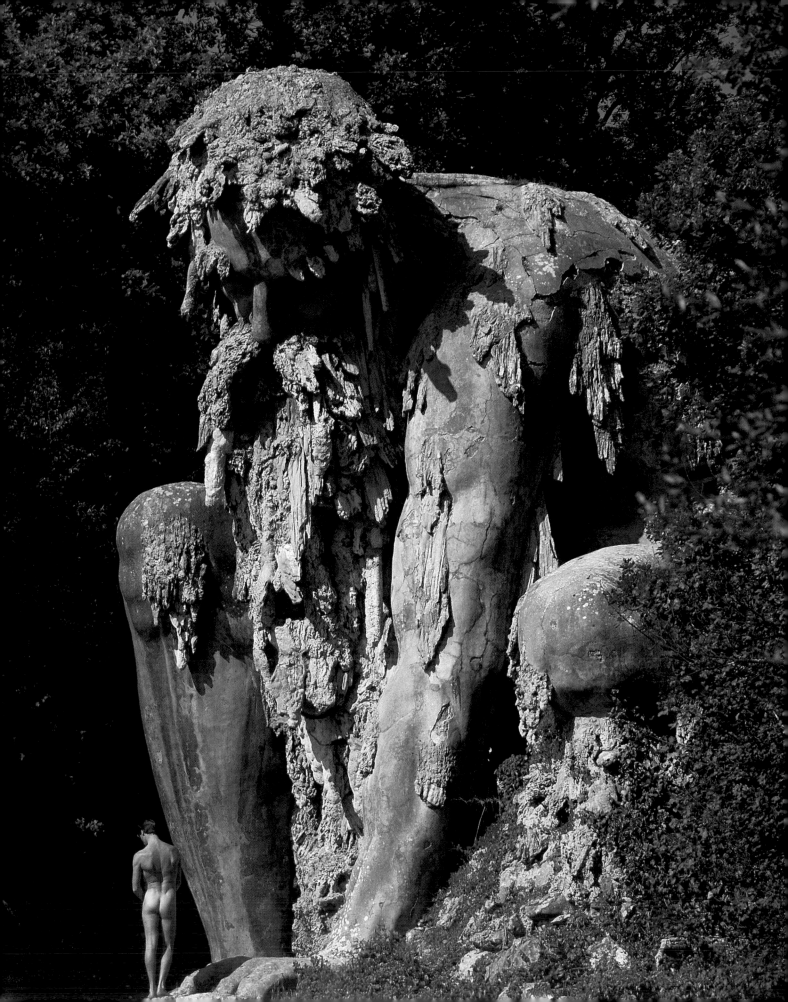

Giambologna's *Apennines* at Pratolino,
Florence, 1984.

Georges Baselitz and his son Daniel, 1984.

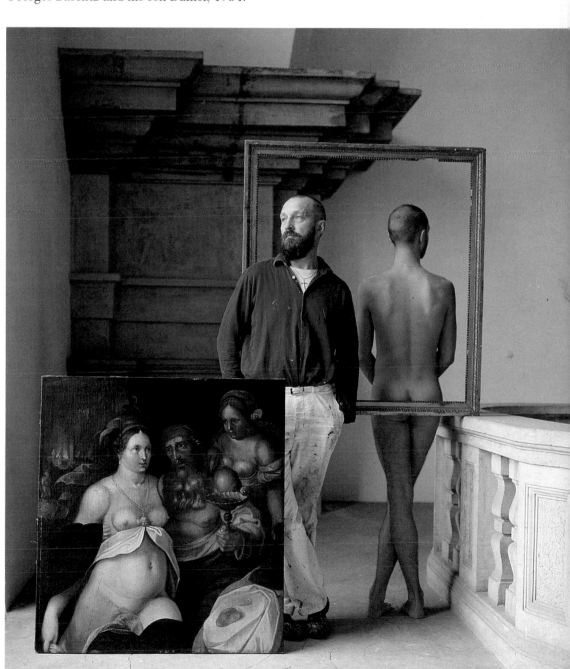

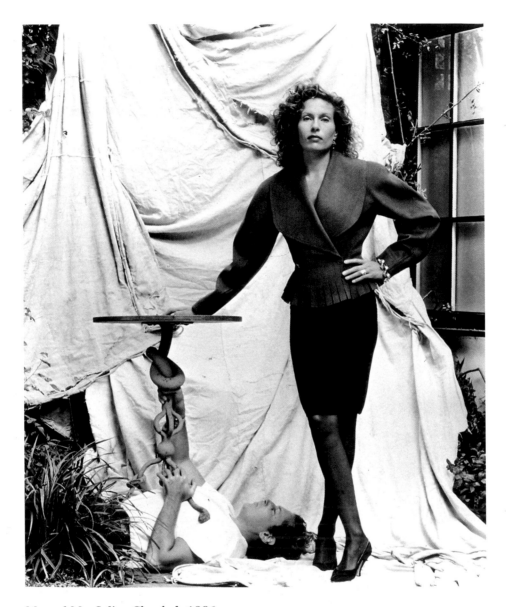

Mr and Mrs Julian Shnabel, 1986.

Joseph Beuys, 1985.

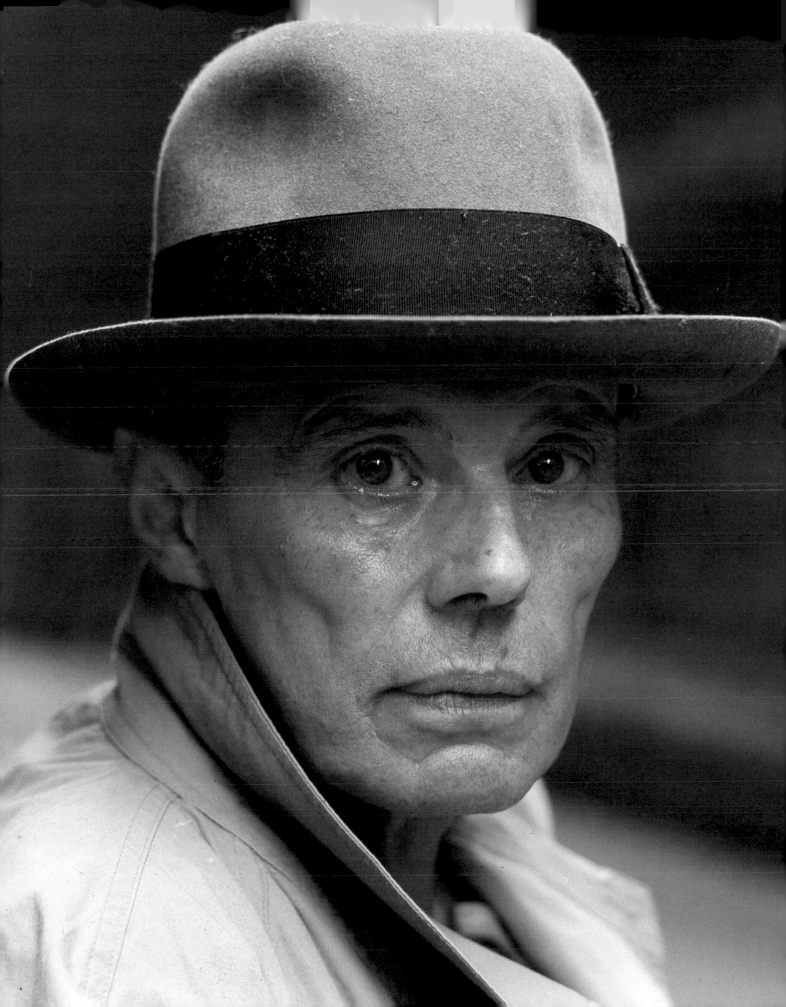

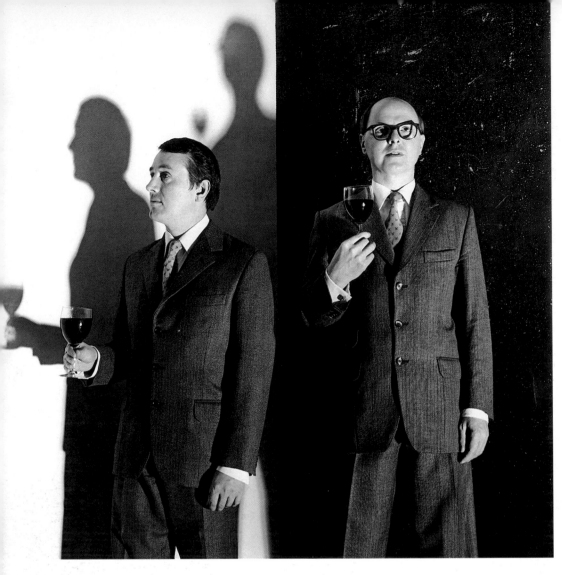

Gilbert and George, 1985.

Lillian Browse and Howard Hodgkin, 1985.

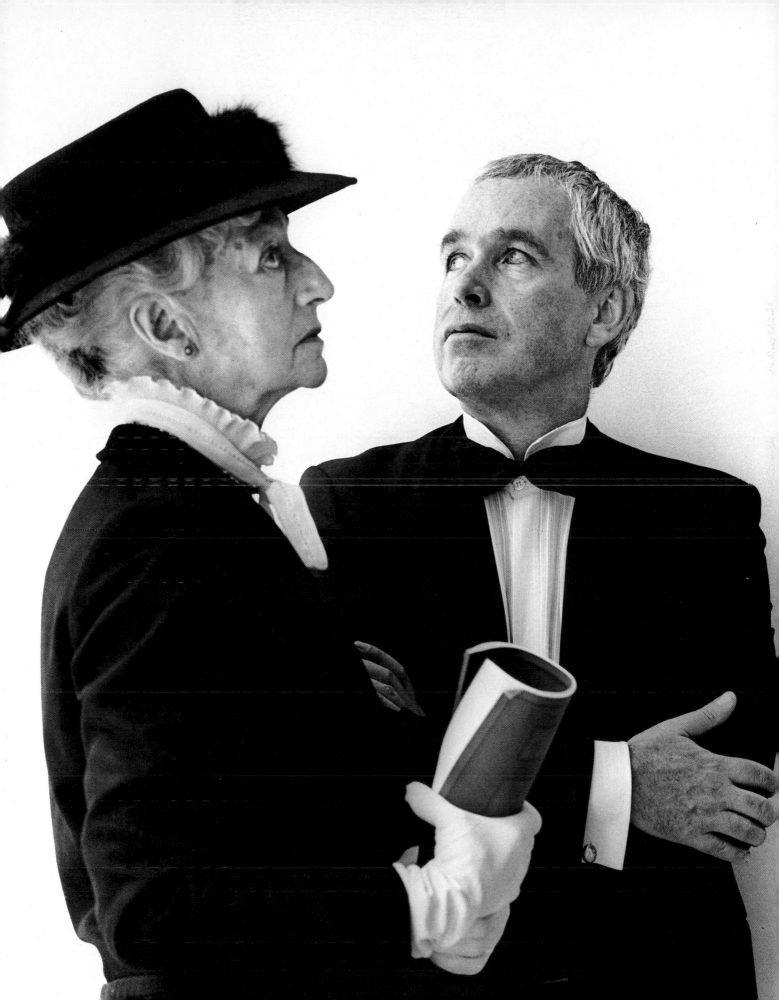

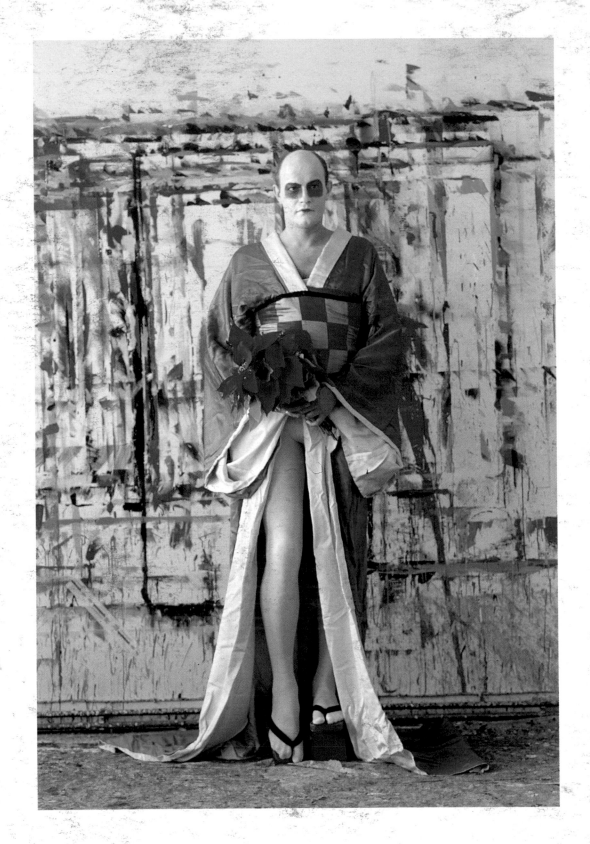

ABOVE Salomi, Berlin, 1986.

RIGHT Willem de Kooning, 1986.

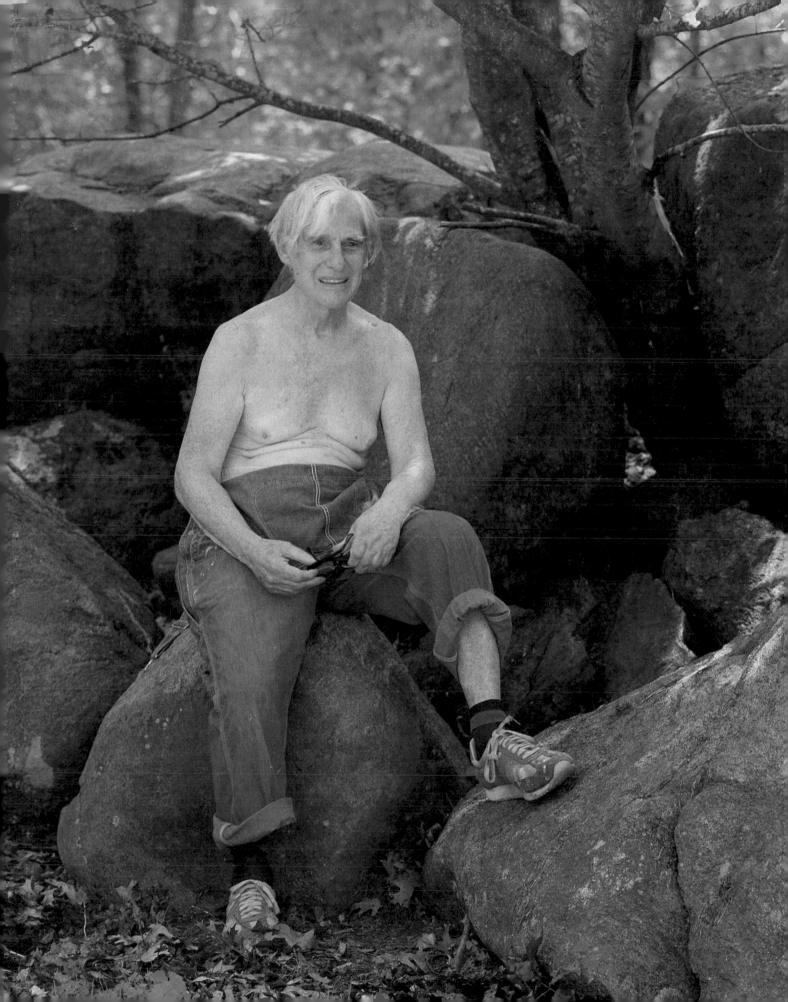

Max Bill, Switzerland, 1985.

Eduardo Paolozzi, 1987.

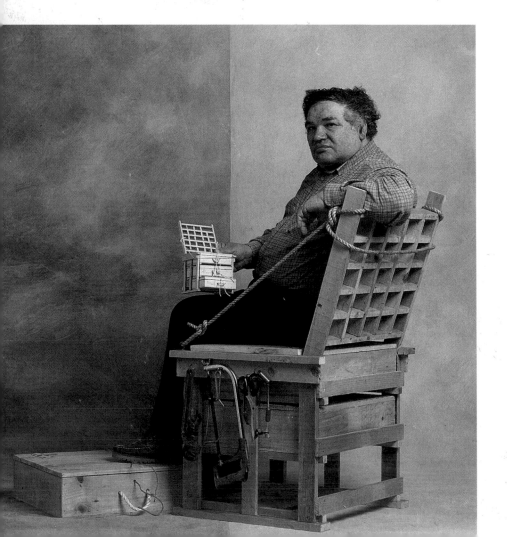

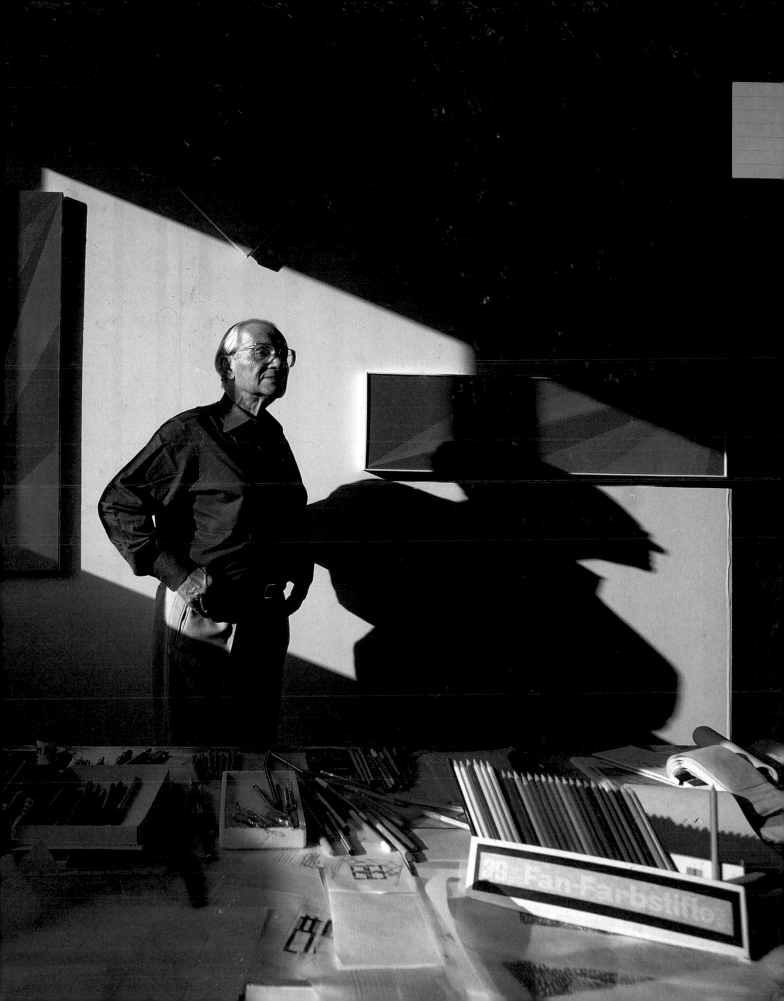

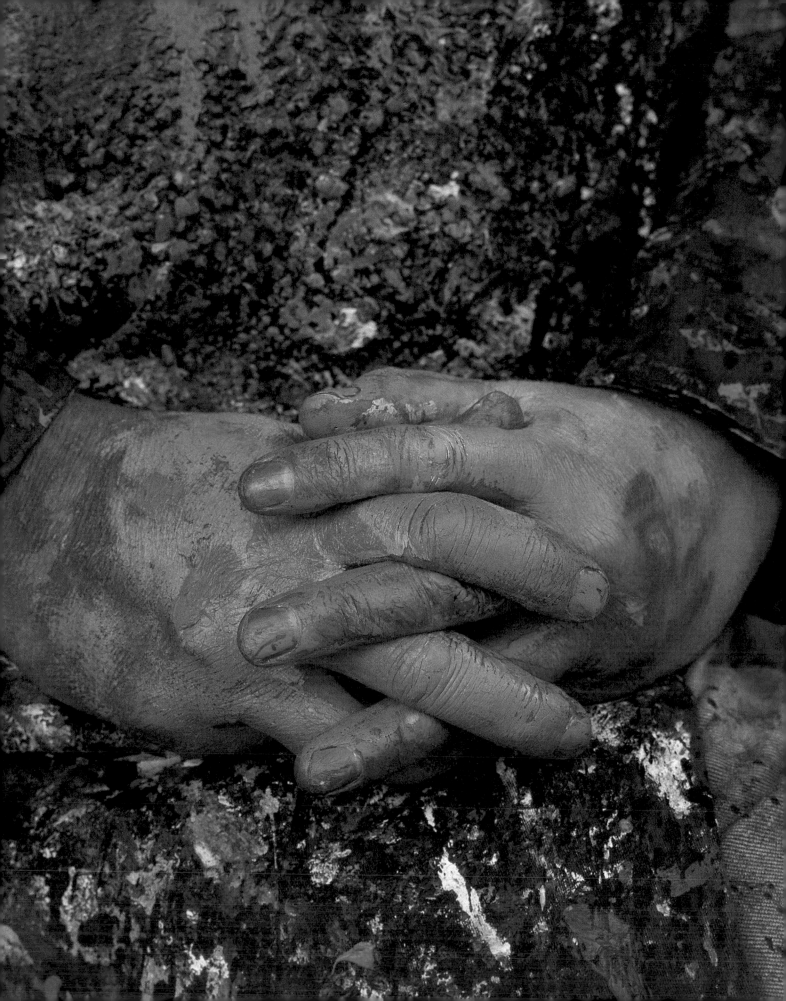

Ian McCulloch's hands, 1986.

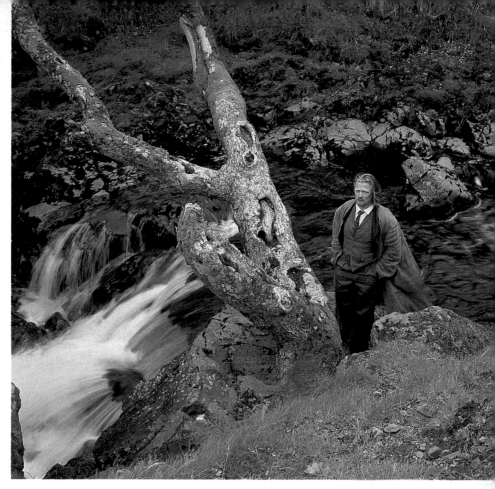

Stephen Campbell,
Scotland, 1986.

Adrian Wiszniewski,
Scotland, 1986.

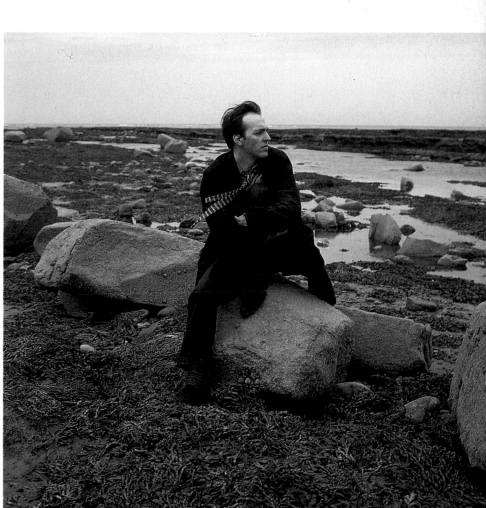

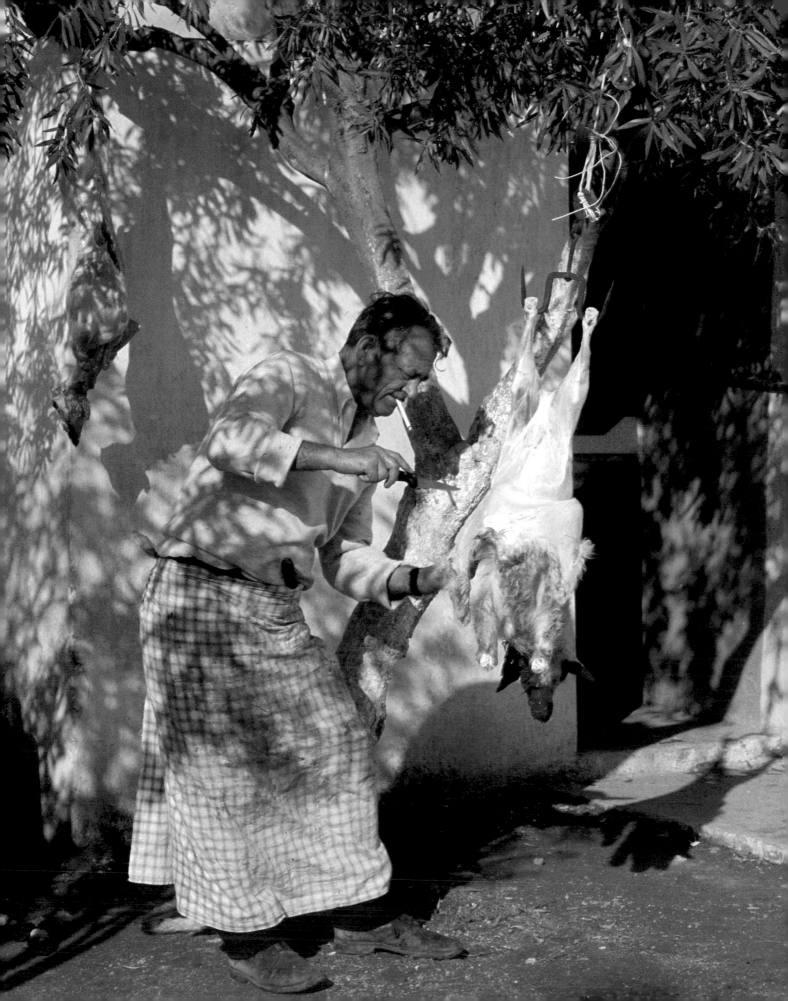

Butcher, Greece, 1984.

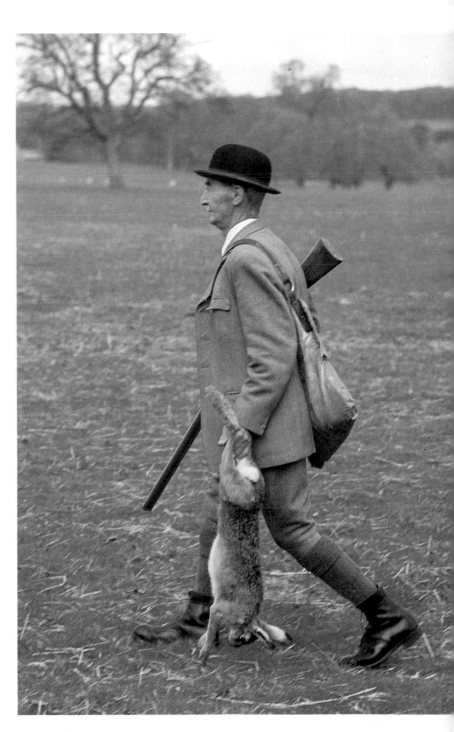

Gamekeeper, Holkham, Norfolk, 1984.

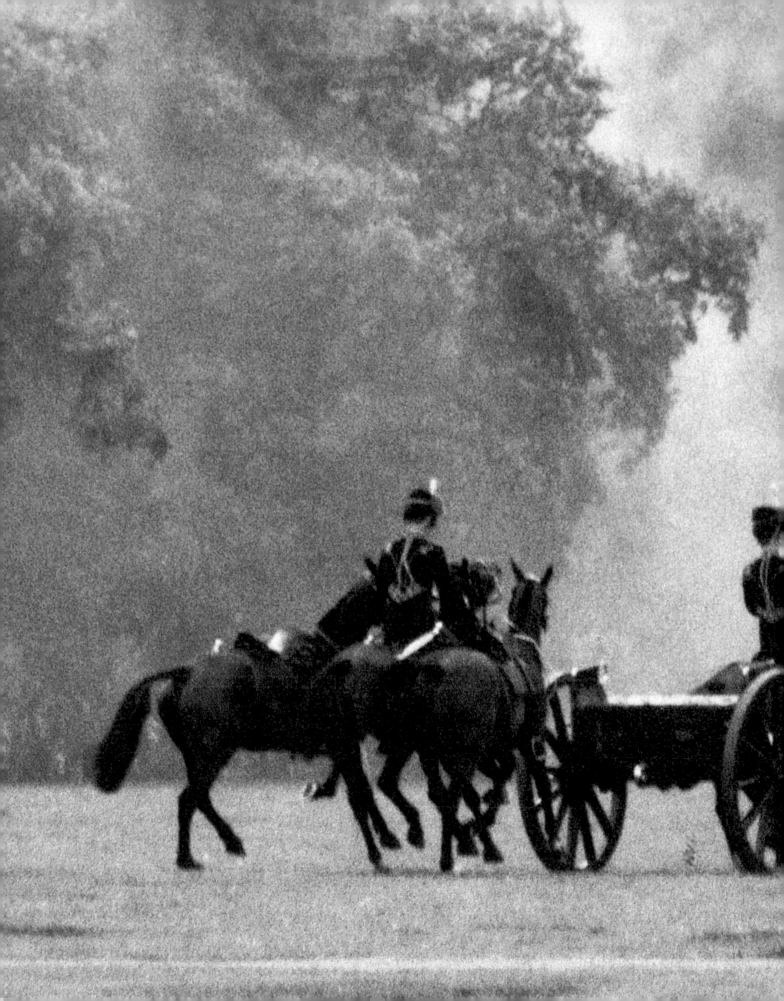

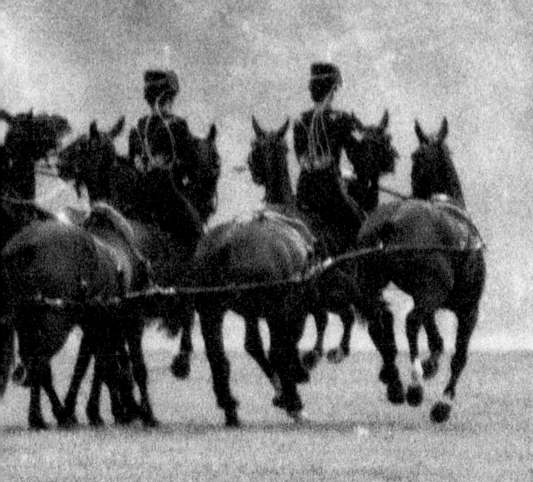

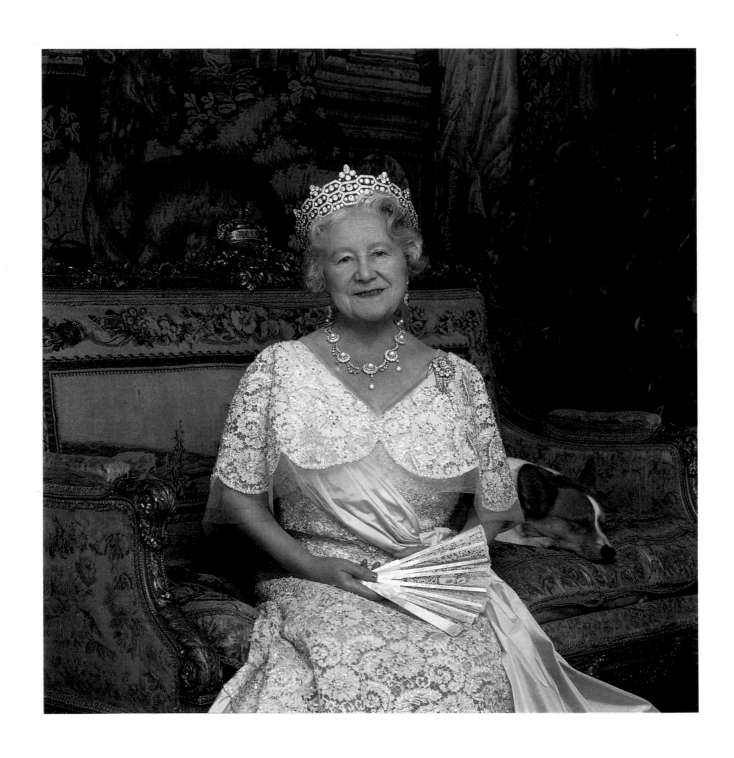

PRECEDING PAGES Royal Salute, Kings Troop, Hyde Park, 1984.

ABOVE Her Majesty Queen Elizabeth The Queen Mother, 1987.

OPPOSITE His Majesty The King of Spain, 1986.

154

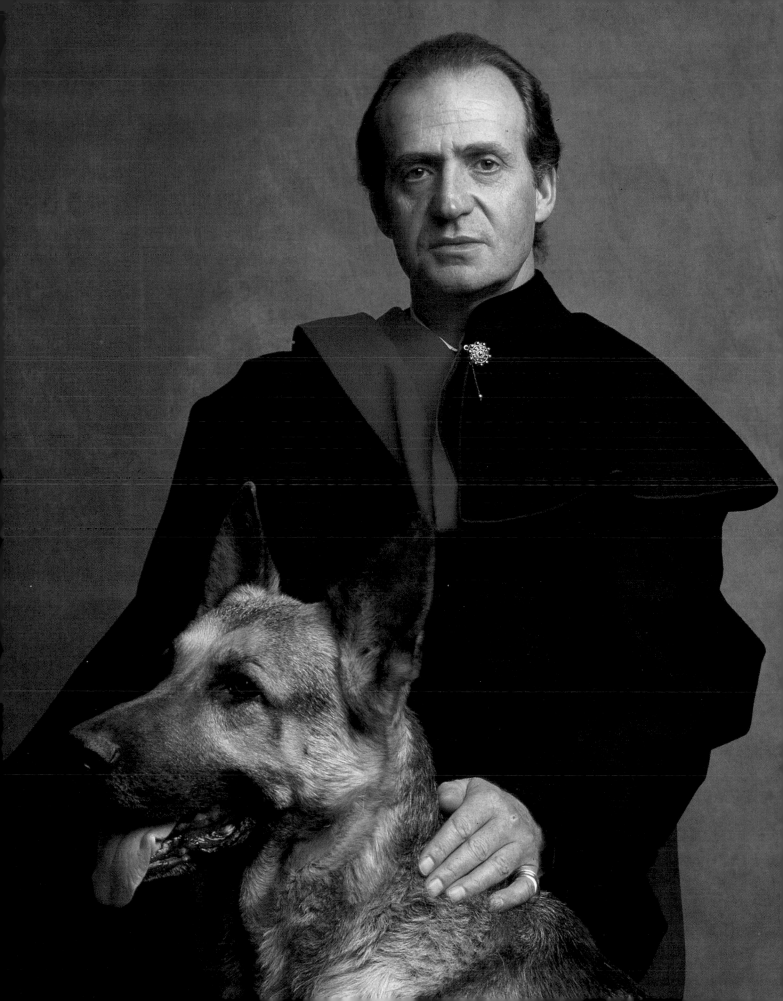

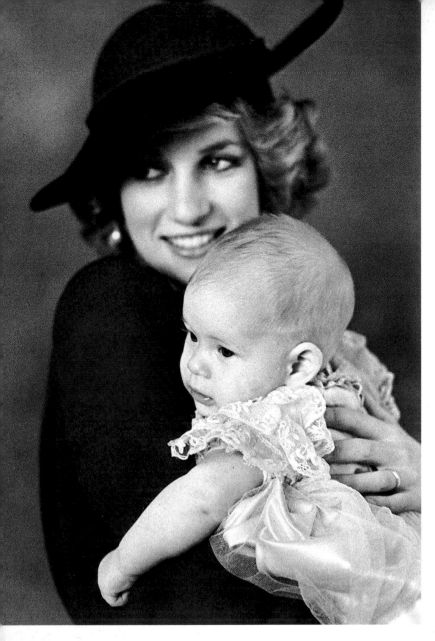

Her Royal Highness The Princess of Wales
with Prince Henry, 1984.

Her Royal Highness The Princess of Wales, 1985.

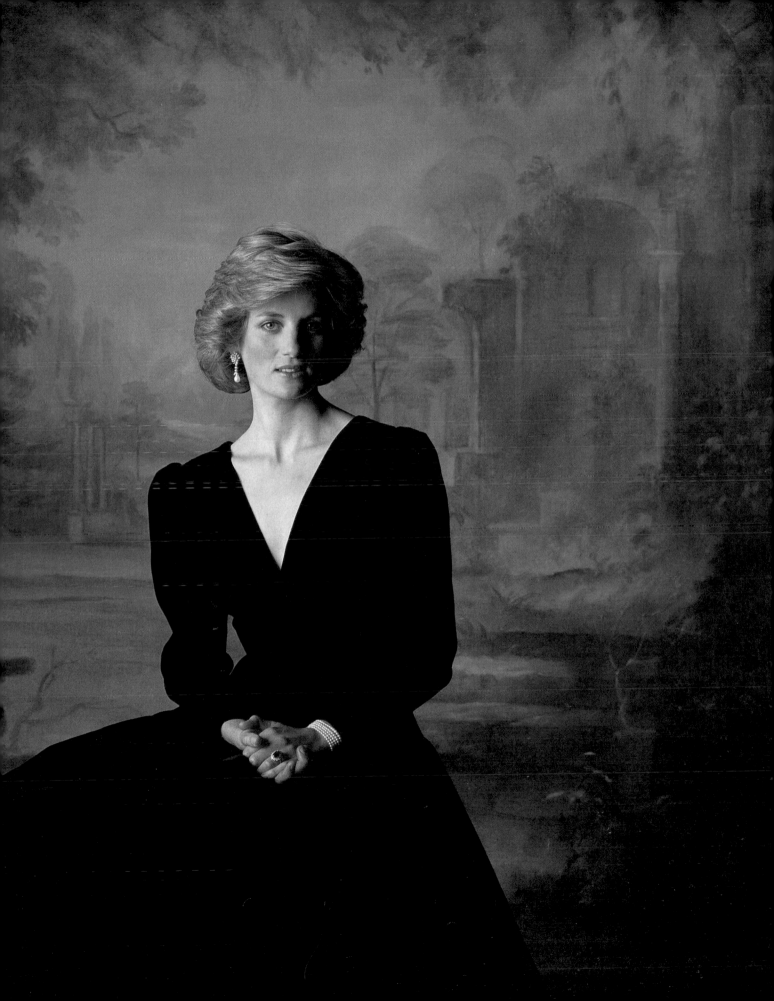

# INDEX OF NAMES